REALTY

REALTY
Beyond the Traditional Blueprints of
Art & Gentrification
A Reader
Ed. Tirdad Zolghadr

HATJE
CANTZ

Preface

How to get the better of gentrification, even by means of—of all things—contemporary art (CA)? This book contains a collection of texts that emerged from REALTY, an ongoing, long-term curatorial effort featuring public events, commissioned artworks, university seminars, and multiple research groups, both formal and informal in nature. Curated by Tirdad Zolghadr, the program focuses on strategies to overcome CA's complicity in processes of renewal and displacement within inner cities as well as the countryside. Within the field, the search for a response to this complicity has increasingly met with frustration and cynicism. Instead of theorizing our failures yet again, REALTY moves from the spleen of melancholia to the vulgarity of suggestion, however embarrassing. It aims to understand how the growing traction of CA can be used to maximum effect in the here and now.

The topic is all the more relevant in the midst of the pandemic. If ever there was an opportunity to rethink CA's relationship to land and location, it is now. The commodification of land and housing is at the heart of our most pressing concerns—concerns that are both ecological and sociopolitical in nature. Moreover, the latter-day strictures imposed by the pandemic on international mobility amount to a historic opportunity. Rarely has criticism of the artworld's extractive logic of one-place-after-another been louder. And rarely has the valorization of local context been as promising as it is today.

To deconstruct the dumb logic of fly in/fly out is not enough. Critique and catharsis are great, but they only really bear fruit when positioned as the first step of a larger process. Hence, the insistence in this book on workable responses, imaginative scenarios, and blue-sky thinking that goes for conditions of production within CA itself. At this point, our appetite for change still needs to be formalized by means of new support systems, protocols, and educational templates. Resistance to capitalism will remain a trite slogan so long as artists see no other choice but to do capitalism's bidding—as smoke screens, cheap labor, or small-time developers.

Since 2017, REALTY has been supported in many ways by the KW Institute for Contemporary Art Berlin. It also received support from the Dutch Art Institute and Sommerakademie Paul Klee Bern. Recent writing and editorial work has been made possible by the Foundation for Arts Initiatives (FfAI). (Another upshot of the REALTY program is my third novel, *HEADBANGER*, which explores this book's contents from an autofictional vantage point.) The focus on Berlin and its surroundings as a case study in this book is due both to KW and to my having lived and worked here for much of my adult life. To counterbalance this quasi-Prussian perspective, about half the contributions are from further afield.

Though interdisciplinary in spirit, the book's onus is unapologetically to art and the purchase it offers—one advantage of CA discourse being that it is informed by practicalities and theoretical research alike, and thus more sweeping in its mapping of references than journalistic or academic discourse often is. The challenge is to then steer this momentum toward a dialectic of falsifiable positions. By this I mean that this is a book that tries, rather loudly, to convince; and not just anyone. (The very fact that you're reading this book suggests your membership in the privileged niche audience we had in mind.)

The book's first editorial essay plots key features of CA at large. KW and the urban developments which have made the venue what it is today figure as a case study. The text also offers a working definition of the term "gentrification," describing the role of local and national governance within it. It concludes by explaining the role CA has played in creating this mess. My second contribution, however, is a taxonomy of possible road maps out of said mess, an antithetical position to the doom and gloom with which the book commences. This second editorial essay focuses on methods of redistribution, democratization, and decommodification, both as government policy and within the purview of CA itself.

The book's other contributions range from recent scholarship to firsthand accounts of artistic agency. Suhail Malik's essay[1] contrasts a public mandate for "anti-gentrification development" with an anti-development stance found among creative workers that he suggests is self-serving and ultimately "uses the urban poor as collateral." Malik's perspective sheds a helpful light on the laissez-faire liberalism that marks CA, while also helping to contextualize the growing

1 First published in *STATISTA: Towards a Statecraft of the Future* (Zurich: Park Books, 2019).

eco-political stance currently found among cultural workers. The con-
tributions of de-growth and other comparable movements have been
groundbreaking, but at the hands of CA's incessant hunt for ramshackle
real estate they can serve as smoke screens for a decidedly less egali-
tarian agenda.

Meanwhile, Laura Calbet Elias's essay offers an analysis of the finan-
cialization processes that currently undergird the workings of real estate
development, using a small slice of Berlin Mitte as a forensic case study
to demonstrate their mechanisms. Calbet Elias also maintains that crit-
ical analysis tends to focus on art's effect on the financialization of other
sectors: she argues that we must foreground the impact on art itself, as
an object of financialization in its own right.

Sabine Horlitz's contribution points to community land trusts as a
tried and tested form of collective ownership—one safely beyond the
reach of market speculation. This mechanism is being deployed within a
wide range of settings as we speak. Her essay also heralds the foundation
of a municipal land trust in Berlin itself.

Marco Clausen shifts the discussion to a rural setting, tracing the
different histories that have contributed to shaping present-day
Berlin's environs, from the land practices of the Prussian aristocracy
to the impact of international finance. He ends by pointing to other
genealogies lying further afield, making a claim for a "stewardship" of
natural resources rather than an ideology of property ownership.

Katya Sander's "Landscape Study," meanwhile, maps the material
traces of rural property regimes in Scotland and Denmark over time, cul-
minating in a similarly poignant appeal for land stewardship as opposed
to the extractive logic of ownership. Her comparative study of ante-mod-
ern agrarian models of property usage suggests new modes of custodian-
ship and what-if scenarios.

Simone Hain's seminal report on the draining of the rivers Oder,
Netze, and Warthe places the construction of the Prussian landscape we
now take for granted within a broader historical context. (Berlin itself
was largely wetlands until the eighteenth century.) Hain describes the
human toll of what was at once a monumental engineering experiment
and a disastrous state-led land grab. But she also offers a narrative
of how a form of modernization based on enlightened technocracy
emerged from the very muck of this eighteenth century catastrophe.

This reader also features Maria Hetzer's captivating description of
communist land reform in the GDR, undertaken in the immediate after-
math of World War II. Although Hetzer's account does not wish to offer a
blueprint for the here and now (as she herself insists), it does remind us

of the political possibilities a state of exception can contain—especially today, when the regime of neoliberal intimidation appears, perhaps momentarily, to be on the wane.

A comparably dizzying sense of Red possibility marks Bahar Noorizadeh's research on planning experiments in the early Soviet Union. Her contribution addresses the short-lived school of Disurbanism, which sought to overcome the rural-urban divide by devising radically new lines of settlement. An unabridged version of the essay published here, accessible on www.realtynow.online, also features the correspondence between Le Corbusier and the disurbanist visionary Moisei Ginzburg. This exchange epitomizes the ideological and geopolitical rifts running through the heart of the modernist movement.

In terms of a critical engagement with the legacy of modernism as we know it, Marion Von Osten's contribution is altogether less forgiving and more entangled.[2] While von Osten's practice as a curator, theorist, and artist unapologetically stood on modernism's shoulders (see her formal embrace of the grid in her work, her monumental engagement with the Bauhaus, or her work on architecture and colonialism in the Maghreb and Sub-Saharan Africa), the scope and rigor of her plea for an "interspecies" approach, as well as a post-anthropocentric rethink of present-day urban planning, makes the titanic blind spots at the heart of the modernist project all too painfully obvious.

Khaldun Bshara ties the urbanization of rural Palestine to the commodification of land in the post-Oslo era. In a sense, his contribution picks up where Von Osten leaves off, placing a Palestinian history of modernization squarely within a history of both Ottoman and European colonialism. At our KW conference in 2020, Bshara's wry eloquence and charm allowed him to explain the Israel/Palestine conflict as directly colonial, without any Germans in the audience falling off their seats in a dead faint.

For her part, Marwa Arsanios offers a snapshot of her persistent research in both Colombia and Kurdistan, based on the testimonies of women who have reinvented theories and practices of agriculture within militarized environments. It is in the rural heartlands of Palestine, Colombia, and Kurdistan that land grabs, in all their violent disregard for nature and human dignity alike, can be most clearly understood as instances of clear-cut colonial dispossession.

terra0 represents the most ambitious artist project in this publication, in terms of experimental rigor and potential impact alike. The

2 Also first published in *STATISTA*.

collective offers a scenario for a fully autonomous forestscape that can be released from human intervention to tend to its own interests and growth via smart contracts alone. Although the terra0 blueprint began as a student project and will remain under development for a long time to come, once this young artist trio realized the staggering implications of their project, they decided to devote their long-term professional trajectories to addressing its technical, ecological, and financial challenges. They have begun with small-scale experiments intended as precursors to scaling up to whole ecosystems.

The two remaining contributions address the chronic lack of support structures within CA, and the part this plays in the saga of art and gentrification. To imagine a life beyond residential capitalism, we do need more than a sheepish sense of being passively part of the problem. By means of her Tuleva initiative, curator Kristel Raesaar explains how you can ensure a pension as a freelancer, even within a fiercely challenging economic environment. Her contribution answers the question of how to develop support systems built by and for their users, with technology no more demanding than an Excel file. For her part, and in the very same spirit of redistribution, writer Penny Rafferty points to recent, ambitious experiments in redistribution within CA, particularly via quadratic voting methods and blockchain technology.

The political economy of art and urban development is a complicated and well-trodden path and soon after embarking on it I found myself indebted to a vast number of conversation partners—kindly experts, activists, and colleagues—who all humored me along this journey. Some encounters were a give and take, others less so. The dazzling Anh Linh, editor of ARCH+, sadly examined me like a fly in his *Karottensuppe*. To the likes of him, this book revisits many well-known topics (1990s Berlin, Henry George, etc.); to others it might provide a valuable introduction. Personally speaking, it is exactly the kind of book I would have wished for when starting out on my research . . . a manual for the art professional to build upon. To say the least, it would have spared me many, many moments of uncertainty and exasperation, over *Karottensuppe* or otherwise.

Above all, it is to the late Marion von Osten to who I am indebted. She not only organized exhibitions in the 1990s that first drew me to CA, but it is thanks to her that I eventually understood gentrification as a dynamic process that encompasses both the urban and rural, the representational and ecological. Although the book perhaps retains a metrocentric bias, it does zoom out to contemplate the city as one fragment

of a much larger biosphere. That it strives to do so at all is entirely Marion's doing.

I would also like to express my thanks to the following individuals, for their part in the long chain of events that led to this book. I would like to thank Tom Eccles, who introduced me to the character-building experience of full-time teaching, and my friend and colleague Suhail Malik, to whom I owe many, many things. I am equally grateful to my collaborators at Riwaq, Ramallah, although I could never bring our project fully to fruition, unfortunately. But the lessons learned are not forgotten. More recently, I owe much to Krist Gruijthuijsen, whose trust and support have been decisive. He took my 2016 polemic *TRACTION* at face value, offering me four years under his auspices at KW to put the book's premises to the test. This is how the lion's share of *REALTY*'s contents came together. I should also mention other KW colleagues who went out of their way to make the REALTY program happen; Duygu Örs, Katja Zeidler, Maurin Dietrich, Mason Leaver-Yap, and especially Sabrina Herrmann.

Many other people are referenced in my two editorial essays. Others not mentioned there include: Deadline Architects Berlin, Rival Strategy London, Esra Akcan, Michael Baers, Diann Bauer, Carl Berthold, Anya Bitkina, Mathieu Blond, Stephan Blumenschein, Erik Bordeleau, Johanna Brückner, Crystal Z. Campbell, Luca Carboni, Sara Cattin, Luiza Crosman, Tashy Endres, Shahab Fotouhi, Felix Hartenstein, Jörg Heiser, Martin Heller, Dirk Herzog, Andreas Krüger, Alexandros Kyriakatos, Friederike Landau, Stephan Lanz, Maria Lind, Azar Mahmoudian, Luke Mason, Samantha McCulloch, Doreen Mende, Alexis Mitchell, Dina Mohamad, Katharina Morawek, Heather M. O'Brien, Rachel O'Reilly, Sarah Pierce, Hans Rudolf Reust, Kristien Ring, Hannah Rocchi, Rachel Rosenfelt, Natascha Sadr Haghighian, Gabrielle Schleijpen, Shirana Shahbazi, Solmaz Shahbazi, Jörg Stollmann, Eric Golo Stone, Niloufar Tajeri, Jonathan Takahashi, Leonardo Vilchis, Andreas Vogel, Ingrid Wagner, and the inimitable Oraib Toukan.

screenshots on previous pages: Christopher Roth, *space-time.tv: REALTY-V*, online TV channels (2018-ongoing)

Provisional Global Snapshots

Tirdad Zolghadr

CA 101

A quick comparison of archetypes is sometimes helpful. When Leonardo
da Vinci settled in Renaissance Venice, he worked as a military engineer,
designing canal systems with a lock mechanism that is still in use today.
Centuries later, deep in the asphyxiating mass of the industrial city, the
historical avant-gardes were less hands-on than Da Vinci but all the more
confident in theory and vision. They reimagined their towns with an arro-
gant hubris that Benjamin later described as a "destructive character,"
one that would have appeared equally preposterous to Da Vinci as to our-
selves. Though the cabin fever pathos did simmer down a bit, the hubris
remained until the 1970s. Creative visitors to faraway locations were
both preposterous and hands-on enough to try their hand at agriculture,
infrastructure development, sniper training, literacy campaigns, and
propaganda. Take those late-modern icons—the Situationist flaneurs
with their *dérives* and *New Babylons*, or the 1970s cool cats lounging in
the cast iron lofts of a deindustrialized lower Manhattan. Even they are
far removed from contemporary art's take on its urban environs.

Something shifted over the last decades of the twentieth century. In
its self-image, the bohemian virtue of art may live on, but in real life,
contemporary art (CA) went from being an upshot of wealth to a source
of wealth in its own right. Today, CA is a capillary network of formal and
self-run venues which together embody a highly specialized skill set, a
fiercely competitive job market, a distinct "moral economy" of indeter-
minacy,[1] and an asset in the ongoing race between competing metropoli-
tan "engines of growth."[2]

In terms of its politics, CA embodies a strong sense of "ontological
liberalism" (I owe this term to Victoria Ivanova)—a liturgy of individual
aspiration on all levels; cultural, sexual, intellectual, economic. In terms
of habitus, CA no longer occupies a niche where the critical intelligentsia

1 Borrowed from anthropologist Didier Fassin, this is a key term in *TRACTION*
(Berlin: Sternberg, 2016), cf., 35.

2 See, for example, Suhail Malik's online lecture, "Art in Cities: Short History and Some
Current Predicaments," https://newmidlandgroup.co.uk/art-in-cities-a-short-history-and-
some-current-predicaments-with-suhail-malik/ (accessed July 23, 2021).

consort with wealthy patrons, but is comprised, rather, of a sprawling cosmopolitan constituency mirroring the deterritorialization of art production itself. Despite these commonalities, and others besides, what is all-important to the field is its insistence that CA is not a field at all so much as a fluid assemblage of incommensurate communities of thought and action, beyond ideology or categorization.

Unnoticed values do tend to be the more tenacious ones. Wishful thinking aside, what are the really existing effects of our artscape within the cycles described in these pages? The metaphors are many. Artists are variously described as pioneers, parasites, a type of magical ointment, stalking horses, foot soldiers, shock troops, kamikaze pilots of urban renewal, revelers enjoying a last hurrah on the deck of the *Titanic*. Luckily, not all the terms for artists are quite as melodramatic. "Gentrification and the Artistic Dividend," a 2014 study published in the *Journal of the American Planning Association* (issue no. 80), describes the impact of the fine arts as "benign" in comparison to film and advertising. As argued by Marco Clausen, to overstate the impact of CA would indeed "culturalize" what is mainly the doing of policymakers and international finance.

Concrete examples of the effective role of CA within a specific redevelopment cycle are discussed extensively in this reader, but CA has a problem not related to net effect. Like the housing market, it is conceptually, psychologically, and economically premised on private ownership, as Andrea Phillips has noted. The race for individual achievement and reputational value is hard-wired into CA's DNA, and its selection processes are administered by a steep hierarchy of gifted individuals. The conditions of production within this skewed meritocracy amount to a "permanence of ongoing necessity." Thus the very idea of "social housing as a long-term commitment to equal access to democratically decided amenities," says Phillips, runs counter to "the psychic, cultural, and, in the end, economically organized needs of artists."[3]

Surely enough, as a field, we have learned to extract what is of interest—a topic, a story, a resource—and head for the next opportunity. Fly in, fly out (FIFO). As others have pointed out before me, once a "project" is completed, the expert moves on, whether they be artists, scholars, or investors. Which is why people mistrust the expert, and look to right-wing rootsiness instead.[4] Time will tell whether the pandemic can introduce a lasting sense of restraint, but prior to COVID-19, this

3 Andrea Phillips, "Art and Housing: the Private Connection," in *Actors, Agents and Attendants*, eds. Andrea Phillips and Fulya Erdemci (Berlin: Sternberg Press 2012), 146.
4 Ivan Krastev, "The Rise and Fall of European Meritocracy," *New York Times*, January 17, 2017, https://www.nytimes.com/2017/01/17/opinion/the-rise-and-fall-of-european-meritocracy.html (accessed July 24, 2021).

rampant extractivism allowed for a worldwide expansion of the art field at breathtaking speed—in the name of no other agenda than an expansion of the self-evident value CA putatively possesses.

The upshot of CA's regimented wanderlust is a poverty of aspiration. It's hard to go beyond gestures when you always have one eye on the exit. After so many blueprint opacities, is it possible to appreciate a clear-cut meat-and-potatoes position? Hardly. To invest in more grounded parameters is to risk being rooted, thus commensurable, thus predictable. Who in our field would ever want to risk cliché.

By way of example, let's take a hypothetical biennial commission. The artist, working from afar, might request, say, a primary school—preferably in a demographically mixed neighborhood—to serve as both film set and exhibition site. Depending on the school, international attention can do more harm than good, so this type of thing would ideally be a careful, time-consuming affair. But regrettably, time is short. Incidentally, the biennial's outreach team may have built a relationship over time with a nearby school. But its advice may not count for much. A principle aim of biennials, after all, is realizing the exchange value of found material. Rather than community welfare, what counts is the school's architecture, iconography, history, ambiance—its ability to fuel the work's spatial resonance and political narrative, whether "Marxist," "decolonialist," or otherwise.

Take, for instance, curator Kate Brehme's doctoral research, which traces the increasing level of abstraction that marks the Berlin Biennale's (BB) relationship to the city.[5] At an early point in BB history, she says, off-site spaces were merely exciting "platforms." Over time, they became "laboratories" for exhibition formats that aestheticized the spaces that hosted them. By 2014, the Berlin Biennale's spectacle of transformation was cogent enough to redefine the very meaning and temporality of the locations it occupied, and to crown them sites of contemporaneity in and of themselves: opaque, ambivalent, indeterminate.

It's a given to the vast majority of my colleagues that we should stick to this kind of art, regardless of the consequences. Why exactly should this particular pursuit of happiness be so self-evident? The success rate within CA is hardly enough to explain our sense of conviction. Career benefits are meager at best, especially in Berlin—the only capital city in the EU poorer than the national average.

At Berlin dinner parties or panel discussions where artists deplore that they are made to compete for scant resources with schoolchildren

5 Kate Brehme, "The Berlin Biennale as Spectacle," presented at "The City in the Biennale" session, 2016 Association of Art Historians Conference, April 8, 2016, Edinburgh University.

and refugees, I shut my mouth. I prefer not to mess with angry Berliners. But I do wonder where the sense of entitlement comes from. In German parlance, you will find a clue in the untiring reference to *Zweckfreiheit der Kunst*, art's freedom from purpose. The continuance of the Euro-humanist tradition valorizes culture beyond use and function, even as we make our claims for decolonization, even as we scoff at Kant & Co. In practice, we uphold this tradition worldwide, almost without reserve. It frees us from the need to explain ourselves—beyond occasional lip service to the occasional populist, whom we privately consider a bigot. As more and more policy-makers ditch the autonomy of art in favor of service to urban development and other things, we need more than *arrière-garde* positions to see us through.

And CA does have more to offer. Thanks to the persistence of critique as our default attitude of choice, our recent inclusion within the corridors of power remains difficult to accept (whether in the context of international diplomacy, educational policy, city development, or otherwise). But CA is now in a better position than it likes to acknowledge. To this day, CA's empowerment remains largely under-theorized. Throughout the recent creative city debates, I was surprised to find common ground between artists and architects. Despite the latter's machismo, both professions like to identify both with the heroic trickster prototype, on the one hand, and the melancholic slave to capital, on the other.[6] Neither of which imply a sense of accountability, let alone change. Fortunately, there are architects, artists, curators, and venues out there that do insist on the difference between what is suave and what is important: practices where the culture of systematic (self-)critique is demystified and carefully put in its place: once critique becomes a catalyst, it can be a ground that proposals can proceed from. (Proceed *from*—not dwell *within*.) As this book will argue, art does not necessarily need to be overtly critical, durational, or experimental in order to be more than CA for CA's sake. It can be as quietist or commodified as you like. What it does need is a stated agenda, grounded over time, in really existing conditions and necessities.

Gentrification 101

"Art and gentrification? I can tap-dance that argument on your forehead." The script is now a familiar one. Since the day sociologist Ruth Glass coined the term "gentrification" in 1964, CA has even learned to preempt it whenever needed. Take the Al Quoz arts district of Dubai, which leapfrogged the whole process of urban decline and renewal by

6 I owe this point to Arno Brandlhuber and Christopher Roth.

building old-school "postindustrial" warehouses from scratch. No need for manufacturing to come and go; art need not wait its turn.

And yet, you would be surprised by the misunderstandings—starting with the eagerness to evacuate social cleansing from the term and instead discuss gentrification as a quality of life issue,[7] as if it were a matter of bike lanes or flirting with the barista. To be clear, not every displacement is a case of gentrification, but every form of gentrification does, by definition, involve displacement. The very point of using the g-word is to pinpoint cases of both regeneration and displacement occurring in tandem, as a coherent two-step process of spatial transformation.

At the outset of the whole process lies the spotting of a "rent gap," a theory developed in 1979 by geographer Neil Smith to describe the disparity between the current rental income of a property and its potentially achievable income. An economic explanation for the process of gentrification: at its end lies an "upgrade" in demographic, material, and symbolic terms. The particular shade of upgrade discussed in this book— one that is prominent if far from universal—involves the transformation of cultural capital into real capital. To use Sharon Zukin's formula: Real Estate + Cultural Capital = Real Cultural Capital.[8]

Even within a single gentrification cycle, the "improvement" of the local population can reoccur several times, including the displacement of its earliest enablers. For their part, those departing, whether hipsters or salaried working-class families, may eventually wind up pumping up housing prices anew in the neighborhoods where they are displaced to. Recent analyses of European and US housing markets emphasize how the lower middle strata of a population becomes displaced by the upper middle ones. One can also refer to Christophe Guilluy's work on the "politics of resentment" in France, which casts the Front National as a party of suburban commuters displaced by inner-city *bourgeois bohèmes* (*bobos*).[9]

Setting aside the cost of rent, if you see old friends leaving, old stores going bust, and new ones not catering to you; if at that point you still won't budge it is probably due to a lack of options. Displacement comes in many shapes and forms. Consider that the Berlin municipality has

7 Stephen Bayley, "The moral case for gentrification," *Spectator Australia*, June 27, 2015, https://spectator.com.au/2015/06/the-moral-case-for-gentrification/ (accessed July 3, 2021).
8 Sharon Zukin, *Landscapes of Power: From Detroit to Disney World* (Oakland: University of California Press, 1991), 28.
9 Andrew Hussey, "The French Elites Against the Working Class," *The New Statesmen*, July 24, 2019, https://www.newstatesman.com/world/europe/2019/07/french-elites-against-working-class (accessed June 30, 2021).

counted approximately 5,000 homeless but guesstimates that ten times as many lack a regular living space of their own.

Finally, we reach a point in the cycle when a good address is established. Much has been written about metrophobic urban villages (within the city, but not of it). According to Matthew Soules, such "ruralist" agendas in the US coincide with the economic, cultural, and political ascendancy of the military. Niklas Maak refers to this moment as "zombification": immigration as a restaurant, urbanity as a vernissage. Even neoliberalism itself can be zombified when risk and volatility are contained by watertight inheritance rights, which are making a strong comeback these days.[10]

Cycles of this kind—from rent gap to displacement to zombification—can take decades. Proprietors often "go long," leaving areas untouched for many years on end so as to eventually maximize return on investment. Samar Kanafani has described the situation in Beirut, where if you take a picture of an abandoned ruin someone will emerge from the bushes to ask what you're doing. The neglect is calculated.[11]

The attempt to cutesify gentrification by ignoring the enforced transfer of populations would be less worrying if it didn't serve to normalize what is historically contingent. Even when displacement is accepted as an inherent part of the equation, it is often relativized as a human condition—as natural as headaches or cantaloupes (some have argued for hunter-gatherers being the first victims of forced displacement, having been "gentrified" out of existence by agriculture some 9,000 years ago)—when the evidence suggests none of these changes are ubiquitous and never will be. In fact, most neighborhoods stay poor or wealthy at a fairly stable rate.

So, if the process is neither universal nor a question of lifestyle, then why, you might ask, should it be of interest to CA? Four reasons. First, it's a matter of understanding your specific environment. The places where CA does rear its head are quite often precisely the locations where the rent gap is at play and "maximum quantitative profit [must be] derived from a qualitatively restricted place" (see Wolfgang Scheppe's "The Ground-Rent of Art and Exclusion from the City," referenced below). Second, developers are now eager to recruit art and culture to

10 Editorial, "Inherited wealth is making a comeback. What does it mean for Britain," *The Economist*, April 27, 2019, www.economist.com/britain/2019/04/27/inherited-wealth -is-making-a-comeback-what-does-it-mean-for-britain (accessed July 22, 2021).
11 Samar Kanafani, "Made to Fall Apart: An Ethnography of Old Houses and Urban Renewal in Beirut," PhD diss. (University of Manchester, 2017), https://www.research.manchester. ac.uk/portal/en/theses/made-to-fall-apart-an-ethnography-of-old-houses-and-urban-renewal- in-beirut(c9db7f27-0d4a-4e5a-b3f6-87b65b0eaae2).html (accessed May 31, 2021).

do their bidding. So if we remain happy with our complicity, at least we can avoid being useful idiots. Third, the commodification of land and housing increasingly pollutes everything under the sun, from the food we eat to our sense of belonging. Finally, even those of my colleagues who acknowledge gentrification as a form of class violence still intuitively share the understanding that, at the end of the day, CA is not the problem but part of the solution. Surely what's good for art professionals must be good for those around them, too. The best-case scenario for a healthy neighborhood is a "mix" of people, one that includes a generous dose of ourselves. Better "desegregate" the place, we mutter, than allocate swathes of hard-up immigrants to the city's margins.

Alas, in a rent gap situation, the presence of culturati almost always leads to a slow bump in property value, and hence to an eviction effect. When it comes to a "mix" of cultured bourgeoisie, and some token subalterns, you will find no studies corroborating a "deconcentration" effect. Trickle Down wealth remains a myth. (Culturati aside, for some two centuries now poverty deconcentration has been a policy against social revolt, and for proactive plague management.[12])

Systemfrage: Primitive Accumulation
Is development feasible without the patterns described above? Is the bad stuff a perverse effect or the system working as intended? With its emphasis on consumer choice, the "demand-side" argument casts development as a result of coalitions between state and private interests, all of them banking on the cumulative, beneficial nature of investment in a given built environment. If successful, one wave provokes the next. A convention center needs airports, which need communication infrastructures, but also hotels, which would benefit from a cultural scene, and so on. Gentrification, according to the demand-side narrative, can be benign or painful, just like development itself.

With its focus on disinvestment and redistribution, the "supply-side" argument tends to frame development as something uneven by necessity. In this scenario, gentrification is just the fin above the water—the natural trait of a creature whose survival hinges on the incessant production of space, one location after another (a point most famously made by Henri Lefebvre). Some would argue that development is less of a shark and more of a parasite, feeding on its host to the point of death. Until then, the reification of what is nonreplicable—wildlife as monoculture, downtowns as gated communities—is a "locational seesaw" that follows Marx's "law of uneven development," famously revisited by geographer

12 Lisa Vollmer, *Strategien gegen Gentrifizierung* (Stuttgart: Schmetterling Verlag, 2018), 100.

Neil Smith.[13] Capital is cyclically withdrawn from some places to be invested in others, with equalizing effects over here (distances disappear thanks to better roads) and differentiating effects over there (stratification according to class and race).

As per the law of uneven development, locations fulfil different roles at different moments, by way of open-air geographies of mass incarceration, new surveillance technologies, normalized usage of institutionalized force, subcontracts for the state monopoly of violence, etc. In earlier stages of modernist urban planning, it was North Africa that was famously bestowed the honor of being an XL scale laboratory.[14] Currently, unprecedented forms of land grabbing are being practiced in the West Bank and Gaza, where landscapes are not the stage but the means for managing civilian populations. At some point a "boomerang effect"[15] will once again duly return to Europe, for better or for worse, and as it has before.

Marx defines the ur-moment of any cycle of uneven development as one of "primitive accumulation." He coined the term in the 1860s to describe the enclosures across England, where commonly farmed land was being fenced off by the gentry and made subject to cash rents, thereby creating a nonlanded class stripped of its traditional assets and rights, wholly dependent for survival on wage labor (Katya Sander's contribution describes the process as it unfolded in the Scottish Highlands over the seventeenth and eighteenth centuries). In this light, our subject matter is less about specific hotspots or crafty villains and more about surprisingly archaic cycles.

Marx's theoretical picture has since been updated to make it less Eurocentric (Onur Ince[16]) and less specific to an epoch (David Harvey's "accumulation by dispossession," or Raymond Williams, who describes a process reaching back to the fifteenth century[17]). I borrow "theoretical pictures" from WJT Mitchell to imply the scrunching of complex "theory-scapes" into something curt, portable, punchy, contagious, and easy to remember. And Marx's ur-instance of placemaking encapsulates many things: it is a touchstone of the colonial era, the agricultural revolution,

13 Neil Smith, *The New Urban Frontier: Gentrification and the Revanchist City* (London: Routledge 1996): 84.

14 Marion von Osten, "In Colonial Modern Worlds," in *Colonial Modern: Aesthetics of the Past, Rebellions of the Future*, eds. Tom Avermaete, Serhat Karakayili and Marion von Osten (London: Black Dog Publishing, 2010), 16–37.

15 Stephen Graham, "Foucault's Boomerang: The New Military Urbanism, *Reading Design*, 2013, https://www.readingdesign.org/foucaults-boomerang (accessed June 10, 2021).

16 Onur Ulas Ince, "Primitive Accumulation, New Enclosures and Global Land Grabs: A Theoretical Intervention," *Rural Sociology* 79, no. 1 (2014): 104–131.

17 Raymond Williams, *The Country and the City* (Oxford: Oxford UniversityPress, 1973), 138.

a removal of structures that hindered the rise of proletarian labor and private property, a trigger for the population boom and industrial expansion, a submission of nonaccumulative logics of subsistence to accumulative ones. As such, it points not only to seizure and extraction, but to the implementation of altogether new constellations.

Hard to ignore a colonial rationale that marks the placemaking process to this day. To facilitate conquest and seizure, spaces are still cast as miserable, unhealthy, dirty, reactionary, etc., and thus in need of being complexified, securitized, saved. Rural areas of interest come to be defined as ugly or as wastelands,[18] while surplus-oriented societies are defined as more worthy than (indigenously owned) subsistence ones. Some places are declared void of history and humanity altogether. See the myth of the empty land awaiting Zionist cultivation from the 1890s onwards. As Rosalyn Deutsche phrased it with regards to 1980s Manhattan, the trick is to make the narrative so malleable that the "x [which] has no history" can be arbitrarily exchanged for the "y [that] has always existed."[19] By and by, any settlement can be made to look perfectly natural, and the surrounding landscape can be reconceived accordingly.

Importantly, Marx considered the rural enclosures both an illegitimate land grab *and* a case of inevitable modernization in the face of underinvestment, primitive agricultural practices, the wasteful use of space, etc. The all-important growth of the working class was contingent upon a population boom, which in turn would have been unthinkable without a drastic increase in grain production—and the modern enclosures it required.[20] Only the maturity of capitalism would trigger organized struggle against it. Engels, ever snarky, summed up the dispute by arguing that, well, let's face it, a troglodyte would never organize a Paris commune in his cave.[21] Such snooty condescension marks a very rich tradition of left-wing intellectuals, from Marx himself on "the idiocy of rural life," to Francois Lyotard on workers "desiring and enjoying dispossession," to left-accelerationists expounding on "primitivist equilibrium" and "folk politics." Trotsky summarized capitalism as a subjugation of town over country before himself advocating for it in the name of socialism.[22]

18 Walter Bagehot, "Britain's delusions about the green belt cause untold misery," reprinted February 11, 2017, www.economist.com/news/britain/21716626-solve-its-housing-crisis-country-must-learn-love-urban-britains-delusions-about (accessed June 14, 2021).
19 Rosalyn Deutsche and Cara Gendel Ryan, "The Fine Art of Gentrification," *October Magazine* 31 (Winter 1984): 91–111.
20 Williams, *The Country and the City*, 140.
21 Friedrich Engels, *Zur Wohnungsfrage* (Berlin: Holzinger Verlag, 2013 [1872]), 18, 19.
22 Williams, *The Country and the City*, 434.

Say we adopted the confident machismo of old. Say we argued that, given the right circumstances, the pain of dispossession will pale in comparison to the long-term benefits of modern development. Why settle for sprawling poverty when you can have a shining city on the hill? Alas. As an engine-of-history type contraption, the limits of top-down turbo development are now plain to see. Setting aside even the thorny matter of forced displacement in the name of a higher cause, however progressive, the apocalyptic scale of biospheric degradation makes limits on growth a nonnegotiable imperative. And the reuse, refunctioning, and reappropriation of existing assets—including the refunctioning and reappropriation of age-old theoretical pictures—makes this even more the case.

The Famous Case of Berlin
Over the last two decades, Berlin has increasingly become an international object of attention. To this day, however, many studies are published with little exposure on the ground. Perhaps this is because international comparisons tend to generally overemphasize what is happening elsewhere already (this very essay being, arguably, a case in point). It also bears mentioning that the gulf between native speakers and anglophones is larger here, and more emotionalized than in many European metropolises. The resentment is as strong as it is mutual. I've heard it said that expat hipsters and Berliners deserve each other, and as a Germanophone expat worst case scenario, I agree.

I'll begin my own storyline with curator Marius Babias's account of a vernissage in 1982, when Joseph Beuys opened the Nationalgalerie Berlin exhibition *Beuys, Rauschenberg, Twombly, Warhol* with works from the Erich Marx collection. At the time, the art collector and developer owned the Villa Schilla in Charlottenburg, that had recently been squatted—part of a broader movement throughout much of Western Europe. When tensions between Marx and the squatters intensified, Beuys justified his role in the Nationalgalerie show by saying "as long as there's a chance to convert a capitalist, I'll speak to him." He also offered to stick a plaque on the Villa Schilla, to place it "under the protection of art."[23] The squatters weren't interested, and, admittedly, the curator in me is disappointed. But the Villa enjoyed a long and happy life nonetheless—far beyond the auratic reach of Beuysian alchemy—and was eventually legalized as a co-op.

As it is, the story is rich enough. One can only marvel at Beuys' failure to appreciate his own role within the real estate food chain and his own

23 Marius Babias, *Berlin: die Spur der Revolte* (Cologne: Verlag Walther Koenig, 2006), 100.

status as a "capitalist to be converted." Such is the deictic magic of art, allowing it to pop up at the right place and the right time over and over again (location, location, location). Fourteen years later, Berlin crash-landed in another era altogether, and Erich Marx paid his tax bill with 20 tons of tallow fat, otherwise known as Beuys' 1977 artwork *Unschlitt*. The work's value was estimated at 6.5 million Deutsche Mark, but bequeathed to the city at only 3.5 million. Babias wryly remarks that the difference amounts to the surplus of the Berlin construction boom: *"Die Differenz ist der Mehrwert des berliner Baubooms."*[24]

West Berlin was still an insular Cold War state of exception back in 1982, braving the communist apparatchiks in polyester suits, peering grimly down from the Alexanderplatz TV tower. This sleepy oasis was home to a very different type of urban romance in the 1990s, however. On the one hand, the fall of the Wall produced an outsized gash of fallow land running straight through the city; on the other, the restitution of property expropriated by Nazis or GDR officialdom created a bureaucratic limbo that lasted a good decade. During this intermezzo, armies of cultural workers invested their blood, sweat, and tears in the unused spaces then dotting Berlin, reinventing them for a year, a month, a night, before moving on to the next site. Berlin became an exemplary zone of "spatial creativity," a "test site," an "adventure playground," a "capital of temporary usage" (*Zwischennutzung*)—a legacy it continues to build on to this day (it is still often asserted that no other city in the world has been demolished and rebuilt as many times as Berlin). The excitement was not entirely free of those seductive colonial tropes referencing uninhabited space; "free spaces" (*Freiräume*) in an "inherent state of lack", or "empty spaces, and empty positions in the very heart of the city" (as Klaus Biesenbach once put it). By the end of the 1990s, the city had not only failed to grow, it continued to shrink. This was good news for cultural workers, whose quality of life is contingent on cheap rent, empty facilities, and unemployment rates remaining slightly above average.

My own take on Berlin, as a critical theory student with a voracious 1990s *Weltbild* and a nice middle-class background, also begins here. I had Grade 1 stubble for a haircut, polyester pants, neon-orange track-suit jackets, and a savvy friend who moved to Berlin with a similarly 1990s appetite. He dragged me to Tacheles, Friseur, Brasilianer, Volks-bühne, even the early KW. Decades later, the city's lost aura still haunts me: I will always consider 1990s Berlin as a home away from home, just as hundreds of thousands of other emigrants like me have.

24 Ibid., 55.

As architect Robert Huber shrewdly puts it, eventually temporary cultural usage tends to "devour its own children." "Protohipsters" like myself woke up one day to the fact that our merrymaking had become part of a bigger urban renewal plan. To what degree the process was premeditated is anyone's guess. Fact is, the only ones to harvest the sweat equity invested over the course of that long decade spanning 1989 to 2001 were not those who made the neighborhoods safe, unique, creative, etc., but legal proprietors both old and new.

While owners calmly anticipated their share of the surplus, few artists planned for anything beyond the heat of the moment. Even the artist association BBK elected to prioritize studio subsidies over securing its own infrastructure. Harsh judgements are easy to render retrospectively, and the collective freedom from the pressure of rent and profit motive was a historical opportunity in its own right. But 1990s insouciance came with a price tag, especially in terms of city policy at large. This was a time of rash en bloc privatization, when some 15 percent of Berlin's public housing stock was sold at a grossly undervalued price. The Tacheles complex, an icon of city subculture, was snatched up in 1998 for the equivalent of 1.4 million euros and flipped in 2012 for 150 million.

As 1990s sunshine segued into the dusky aughts, Berlin did not have to wait for austerity urbanism to hit a financial crisis. During the 1990s, a publicly owned bank had been gambling with public assets as security for real estate transactions. In 2001, they lost the assets wholesale. As a result, the city suffered budget cuts and austerity dictates grotesquely similar to the ones Berlin imposed on Greece a decade later. The German capital was coerced into selling off assets when they were at their cheapest, and the irony should not be lost that it was the newly elected left-wing coalition government that was forced to cut housing subsidies and accelerate the sale of municipal property. 2001 saw the privatization of 140,000 units to bidders, including Goldman Sachs. At the time of writing, over twenty million square meters have been sold, an area the size of Friedrichshain-Kreuzberg.

This was also the moment when the hungry push to at last become a "normal" European city became more palpable. In a testament to CA's new worldwide status, at this sensitive moment art was not sidelined but peddled at the highest levels, on an intercontinental stage, as a winning formula for an impoverished city.[25] When, in 2003, an EU report underlined the importance of temporary cultural usage in urban development, the mayor was quick to declare such things a "Berlin tradition." Admit-

25 Annette Maechtel, *Das Temporäre politisch denken* (Berlin: b_books verlag, 2020), 18.

tedly, there wasn't much choice in the matter. Art was one of the few things the city had going for it. In 2006, 10 percent worked in the cultural sector and punched above their weight by securing 13 percent of economic output. Over 9,000 artists worked here—of which nearly 7,500 had previously stated they were in need of affordable studio space.

From the point of view of whoever hatched this plan, it worked. The city is now growing fast and real estate is the investment of choice, buoyed by low interest rates. Even the cultural workers who put Berlin on the map have lived to tell the tale, if only barely. For now, they're hanging in there, in a city where rent has nearly doubled since the 1990s. On the other hand, over 80 percent of all Berlin residents remain tenants, and the city still ranks highly in European social justice indexes. What's more, things look better politically. As my second essay explains, at long last momentum is clearly in favor of the public sector retaking control of city development.

The Famous Case of KW

One of the easy scapegoats of this epic tale of boom and bust is a mid-size CA venue in the picturesque Scheunenviertel ("Shed Quarter"), named after the seventeenth century cattle barns once located in the area. The quarter is just south of the busy Torstraße ("Gateway Street"), which marked the city limits for much of Berlin's history. Right outside the gateway is where cheap labor was once housed, an intimidating part of town which was famously badass, penniless, and self-policing. As late as the 1980s, the GDR government attempted a communist rent gap effort of sorts: the area was slated for demolition and renewal, and "white trash" was housed here, including a generous handful of neo-Nazis. When the GDR collapsed, squatters introduced the neighborhood's first whiff of the international bourgeoisie.

The squatters had 1990s turmoil on their side. It took at least six months for a property restitution demand, of which there were 24,000 at the time, to make its way through the system. Facing an urgent need for affordable real estate, the municipality handed out thousands of temporary usage licenses across East Berlin. The most prominent of these municipal clerks was Jutta Weitz of the public holdings firm WBG Mitte, who favored video rentals over dentists, project spaces over tax advisors, and even hosted networking salons in her apartment. Weitz's number was reportedly pinned to a PS1 bulletin board in New York. To some degree, it was her conception of what constituted a creative neighborhood that made Mitte a bastion of CA and techno. Weitz stayed under the radar until the noughts, when urban regeneration qua culture

became official policy, and she was feted in the mainstream press as a technocrat vanguard.[26]

One fine day in the spring of 1991, Weitz handed over a disused margarine factory on Auguststraße to a loose coalition of artists formally represented by the associations B.E.A.M. and Gemeiner Kunstverein. They immediately got busy; much of what occurred over the half decade to come was documented in below papers, a zine printed on-site by artist duo Dellbrügge & DeMoll. Decades later, in 2017, the duo officially kickstarted the REALTY program with a poignant presentation of below papers on site at KW.

Among the city slickers at the margarine factory, one member of the *Gemeiner Kunstverein* stood out. This was a pale, gawky, smooth-talking medical student named Klaus Biesenbach, who had a precocious aptitude for making things bigger, louder, and faster than anyone at the time cared to imagine. Young Biesenbach had surprisingly good connections for a medical student, spanning the art field and the political spectrum and including conservative CDU functionaries. By June of 1992, he had already organized *37 Rooms*, a parallel event to documenta 9, where he exhibited artworks in hotel rooms, living rooms, schoolrooms, and toilets up and down Auguststraße. Neighbors already wary of urban renewal pressures watched in alarm as 25,000 stylish visitors crisscrossed the rundown street within a single week. *37 Rooms* charmed the hell out of everyone, with a Berlin Senate report expressing surprise at how easily CA had found its footing in the new market economy, to the point of being in "danger of alienating the area."[27] On the 25th anniversary of KW in 2016, *Der Tagesspiegel* ran an article entitled "Where the Wild Artists Were," reminiscing about how "the mix of rags and megalomania was convincing; everyone came."[28]

We will never know whether the self-run wonderland collectives could have endured without the pointed intervention of their more ambitious members. At the time, CA was the only macrovision publicly on offer. Soon, the factory was under heritage protection, acquired by the national lottery and leased to the association KW BERLIN for art-cultural purposes, with Biesenbach at the helm. As the neighborhood morphed into a bougie ghetto for the first time in its history, KW obdured, becoming

26 Ibid., 94.
27 Ibid., 92.
28 Nicola Kuhn, "Die Mischung aus Hemdsärmeligkeit und Größenwahn überzeugte, sie kamen alle," *Tagesspiegel*, November 24, 2016, https://www.tagesspiegel.de/kultur/die-berliner-kunst-werke-werden-25-wo-die-wilden-kuenstler-wohnten/14890898.html (accessed June 15, 2021).

a reluctant poster child for the gentrification springing up around it. To critics, the story of KW is another classic tale of opportunism and institutionalization, tracing a path from rock-n-roll to Prada. But as I've argued above, to scapegoat a *Kunstverein* is to overly culturalize the issue. Even if we assume that curatorial intention had any leeway whatsoever, within this high-stakes game of real estate acquisition, to berate KW for lacking the foresight few Berliners could muster in the 1990s is a bit unfair. But the emotional charge is obvious, and reached a climax in 2010, when BB6 was met with ad hominem attacks on team members in the shape of street posters and graffiti.

The fact remains that KW is a rare survivor of the scramble for Mitte real estate. Even the harshest of critics must acknowledge the dazzling case of *Verstetigung*—using the means and methods of CA for entrenchment, digging in one's heels, continuation in the face of adversity. As such, their example provides many lessons. Instead of yielding to yet another indoor spa, KW became one of the most visible institutions in the German artscape. If, in terms of financial clout, it remains a dwarf, in terms of sociocultural capital, KW has the ear of many a city legislator.

KW also stands accused of laying claim to 1990s Berlin at large. The era was indeed a last glorious moment of underdocumented, offline subculture, and as such it is vulnerable to appropriation. Again, it is easy to accuse KW of a historiographic power grab, but plenty of middle-aged Berliners have only just started sorting through the fanzines and Super 8 spools lying around in their cellars. A true child of the 1990s, KW only organized its own archive after 30 years of existence.

Then again, in terms of a future demand for a more forthright relationship to the cityscape and its history, why not give credit where it's due? For example, what to make of the KW website's "about" section, that still celebrates Biesenbach as a single-handed man of the hour. Even municipal websites now echo KW's monological narrative of a genius hotshot, over and above the group creativity on the ground.

For a more detailed case in point, when it comes to such art-institutional demands, allow me to zoom in on the blazing hot summer of 2018. This is when KW held an off-site show on Moritzplatz, using a Kreuzberg premises owned by PANDION AG, a real estate giant from Cologne. PANDION is infamous for its use of "artwashing" to soften up a given location before moving in for the kill. The previous year, the firm allowed street artists to run rampant in an empty building near the Zoological Gardens to sensational effect: 80,000 visitors queued up to view the indoor graffiti. Only then did

PANDION begin converting the building into luxury condominiums for a clientele from Egypt, Cyprus, Israel, the UAE, and Hong Kong.

PANDION's Moritzplatz development is a slick, high-end office/studio complex in a working-class neighborhood perched notoriously on a gentrification tipping point. This time it was not graffiti but CA that PANDION chose in order to facilitate its entrance. A host of art institutions accepted the invitation to stage exhibitions—framed by obnoxious creative city slogans—including the Weißensee Kunsthochschule, then in desperate need of a venue for its graduation show.

When I learned only a few months before our vernissage about KW's collaboration with PANDION, I found myself caught with my pants down. I had made so many hopeful claims at that point regarding KW's new and improved relationship to the city that I looked like a complete idiot. Or a hypocrite. Or both. Obviously, canceling KW's contract with PANDION was not an option, but canceling REALTY was. This was worse than institutional-critique-as-fig-leaf. This was a shitshow. After an initial shrill, melodramatic outburst, I was relieved to find support among the KW outreach team. But before pulling the plug on REALTY, we decided to make the rounds, consulting activists and civil servants in the vicinity of Moritzplatz so as to gauge opinion and gather suggestions. Many were proffered, including the suggestion that I go fuck myself. A public workshop ensued. Not all ideas are workable.

Among the more fanciful scenarios, my personal favorite—well before COVID-19—was the idea of "Quarantined Art Zones" that would restrict CA to areas where no rent gap is manifest and therefore no toxic side effects would be unleashed. Three other ideas stood out. The first: REALTY played a tiny part in the founding of Kunstblock, a coalition of artist-activists who now organize anti-gentrification protests in public space (awkwardly, an early Kunstblock intervention unfolded at the KW vernissage on PANDION premises). The second: members of the urban garden Prinzessinnengarten complained that hardly anyone in the Moritzplatz neighborhood knew what was going on, so we commissioned artist Larissa Fassler to produce large-scale billboards and street posters that went up all around Moritzplatz (a project entitled *Emotional Blackmail*), mapping out real estate developments in the area.

REALTY also convened a KW staff retreat on the premises of ExRota Print. Here, the entire PANDION saga was debated in detail. The resulting moment of heartfelt political solidarity among the team was unforgettable: we penned a collective statement concerning the role KW had played in city politics in the past, pledging to change course. The ripple effect of such an open letter would have been dramatic.

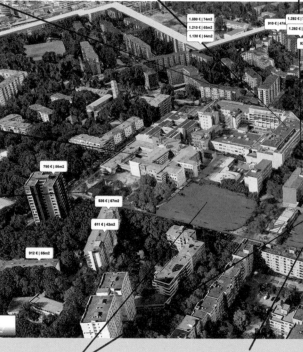

Larissa Fassler, *Emotional Blackmail*, street posters and billboards of varying sizes (in both Turkish and German), 2018

PLATZ

Güncel Kira indeksi:
Net kira
7€/m² altında

GSG - HOF
PRINZESSINENSTRAßE 19-20
planlanan inşaat
tamamlanma tarihi 2020
9000 m² büro alanı,
planlanan kira: 25,50 €/m²

✳ **MILIEUSCHUTZ**

inşa kitapçığında ki
ERHALTUNGSSATZUNG 172 fff
maddesi için halk dilindeki
kavram

Hedef: ikamet eden halkı başkılara
karşı korumak, şehirsel inşa
hatalarını önlemek

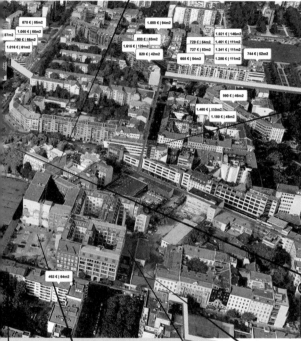

Labels on photo:
- 875 € | 55m2
- 1.060 € | 66m2
- 87m2
- 190 € | 66m2
- 1.016 € | 61m2
- 1.550 € | 84m2
- 800 € | 83m2
- 1.616 € | 129m2
- 820 € | 42m2
- 1.921 € | 146m2
- 729 € | 64m2
- 727 € | 53m2
- 668 € | 54m2
- 1.461 € | 111m2
- 1.341 € | 111m2
- 1.286 € | 111m2
- 744 € | 52m2
- 990 € | 46m2
- 1.460 € | 110m2
- 1.180 € | 48m2
- 462 € | 64m2

Allmende e.V.

✳ Alternativ göçmen
politikaları ve kültür evi

bir zamanlar Kottbusser
Damm 25

2015'de büyük bir polis
şiddetiyle boşaltıldı,

2017'den bu yana
KuB - mülteci ve
göçmen iletişim
ve danışma derneğinin
yerinde
(Oranienstraße 159)

PRINZESSINENGÄRTEN
(ortak mülkiyet)

2009 yılından bu yana
Spekülasyonlardan arındırılmış
yeni kentsel yaşam formu
sunan pilot proje

yıllık 50.000 ziyaretçi,
sayısız gönüllü

RITTERSTRAßE 12-14

Hollanda emeklilik fonu PGGM ve Rockspring
Property Investment Managers LLP 250 milyon
curoluk girişim planlamasıyla bir
"TECH HOT SPOT" başlattı

20 tane küçük işletme 24€/m² yeni kiralama ücreti
yüzünden yerlerinden edildi

RITTERSTRAßE 6-7
eski posta şubesi

2019'dan itibaren
yüksek değerli bürolar

25,00 €/m²
den başlayan kira ücretle

RITTERSTRAßE 8

Şimdiye kadar
küçük/orta düzey
firmaların yeri

2018'de iki tane
iş alanının yeni yapısı

RITTERSTRAßE 112-113

eski Berlin inşa programı
950/60'lar daire konsepti

Hence, despite the director's best efforts, its publication was nixed by the board.

Finally, the most ambitious idea to emerge from our mea culpa round of the neighborhood was floated by Kreuzberg Councilor for Housing Florian Schmidt, an outspoken champion of "the right to the city" and celebrity punching bag in both the conservative and liberal press. Schmidt suggested we hook up with all the other venues who were in bed with PANDION, and use the glamor factor of CA for a media campaign. Perhaps we could morally blackmail the firm into devoting a good chunk of its new-build to the sociocultural needs of the city. With Schmidt's blessing, I reached out to our artwashing partners, two of whom did signal an open mind to the scheme. However, my first meeting at PANDION's Berlin headquarters put paid to the idea then and there. The management did signal an open mind, but requested zoning exemptions, additional building volume, fast-tracked paperwork, and improved access to policymakers as preconditions for even joining Councilor Schmidt at the negotiating table. And that was the end of that.

Planetary Scope

In a 2015 piece in the *New Left Review*, Fredric Jameson argued that all politics currently revolves around real estate. The privatization of public assets, territorial warfare, the degradation of the biosphere, mass migration, even neonationalism all boil down in one shape or form to the commodification of land.[29] As you might imagine, I do subscribe to this point of view—which is why I should own up to the universalizing tendency at play in both of my editorial essays.

The planetary thrust of terms such as "gentrification" is a double edged sword. The term's shorthand efficiency may even reenact the very expansionism it critiques[30]—yet another anglophone storyline, catchy and self-fulfilling, that makes the West/North look like the inevitable future of the East/South. Who knows what other phenomena are being eclipsed by terms like "urban renewal"? Boulevards, for example, will forever be Haussmannian, even though Mexico City and Buenos Aires had already crafted those modes of urban redevelopment later attributed to Paris.[31]

29 "Fredric Jameson, "The Aesthetics of Singularity," *New Left Review* 92, Mar/Apr (2015): 32–101.
30 Loretta Lees, Ernesto López Morales and Hyun Shin, eds., *Global Gentrifications: Uneven Development and Displacement* (Bristol: Policy Press, 2015), 26.
31 Mohamed Elshahed, "Prospects of Gentrification in Downtown Cairo," in *Global Gentrifications: Uneven Development and Displacement*, eds. Loretta Lees, Ernesto López Morales and Hyun Shin (Bristol: Policy Press, 2015), 129.

If anything, we will increasingly be in need of new and improved terminology. The sheer speed with which events unfold today is unprecedented. Even considered as a purely quantitative phenomenon, the current rate of settlement, urbanization, and suburbanization confronts the researcher with a bewildering learning curve (China, for instance, poured more concrete from 2010 to 2012 than the gluttonous USA deployed over the entire twentieth century). But any cogent terminology we may devise still makes for a taxonomic headfuck. A 2007 UN report claiming half the world lived in "cities" immediately became a controversial case in point. The idea of the "welfare state," for its part, covers a wide range of models in the EU alone (liberal, corporatist-statist, social-democratic, familial). In many places, "public housing" never signified the safety net it does in others, while in the United States all housing is in effect "public," since most home mortgages are underwritten by two federally backed companies created by Congress and subsidized by tax deductions on mortgage interest.

Gentrification itself comes in many shapes and forms—rural, new-build, state-led, transnational, turbo, supergentrification, etc.—with its objectives being just as diverse. Gentrification can provide a safe haven for capital or a way of realizing a quick profit, a means of city branding, securing higher tax revenues, conserving national heritage (e.g., downtown Paris), or catalyzing macroeconomic development (e.g., new infrastructure and housing across China). Another motive can be social engineering, as in Rotterdam[32] or prewar Damascus, which faced the triple threat of globalization, democracy, and free markets.[33] Even when return on investment is a key motivator, the margin may be defined by cheap credit or by housing markets and vacancy rates, with very different implications on the ground.[34]

To allow for a variety of causes and effects is one thing, to deny the very option of a global snapshot is another. To paraphrase Raymond Williams, the persistence of concepts counts as much as their historicity. Ultimately, gentrification need not be epistemologically present for it to unfold de facto (if anything, the perception may diminish as the fact increases). In 1990s Lisbon, analysis was largely restricted to student dis-

32 Justus Uitermark, Jan Willem Duyvendak and Reinout Kleinhans, "Gentrification as a Governmental Strategy: Social Control and Social Cohesion in Hoogvliet, Rotterdam," *Environment & Planning* 39, Issue 1 (2007): 125–141.

33 Yannick Sudermann, "The Case of Old Damascus, Syria," in *Global Gentrifications: Uneven Development and Displacement*, eds. Loretta Lees, Ernesto López Morales and Hyun Shin (Bristol: Policy Press, 2015), 395–417.

34 Tolga Islam and Bahar Sakizlioğlu, "The Making of, and Resistance to, State-Led Gentrification in Istanbul," in *Global Gentrifications: Uneven Development and Displacement*, eds. Loretta Lees, Ernesto López Morales and Hyun Shin (Bristol: Policy Press, 2015), 258.

sertations. In much of Switzerland, this remained the case two decades later. When the German newspaper *Die Zeit* was writing up a piece on urban renewal in Bern, it had to rely on a high school paper penned by a teenager named Lars Stucki. But more often than not, denying the existence of a structure is conducive to its unchecked global expansion. Most artists, for example, instinctively repudiate the existence of any such thing as CA per se. The instinct is a system-affirming one. While a disenchanting activity, indicating the connection between a five-star MFA in Manhattan and a project space in Tehran, or a London mega-plex to a reading group in Taipei, does offer the option of reform and redistribution.

See also the example of the "socialist city." Variations include garden cities, disurbanist fantasies, 1920s Red Vienna, Stalinallees, post-Stalinist Khrushchyovkas, Sweden's One Million program, Yugoslavia's "socialized ownership" co-ops, Marxist-feminist experiments in 1950s Tehran, and more.[35] Some will be quick to deconstruct any possible common ground; to others, building on a "Landscape of Communism" is a helpful strategy.[36] In other words, and depending on your agenda, strategic essentialism makes sense, even when the terms are far more debatable and far less empirically grounded than "CA" or "gentrification."

At the risk of sounding dramatic, it is the very possibility of a sense of place that is now at stake, along with the exemplary "genius loci" appropriate to that place. Gentrification is the eye of a storm that is crafting hitherto inconceivable material and ideological environments. Not even the most basic comparisons across nations, regions, landscapes, towns, and neighborhoods would be possible without umbrella terms. To forgo those common denominators, however crude, is presently not the best of options.

Financialization

As David Harvey and others have argued, the core institutions of the capital classes weathered the financial crisis of 2008 by avoiding investments in manufacturing and storing most of their wealth in land and property.[37] Capitalists have made similar choices before: in the mid-nineteenth century, a capital surplus absorption problem was solved by widespread investment in Hausmannian reconstruction schemes and colonial development. But the sociopolitical implications are now otherwise.

35 See Hamed Khosravi, "Planning a Revolution: An Unfinished Project for Tehran (1955–1977)," in *Shifting Panoramas*, eds. Solmaz Shahbazi and Azar Mahmoudian (Berlin: Institut für Auslandsbeziehungen), 38.
36 Owen Hatherley, *Landscapes of Communism* (London: Penguin, 2016).
37 See for example: David Harvey, *Rebel Cities* (London and New York: Verso, 2013).

When it comes to the forms of powerplay discussed in this book, financialization is a key part of the equation and the thing that sets our current era apart most clearly. Many basic definitions suggest financialization is a form of profit-making via "financial channels"—i.e., currencies, loans, shares, and derivatives—as opposed to profit via the production and trade of commodities. But it has effectively bled into the minutiae of everyday life as well. Notice how everyone these days, from curators to sitcom characters, use terms like "collateral," "leverage," and "equity" in everyday speech.

To begin with, financialization is both a symptom and pillar of neoliberal governance. Imagine financial benchmarks showing up in offices where the sole mandate had previously been the equitable dispensation of a public service. Berlin's *Liegenschaftsfonds* (public holding firms), for example, are now pitted against one another. When revenue dips below par, general social welfare is weighed against the desirability of a more well-heeled tenant demographic.

For its part, the very diversification of financial tools suggests a whole new ballgame. In real estate development, the traditional approach is the "value-added strategy." In her 2013 study of Berlin, Sabina Uffer avows that investors following this approach typically expect a 13 percent return over a six year period.[38] During this time, they usually upgrade the building while phasing out particular tenants. The "opportunistic strategy," by contrast, aims for a higher rate of return in half the time. In such instances of "impatient capital," properties are leveraged when credit is cheap (so timing is crucial), with the aim being to flip the product as soon as possible. At best, upgrades are purely cosmetic and vacancies are dealt with only if the market situation delays a sale. Even then, rental revenues play a minor role as any tenant is acceptable, regardless of poverty concentration concerns.

At this point, the price spiral of land and housing is no longer down to Harvey's core institutions of the capital classes. Whoever is in a position to do so will eagerly engage in AirBnB subrentals, "land banking," a "housing career." We secure our retirement this way, watching our pension funds invest in properties in order to spread risk in a volatile environment. And with our offspring in mind, the resultant insecurity leaves us clinging to what we have, which is how we produce record amounts of underutilized housing.

38 Sabina Uffer, "Uneven Development in Berlin's Housing Provision: Institutional Investment and its Consequences on the City and its Tenants," in *The Berlin Reader: A Compendium on Urban Change and Activism*, eds. Matthias Bernt, Britta Grell, Andrej Holm (Bielefeld: transcript Verlag, 2013), 155–170.

Importantly, financialization also implies a change in the nature of commodities themselves. Up until the 1990s, institutional investors such as pension funds or universities assumed working knowledge of material conditions on the ground was a useful thing. Today, an understanding of the commodity is no longer necessary to reap a profit from it on the financial markets (particularly among large-scale conglomerates, whose investors have a stake in producing dividends rather than the stuff made by the company their money is invested in). If interest rates go negative, real estate will become even more of a currency. Platforms such as www.velox.re or www.pangea.io already lure individual investors with promises to make the real estate market as easy as to participate in as the stock market, skipping professional intermediaries such as notaries or agents altogether. Such developments fuel the conviction that a home can now make more money than whoever lives in it. A home may be a primal site of security, desire, and "a social engine of display and acculturation" (I owe this turn of phrase to Andrea Phillips), but once your neighborhood becomes an investment fund with sidewalks, more things change than cosmetic upgrades. Landlords used to depend on local tenants; the opposite is the case now, since local tenants stand in the way of maximum rent. "Unproductive dwellings" cannot compete with the sums generated by people passing through, which is why in towns like Venice, longtime residents are nearly extinct, since they "underperform" economically.[39] The housing stock of entire regions is now being transitioned to a sublet economy, of which boutique hotels and Airbnb are only the most visible markers.

Villeggiatura

Allow me to indulge in a family anecdote. My grandfather Mohamad was born into desperate feudal conditions in Mehrazin, a village southwest of Tehran. An illiterate orphan, he joined Reza Shah's historic military campaign to modernize the country by any means necessary. Young Mohamad excelled at his work, returning to Mehrazin as an officer, no longer illiterate and with a network of friends in the capital. As Iran was then undergoing political turmoil and land prices were low, Mohamad purchased a plot of land in his home village, where he grew wheat and barley. Food prices shot through the roof with the allied occupation of Iran during World War II, and Mohamad eventually managed to buy up much of the land within and around Mehrazin: self-made gentry, homegrown.

39 Wolfgang Scheppe, "The Ground-Rent of Art and Exclusion from the City: The exemplary quality of Venice's singularity," *ARCH+: The Property Issue*, May (2018): 14–31.

My own father has run the farm for some 40 years now. Some of his time is spent tending to fruit trees and cattle, but more often he is preoccupied with pervasive drought, Sisyphean poverty management, and endless streams of visiting urbanites, who come to chill in the countryside on weekends. By and by, these city types began to purchase plots of land within and around Mehrazin, which, thanks to the drought, were again cheap. Some pursue their monarchist fantasies there in the shape of quasi-palatial new-build retreats, with high walls and cheesy Persepolis motifs. The feudalism my grandfather escaped from a century ago has now returned as architecture, and farce.

It was only when I began preparing the *villeggiatura* conference on rural gentrification that I noticed how typical this story is. Every year, 120,000 square kilometers of farmland are lost globally on account of drought alone. There are already nearly three times as many people fleeing environmental catastrophe as war.[40] From Iran to Brandenburg to Texas, disregarded publics have been turning to the ballot box for sweet revenge on liberal elites. Mehrazin is a case in point, even in terms of the landscape becoming an aestheticized stage for urban enjoyment. European versions of this tendency once borrowed from Chinese motifs, preceded by Egyptian, Babylonian, and Mesopotamian stylizations.

In Europe, poetry was long the medium of choice for any elite definition of landscape ("Honor and Empire, with revenge enlarged," as John Milton put it). As of the Renaissance, painting gradually took over, leading to those luscious representations of the exoticized colonies, or the English rustics, whose idealized landscapes coincided with the enclosures mentioned above, or Meindert Hobbema and Jacob van Ruisdael's canonical depictions of the "Great Bog of Europe," aka the Netherlands.

Throughout this essay, your "Mehrazini" writer has used references, case studies, even terminology that mirrors a metropolitan mindset, one nurtured by long generations of looking—some twelve millennia of ocularcentric representation, where everything is measured in degrees of distance from the downtown center of the Real. No wonder urban writers wildly overestimate its attraction. In fact, a city is not a lighthouse for the huddled masses to flock to so much as the random effect of an indifferent free market. As Marco Clausen argues in his contribution, a city is the best option once your means of subsistence have been obliterated from the ground up. Even suburbanites come here for reasons of "spatial capital", so as to balance work, family, childcare, etc. The creative minority

40 Georg Ehring, "Mehr Klimaflüchtlinge als Vertriebene durch Krieg," *Deutschlandfunk*, November 8, 2017, https://www.deutschlandfunk.de/weltklimakonferenz-mehr-klimafluecht-linge-als-vertriebene.1773.de.html?dram:article_id=400100 (accessed June 5, 2021).

that comes here for all the metropolitan razzle dazzle are merely the ones who trumpet their desires the loudest.

The latter, regardless of proximity to rural forbearers, are more familiar with rent strikes in Kreuzberg than farmer protests in Brandenburg, even though the stakes are much higher in the countryside: our very food supply hangs in the balance. And agrarian forms of late capitalism play a primordial part in chains of primitive accumulation worldwide (for example, Korean firm Daewoo nearly succeeded in buying up a large part of Madagascar in 2008). Looking at the tropes that define rent struggles in Kreuzberg, one does begin to notice a muscle memory of the countryside, from Cuba to China, which were the high ground of continuous revolt throughout the entire era of socialist and anticolonial resistance.[41]

The REALTY conference was cocurated with Marion von Osten in November 2020. The event's title, *villeggiatura*, was a self-ironic reference to the Arcadian retreats for urban elites in Renaissance Italy. Our event took place in the midst of the COVID-19 pandemic, via Zoom, which made the ecopolitical subtext resonate all the more loudly. Contributors included Axel Vogel, head of the Brandenburg Ministry of Agriculture, Environment and Climate Protection (MLUK), Marxist economist Grace Blakeley, and Wolfgang Kil, a prominent chronicler of rural exodus in East Germany. Among the dizzying conversations that transpired, one that stood out involved the age-old challenge of bridging the urban/rural divide. Can metropolises ever render their struggles more useful to others? Apart from some rare exceptions (e.g., Chiapas, Mondragón, Marinaleda), the right to the city still enjoys disproportionate amounts of mainstream attention, for now. Even with the involvement of the fanatically urban CA, can shared necessities outweigh conflicts of interest or narrow definitions of stakeholding, leading to tactical alliances or long-term checks and balances? Artists who have left age-old urban imperatives behind are no longer such a rare phenomenon. And if CA can do it, then nearly anyone can. See the countless ongoing research initiatives, such as that of Yasamin Ghalehnoie in the Hormoz Strait, or ecopolitical artist collectives emerging in unlikely places such as Amman, Jordan.[42] See also the Nouveaux Commissionaires networks across Europe, or the work devoted to peasant struggles by the SAKA

41 cf. the closing chapters of Raymond Williams' *The Country and the City* (Oxford: Oxford University Press, 1975); or Janet Afary, *The Iranian Constitutional Revolution 1906-1911: Grassroots Democracy, Social Democracy, and the Origins of Feminism* (New York: Columbia University Press 1996), 146.

42 See for example the research collective Bahaleen, a roaming artist residency in Jordan, which engages with themes of relocation, movement, and dwelling.

collective in the Philippines; or, in this volume, the *villeggiatura* contributions by Katya Sander, Bahar Noorizadeh, and Marwa Arsanios.

At the hands of persistent efforts such as these, even conservation and heritage, once the classic Trojan Horses of gentrification, can move from nostalgic Covent Garden garishness to the speculative challenge of preserving the future. As Khaldun Bshara's contribution to this reader attests, the Palestinian West Bank has become a stronghold of cutting-edge takes on conservation, be it the preservation of villages, biotopes, material evidence, or national heritage. Riwaq and Decolonizing Architecture are prominent examples, but lesser known organizations also exist, including Arts & Seeds in Battir, Sakiya in Ein Qiniya, or Dar Jacir in Bethlehem (whose premises were ransacked by the IDF in June 2021).

Statecraft

A milestone in gentrification history was President Carter's 1977 speech, staged in a dusty lot in the South Bronx, in which urban revitalization was heralded for the first time as a key component of economic development. Why mention such an awkward, melodramatic moment? Because thus far we have omitted the biggest player on the field. Nothing happens without the state. Even considering restrictions on spending imposed by multinational bodies, the leeway of national governments remains astonishing—including those governments who claim to have ceded the stage to austerity regimes, and others who have been genuinely weakened and discredited by endorsing harsh domestic policies. International finance continues to rely on policymakers for the leeway it requires.

As I argue below, the agency at stake does not concern legislation alone. The right to housing is enshrined in article 28 of the 1948 United Nations Declaration of Human Rights, and in the legislation of some seventy countries. A city statute law in Brazil guarantees local control over development in the name of use value above exchange value. Mexico City introduced a Right to the City charter in 2010, even if it relies on the free market to give it force. To announce these laws is one thing, to enforce them is another. Rules and regulations are part of a larger state of "lawfare" where legal hacking is the norm. Primitive accumulation is ongoing: fraud and violence are not part of some faraway early stage of capital. In other words, a law is as good as those charged with implementing it (it's telling that the Berlin civil servants who monitor Airbnb activity, or the sale of housing, make less than two thousand monthly).

If many such laws are watered down or bypassed altogether, others are pitted against one another in a flurry of false choices; immigrants

vs. pensioners, the environment vs. the poor. "Green Paragraph" §559, which regulates ecological upgrades in Germany, is considered a major cause of displacement (even when insulation and thermal heating are paid off, your landlord is under no obligation to reflect that in your rent).

The good news is, we do have options. The bad news is there are many ways in which governments cheerfully continue to be part of the problem. The following section describes five such behavioral patterns: placemaking, citizen formation, homeownership, assisted capitalism, and redevelopment as a government project in its own right.

1. Placemaking

To quote Tom Dyckhoff: "no bridge can sit there quietly, keeping to itself, it has to be interesting."[43] The most conspicuous government tactic is that of putting places on the map as brands, hubs, opportunities, and *villeggiatura*. The tastes of faraway suitors are pandered to by way of mythical success story combo packages. See, for instance, the Kollhoff Plan to "Manhattanize" the Berlin skyline, orientalist plans for Gezi Park, or the creative city blends of Brooklyn/Barcelona.

As the "territorial innovation model" pits neighborhoods and authorities against each other in a competition for resources, cachet, and foot traffic, the effects of this slippery slope are only understood in the long term. For the present, the effect is a colossal skewing of resources toward outsized "engines of growth," with the GDP of superstar metropolises typically matching that of the rest of the country put together. Even within these centers themselves, the impact is more often than not a mixed bag, to put it diplomatically.

Placemaking is not only about sexing up, but also about "phobogenic" tactics that highlight moral and economic decay within given settings. What the French call a "politics of rot" (*politique de la pourriture*) marks a neighborhood's availability for investment, improvement, and catching-up. For a healthy rent gap to materialize, however, a sense of possibility must also prevail, and the metaphors of choice should signal grace under pressure, creativity under duress. To see enterprise is to create enterprise. In the Bijlmer area of Amsterdam, for instance, murals with colorful hip-hop motifs have appeared in locations visible to commuters, conveying the idea of a neighborhood in transition.

43 Tom Dyckhoff, "How to Bring Cities Back from the Brink," *The Economist*, May 6, 2017, https://www.economist.com/books-and-arts/2017/05/04/how-to-bring-cities-back-from-the-brink (accessed May 6, 2021).

2. Citizen Formation: *Vorderhaustauglich*

As families from the Turkish countryside began moving into Kreuzberg over the course of the 1960s and 1970s, one of those fantastic German neologisms was born, *vorderhaustauglich*: "front-house-compatible." In other words, the term is a way of distinguishing between tenants who can "represent" and those better crammed in the back.

Representability aside, class segregation in Germany and beyond is still widely cemented in bare-bones monetary fashion. In Berlin, a rent hike is not necessarily applied to all tenants of a housing block, but to those, rather, who fail to match a desired profile.[44] Then you have the matter of bureaucratic literacy. Germany is a welfare state of great corporatist-statist complexity, where administrative know-how is a way to separate the wheat from the chaff, especially when language barriers are added to the mix. But even among white German *Biodeutsche*, dealing with officialdom can make for an uphill battle. When the Wall came down, Prenzlauer Berg was the site of an astonishing case of population transfer. West Germans not only had a taste for cobbled streets and a familiarity with market conditions, but a working knowledge of federal paperwork for leases, grants, and subsidies.[45] It wasn't difficult to outflank East Germans whose rent had not changed since 1936.[46]

Another frontline of *Vorderhaustauglichkeit* is neighborhood micromanagement, the most legendary example being the "beer and piss patrols" of NYC mayor Giuliani ("your bottle lets me check your ID"). Sidewalk musicians can suddenly be fined, while big festivals are greenlighted with relative ease.[47] Some urbanists also point to the co-optation of civil support networks. Managerial policy, they argue, can turn protest into participation by bringing pressure groups with different agendas (unions, religious congregations, small businesses) around the bargaining table, encouraging them to agree to terms favorable to the smallest common denominator. The result is a spirit of prescribed pragmatism, or "the poor governing the poor."[48] (That said, given the inherent

44 See Greta Ertelt, Georg Thieme, Christiane Uhlig & Carlotta-Elena Schulz, "Die Statemade Rental Gap," in *Gentrifizierung in Berlin*, ed. Ilse Helbrecht (Bielefeld: transcript Verlag, 2016), 144.

45 Sabine Rennefanz, "Schäm dich, Arbeiterkind!" *Berliner Zeitung*, February 20, 2021, https://www.berliner-zeitung.de/politik-gesellschaft/schaem-dich-arbeiterkind-li.140996 (accessed May 16, 2021).

46 Maechtel, *Das Temporäre politisch denken*, 164.

57 Michael Janoschka and Jorge Sequera, "Gentrification Dispositifs in the Historic Center of Madrid," in *Global Gentrifications: Uneven Development and Displacement*, eds. Loretta Lees, Ernesto López Morales and Hyun Shin (Bristol, 2015), 386.

48 see Tashy Endres, "Widerstand und Macht", in *Dialogic City—Berlin wird Berlin*, eds. Arno Brandlhuber, Florian Hertweck and Thomas Mayfried (Cologne: Verlag Walther König, 2015), 521–548.

struggle involved in different stakeholders joining forces around how-ever small a platform, this big brother tactic isn't always applicable.)

On a more macroideological level, the best way to entrench differ-ences is to individualize responsibility altogether. If CA's ability to make precarity fun is impressive enough, it does not compare to the magical skill of policymakers, who have somehow managed to make insecurity desirable on a mass scale. Collective systems such as public housing and pensions have been undermined in a layered process of reform, jerry-rig-ging, and private alternatives. With instability magically normalized, gentrification is pitched as a coping strategy to some and an exciting treasure hunt to others. Those remaining are left to a soft violence of low expectations. Take the 2017 Berlin referendum on whether to keep Tegel Airport up and running. Most nearby residents voted in favor; the noise and air pollution is what might have kept eviction at bay.

By now, property is a straightforward criterion for enjoying a basic political prerogative. Citizenship-by-investment programs are budding in the US, Spain, Austria, Greece, the Czech Republic, and elsewhere. On the one side we have the homeowners; on the other, the heavily mort-gaged quasi-owners, renters, immigrants, the homeless, live-in care-givers, domestic staff, and so on.[49]

3. Homeownership: The Luxury Curse

A few months after the Tegel referendum, Peter Altmaier, Federal Minis-ter for Economic Affairs and Energy, argued at a 2018 real estate con-vention that we needed to turn Germany into a nation of homeowners; otherwise, voters would all go communist. Does homeownership lead to conservatism? There certainly is a stark difference between a right to housing and a right to buying and selling it. Once political parties commit to the latter, they are beholden to a particular form of growth. No government can allow for a dip in domestic real estate prices once a majority of the population are homeowners, as in the post-Thatcher UK.

There are additional reasons why homeownership leads to complai-sance. Given their reliance on jobs within commuting distance, home-owners are more vulnerable to economic downturns. Though they can always settle for less suitable jobs or commute longer hours, the price is a steep loss in overall productivity. What is more, property ownership sparks what is called a "high income elasticity of demand": a mere 10

49 In the UK, affluent citizens who are not expecting to inherit property do not consider them-selves privileged and are also less likely to vote conservative. Editorial, "Inherited Wealth Is Making a Comeback," *The Economist*, April 27, 2019, www.economist.com/britain/2019/04/27/inherited-wealth-is-making-a-comeback-what-does-it-mean-for-britain (accessed July 22, 2021).

percent jump in income leads to 20 percent more investment in homes and gardens. Quite obviously, this is about more than lifestyle alone.

Almost two centuries ago, Friedrich Engels' take on universal home-ownership was characteristically caustic. Well, he quipped, we may as well "crown all 40 million subjects of the German empire German emperors, and promote every soldier to the rank of colonel."[50] Making property owners out of proletarians, Engels warned, would only weaken their exit options and bargaining power, since a threat to walk out on their employer would be less easy to act upon. Property or revolution. To submit one salient example, it has become a truism in today's West Bank that cheap mortgages in the wake of the Oslo Agreement had a more pacifying effect than Israeli tanks ever did.[51]

4. Assisted Capitalism

Since the 1990s, some 70 percent of Tehran's municipal revenue has come from fees for additional density, mainly via high-rise construction, widely known as "selling the air."[52] But even in more, shall we say, operational democracies, the state's collusion with private interests remains politically palatable, even when private interests remain the sole beneficiaries. Selective zoning exemptions and "golden visa" programs for investors [53] are still practiced throughout the EU. Evictions, too, can be accelerated by way of sudden zoning enforcements—consistently deployed in the US—or by digitizing the process to avoid protests, as has been the case in Greece.

During the financial crisis, Greece was subject to what Georgia Alexandri terms "odious taxation,"[54] which turned homeownership into a curse.[55] Increased tax rates and cuts to welfare provisions were accompanied by a deregulation of lending practices, which soon became predatory, leading to the mass dispossession of homeowners—to the benefit of banks.

50 Engels, Engels, *Zur Wohnungsfrage*, 33.
51 Walter Benjamin described capitalism as the first religion that does not redeem, but indebt ("der erste Fall eines nicht entsühnenden, sondern verschuldenden Kultus"), with a play on Schuld as both "debt" and "guilt" in German; Walter Benjamin: "Kapitalismus als Religion [Fragment]," in: *Gesammelte Schriften*, eds. Rolf Tiedemann and Hermann Schweppenhäuser (Frankfurt am Main: Suhrkamp Verlag, 1991), 100–102.
52 Azam Khatam, "Tehran, a City Constantly under Construction," in *Shifting Panoramas*, eds. Solmaz Shahbazi and Azar Mahmoudian (Berlin: Institut für Auslandsbeziehungen, 2019), 16.
53 https://www.goldenvisas.com/
54 Georgia Alexandri and Michael Janoschka, "Who Loses and Who Wins in a Housing Crisis? Lessons From Spain and Greece for a Nuanced Understanding of Dispossession," *Housing Policy Debate* (2016): 18, 19.
55 Niki Kitsantonis, "Greek Homeowners Scramble as Repossession Looms," *New York Times*, October 30, 2016.

What now passes for "social housing" in Germany is another example. Although paraded as a public service, social housing has been a gargantuan gift to the construction sector generation after generation. Some twenty years into their existence, the ensembles are handed over to the parties who built them and rent control is phased out. Onetime lawmaker Andrej Holm has termed the practice "publicly subsidized displacement management."[56] Conversely, radical disinvestment in the housing market further undermines the bargaining power that a municipality relies upon. To cut loans and subsidies for construction and upkeep is to put local government in a weakened position where it can no longer make demands.

5. The State as Mover and Shaker in Its Own Right

My last behavioral pattern pertains to the subtle difference between assisting the private sector and competing with it. To paraphrase David Graeber: the successful exercise of property rights ultimately rests on bureaucracy and the threat of violence. Given the state monopoly on both these things, a public mandate offers a strong edge on the marketplace.

At times, it's a simple case of deploying vast portfolios to better navigate the market, as in the case of public holding firms in Berlin. But a public body also has the option of using the collective futures of its citizenry as collateral. See the research by artists Vermeir & Heiremans on the London Jubilee subway line.[57] It was one thing for the municipality to levy local businesses to repay upfront construction costs over twenty-five years, another entirely for authorities to guarantee rates of return to international investors by using inner city growth as security. The latter amounts to repaying government debt by guaranteeing a certain development rate. You don't have to be David Harvey to see that the logic of this deal involves the necessary diminution of affordable housing provisions in favor of other types of development.

A government can even safeguard its own ventures juridically. It's telling, for instance, that legislation was issued to render the Jubilee scheme untouchable for twenty-five years.[58] Or take Istanbul, where the 2005 Law on the Protection of Deteriorated Historic and Cultural Heritage through Renewal and Reuse (Act 5366) allows for expropriation at will, alongside tax-free transactions in select locations, which can reduce

56 see Thieme, *Gentrifizierung in Berlin*, 116.
57 Vermeir & Heiremans, *A Modest Proposal* (London: Jubilee vzw, 2018).
58 JUBILEE—platform for artistic research and production, https://jubilee-art.org/?rd_news=vermeir-heiremans-a-modest-proposal-symposium&lang=en (accessed May 31, 2021).

operating costs by 35 percent.[59] Together with the legal grey areas and the informality of relocation schemes, the law granted the ruling AKP party a high degree of discretionary power.[60] Or take a famous case from Beirut, where, shortly after the civil war, parliamentarians with big stakes in real estate ratified laws that allowed for a scale of demolition dwarfing the "urbicide" of the war. In a rare case of transfactional harmony, Hezbollah has also become known as an active developer and occasional gentrifier.[61] Speaking of Hezbollah, the Iranian Sepah (Revolutionary Guards) enjoy paramilitary privileges that facilitate their own massive redevelopment schemes throughout Iran, underscoring the age-old link between military organization and large-scale development.

Sometimes it's hard to say where public policy ends and class revanchism begins. The term may smack of leftist melodrama, but the more stories one hears, the more obvious this underlying motivation becomes. In the wake of Hurricane Katrina, Congressman Richard Baker put it nicely: "We finally cleaned up public housing in New Orleans. We couldn't do it, but God did."[62] Or consider Grenfell Tower in London, where cheap cladding led to a cataclysmic fire: the cladding for all 120 apartments cost less than what Kensington Council made from the sale of only two housing units the previous year.[63]

CA as Gentrification as CA

As the above section outlines, in order to efficiently govern, the political and economic elites hope to administer not only our labor power, assets, and legal rights, but also our values, lifestyles, anxieties, and aspirations. The following sections ask how CA facilitates the latter. To claim that CA is simply toxic is as irrelevant as saying we're only carnival barkers. As a malleable part of a capillary division of labor, our role in gentrification can be zero, marginal, or impressive, depending on circumstance.

The following section describes a set of four unique selling points that can make CA a partner of choice in redevelopment schemes. To be

59 Islam and Sakizlioğlu, "The Making of, and Resistance to, State-Led Gentrification in Istanbul," 250.
60 Ibid., 260.
61 Tracy Nehme, "Preserving Housing Memory in Postwar Lebanon: Case Studies of Selected Houses and Neighborhoods," M.A. Thesis, American University of Beirut, 2018.
62 Naomi Klein, "Naomi Klein: How Power Profits from Disaster," *The Guardian*, July 6, 2017, https://www.theguardian.com/us-news/2017/jul/06/naomi-klein-how-power-profits-from-disaster (accessed August 3, 2021).
63 Robert Booth and Rob Evans, "Grenfell: Ccouncil Made More on Two House Sales Than It Spent on Cladding," *The Guardian*, July 20, 2017 https://www.theguardian.com/uk-news/2017/jul/20/grenfell-council-made-more-on-two-house-sales-than-it-spent-on-cladding (accessed July 23, 2021).

clear, the premises outlined do not embody four quirky alternatives to government agency so much as complementary factors arising within and alongside it. The symbiosis becomes obvious when the state chooses not to engage in regeneration. For example, Townhouse Gallery in Cairo did its thing throughout the 1990s and early 2000s in the absence of a municipal plan to capitalize on the middle classes returning to the down-town area. Perhaps this is why, despite its international prominence, Townhouse has been spared the mantle of CA-as-gentrifier.

Placemakers, Accidental and Otherwise
The Wikipedia entry on gentrification explains that "artist's critique of everyday life and search for meaning and renewal are what make them early recruits for gentrification."[64] Artists' "search for meaning" can indeed secure them a vanguard status, even as investors in their own right. We all have artist friends who have used that truffle pig capacity to sniff out opportunities. For a pitch-perfect description of this, see Chris Kraus' novel *Summer of Hate*, where the author's fictional alter ego theorizes art and flips houses with equal aplomb. Artists more commonly invest not cash but sweat equity in renovating fallow spaces across the city and, increasingly, across the countryside too. Thus, if my story of Berlin has been told many times before, it also resembles other places. Canonical examples include Fluxus, Warhol, Gordon Matta Clark in the Manhattan of the late 1960s and early 1970s, or London over the course of the 1980s and 1990s—e.g., the 1988 Freeze show that kickstarted the YBAs, in a venue secured by Damien Hirst and owned by the Docklands Development Corporation. Other examples are legion.

Few in the field are strangers to capitalizing on that state of exception that can be conjured up by some temporarily abandoned space, where CA can be the rare kick in the chutney of life. Why deny oneself such a playground of possibility, especially as an artist who lacks basic support systems? The rate of poverty among artists is proverbial. In Berlin, the average monthly income of an artist is 850 euros. Ninety percent of artists will never be able to retire; their average pension is estimated at 357 euros (most are looking at 280 euros per month).[65] The numbers in most places tend to be comparable, or worse.

64 "Gentrification," Wikipedia, https://en.wikipedia.org/wiki/Gentrification (accessed June 23, 2021).
65 Uwe Romanski, "Hauptstadt der armen Künstler," *Deutsches Institut für Altersvorsorge*, August 29, 2018, https://www.dia-vorsorge.de/einkommen-vermoegen/hauptstadt-der-armen-kuenstler/ (accessed July 31, 2021).

As M.F.K. Fisher puts it in *How to Be Cheerful Through Starving*: "It takes a certain amount of native wit to cope gracefully with the problem of having the wolf camp with apparent permanency on your doorstep. That can be a wearing thing, and even the pretense of ignoring his presence has a kind of dangerous monotony about it." [66] It's important to underline, however, that the permanence of cheerful starvation is not the fate of artists in particular but of the precarious middle classes in general. And we middle classes, by and large, do tend to have options.

The middle classes that provide CA's workforce are both a casualty of and an active participant in gentrification as we know it. The "kipp-bilderesque" flickering back and forth between victim and perpetrator, duck and rabbit, is strange enough to soak up a lion's share of the media attention. Artists are merely a stylized version of this ambivalence, as they flicker from Van Gogh to Damian Hirst and back again. Artists or not, we middle classes enjoy far more airtime than the displaced working classes do, or even the financiers who do the displacing. The flickering means we can be progressive allies one moment, entitled gentry the next: pining for cheap rent while craving a housing career; crippling the poor while identifying with their distress.

A discussion of CA-as-placemaker would not be complete without a brief mention of its top-down deployment to manufacture high-end hotspots. Recent museum megaplexes in Spain or the UAE, for example, have emerged independently from artist pioneers on the ground, or the human timelines they operate within. For an evocative account of top-down time scales, see art historian Jo-Anne Berelowitz's description of the visions that preceded the founding of the Los Angeles Museum of Contemporary Art (better known as MOCA), when it was imagined as a Roman temple on the hill, a new center of the center of Western civilization to come. [67]

Creative Markets for Creative Disruption

By way of research for *TRACTION*, [68] I spent two years jotting down the good objects my colleagues would mention as their core concerns. Among them were: circulation, contingency, destabilization, ephemerality, flânerie, hubs, indeterminacy, migration, porousness, uncertainty, vertigo, and wandering, to name but a few. Whether in terms of medium, physical space, cultural tradition, or intellectual discipline, we obviously

66 M.F.K. Fisher, *How to Cook a Wolf* (Albany: North Point Press, 1988 [942]), 81.
67 Jo-Anne Berelowitz, "Protecting High Culture in Los Angeles: MOCA and the Ideology of Urban Redevelopment," *Oxford Art Journal*, Vol. 16, 1993, pp. 149–157.
68 Tirdad Zolghadr, *Traction* (Berlin: Sternberg Press, 2016).

see creative disruption as a best case scenario. Its tropes allow us to disidentify with the power we actually wield as a hallmark of mainstream aesthetic education, soft power diplomacy, consumer behavior, infotainment, etc. What's more, these tropes explain why the dogged persistence that is required of community organizing and policy is fundamentally at odds with the FIFO logic of our field.

Flight, displacement, and constant auto-reinvention are an inescapable reality to millions, but the tropography of choice for cultural elites. Through the prism of CA, the world at large becomes an adventure of perpetual redevelopment. What is more, in terms of "capitalist realism" (Mark Fisher), this fetish for flux dovetails with many entrepreneurial tenets described in this book. When CA comes on the scene in neighborhoods on the tipping point, it can make what is painfully contingent feel inevitable, regenerative, normal. A sense of *fait accompli* is conjured, a preemptive nostalgia, even before a neighborhood dissolves. Participatory, process-based CA is particularly effective (General Public Agency,[69] a pair of London-based curators who aimed to marry art and regeneration in the early 2000s, would argue that the more it looks like art, the less effect it has). Timing plays an undeniable part, when it's deployed. Corporate "plop" art, for example, will appear when popular struggles are over and done with, while participatory CA is commissioned at raw and sensitive moments in the process of neighborhood transformation. In tenor, it does not favor shouted demands so much as a commemoration of vulnerable humanity: oral histories, black-and-white memories, playful heterotopias as social commentary.

At times, CA can be creatively disruptive enough to spark a momentary rent gap on its own accord. A eureka moment for me personally was Thomas Hirschhorn's off-site *Battaille Monument*, shown at the 2002 documenta. Hirschhorn took a boring middle-class neighborhood of immigrant families and peppered it with his trash-can aesthetic and trademark touches of high-culture pathos. The press duly reported it as an urgent intervention in the daily life of a Turkish ghetto.

Level Playing Fields (Artwashing)

As a strong example of capitalist realism, CA tends not only to naturalize an ill-starred situation, but also to foster a spirit of can-do meritocracy as well. At a pinch, it has you believe we are all on a level playing field of equal opportunity. See Tony Blair's New Labour, which commissioned UK artists to tackle the poverty of aspiration endemic among the working

69 Now defunct, General Public Agency's archive can be viewed at: http://www.generalpublicagency.com/index.html (accessed August 23, 2021).

classes. To be sure, workshops aimed at confidence building, skill sets, or emotional ownership are hard to come by and can make a colossal difference. I am not suggesting these efforts be taken lightly. But even as the can-do spirit may foster the above traits, it can by the same token dissimulate the conflicts of interest at play. Writing on the extraordinary work of Theaster Gates in Chicago, Marina Vishmidt describes how creativity can become "populist" in that it that reassures every worker and artist that their interests are no different from those of capital.[70] This, in turn, allows CA to cater to capital all the more.

See the Assemble collective, which was awarded the Turner Prize for their work in the Granby Four Streets area of Liverpool. News coverage gave the impression the initiative was a bottom-up affair in a neighborhood owned by a Community Land Trust.[71] As Stephen Pritchard has pointed out, only some of the units involved were owned by a CLT. The latter did commission Assemble, with the encouragement of the investment firm Steinbeck Studio, who kept the CLT financially afloat and was waiting to redevelop other sites around the city.[72]

Steinbeck Studio itself was never in itself the limelight and reportedly had mixed feelings about the modest share of public attention it did receive. This makes sense. Artwashing is not sponsorship. Even when fueled by investors (see also the People's Bureau collective, who were bankrolled by London developers Delancey DV4), its job is not to glamorize the financial forces behind our built environment so much as humanize them, or dissimulate their presence altogether.

Zombification

Just one last thing and then I promise to stop complaining. As even a diehard CA enthusiast will admit, art is known for its intriguing capacity to reify what is ineffable, personal, and distinct—be it a childhood memory, a political trauma, or a neighborhood identity. Even when displaced residents have left the scene at the very end of the social cleansing pro-

70 Marina Vishmidt, "Mimesis of the Hardened and Alienated: Social Practice as Business Model," *e-flux journal*, Issue 43, March 2013, https://www.e-flux.com/journal/43/60197/mimesis-of-the-hardened-and-alienated-social-practice-as-business-model/ (accessed July 23, 2021).
71 See, for example: Charlotte Higgins, "Turner Prize Winners Assemble: 'Art? We're More Interested in Plumbing,'" *The Guardian*, December 8, 2015, https://www.theguardian.com/artanddesign/2015/dec/08/assemble-turner-prize-architects-are-we-artists (accessed August 15, 2021).
72 See Stephen Pritchard, *Artwashing: The Art of Regeneration, Social Capital, and Anti-Gentrification Activism*, PhD Thesis, University of Northumbria, 2017, pp. 179–186, and Pritchard, "Artwashing: Social Capital and Anti-Gentrification Activism" (lecture transcript), *Colouring In Culture*, June 17, 2017, https://colouringinculture.org/uncategorized/artwashingsocialcapitalantigentrification/ (accessed June 1, 2021).

cess, CA can still preserve the outward appearance of the nonreplicable qualities of a place.

On any lively street corner, things like indeterminacy, flux, and contingency are not values or goals but a banal part of everyday life. The fact that social cleansing wipes them out is a problem even to the architects of gentrification themselves. To paraphrase Niklas Maak: who wants a million dollar apartment flanked only by guard dogs and CCTV? To a degree, it is possible to resurrect the spice of life in simulacral form. After all, quirky open-endedness is the hallmark of any festival or *Kunsthalle* worth its salt. Multiculturalism, for its part, can be secured by gastronomic means, or by curators and artists voicing urgent topics of global resonance, while agonistic conflict can be revived in panel discussions on "urban resilience." Imagine Berlin Mitte without its artscape: the loss in credibility would be painful and costly.

Nor does CA itself escape zombification. It cannot help but continue to add value until it prices its own foot soldiers out of existence, with the venues, businesses, and services that once formed its dense biotope relegated to the outskirts. When the rent for flats and studios rise, the price tag for professional access rises with it. Then, the role of an upper-middle-class background becomes ever more important. In the scramble for the finite resources remaining, those who have stayed are pitted against each other, until our field is as economically stratified as it is intellectually pointless. But hang in there, now for the nice part.

Capitalizing Antigentrification

Suhail Malik

Since the early 2000s, city planners across the planet have adopted creative-led gentrification as a development strategy for increasing the wealth of cities, while also promoting inclusiveness, diversity, and social integration—all of which are important to these cities' engagement in global networks, as well as increasing capital with minimum political objection. An all-round win. However, faced over the same period with growing socioeconomic inequality between major global cities—especially "superstar cities" such as New York, London, Shanghai, and Dubai—as well as within them, even Richard Florida, proselytizer-in-chief for creative gentrification as a path to urban "renewal," has recanted his earlier prescriptions:[1]

> ... our geography is splintering into small areas of affluence and concentrated advantage, and much larger areas of poverty and concentrated disadvantage. It became increasingly clear to me that the same clustering of talent and economic assets generates a lopsided, unequal urbanism in which a relative handful of superstar cities, and a few elite neighborhoods *within* them, benefit while many other places stagnate or fall *behind*. Ultimately, the very same force that drives the growth of our cities and economy broadly also generates the divides that separate us and the contradictions that hold us back.[2]

Gentrification is integral to a process that socially entrenches income inequalities and the concentration of wealth by means of the increased spatial segregation of rich and poor within cities, between cities, and of cities against adjacent regions. Along with the spatial recomposition of inequality, interactions across different income demographics have

1 'Superstar cities' is a phrase Florida adopted from Joseph Gyourko, Christopher Mayer & Todd Sinai, "Superstar Cities," *American Economic Journal: Economic Policy* 5 no. 4 (2013): 167–99, www.nber.org/papers/w12355.pdf (accessed July 31, 2021).
2 Richard Florida, *The New Urban Crisis: How Our Cities Are Increasing Inequality, Deepening Segregation, and Failing the Middle Class and What We Can Do About It* (New York: Basic Books, 2017), xv.

increasingly become commercially organized, displacing public engagement on the basis of social commonality or equal claims to city use.

Displacement, rent rises, privatization, corporatization, and cultural homogenization by a transnational elite are all part of this process, as is the capital control and social hegemony maintained by those same elites. As Florida highlights, this entails reduced social mobility and the reinforcement of poverty traps. And whereas creatives often functioned as a *spontaneous* frontline of gentrification in the latter third of the twentieth century, today the art field is now fully programmed into the conversion mechanisms of urban and capital development. Contrary to the imperatives of an artistic milieu that abides by leftist-critical imperatives, as contemporary art mostly does, art—contemporary art in particular—has for some time been an attractor rather than a spoiler for capital and municipal investment, formatted by gentrification.

This presents a formidable dilemma for the critically-minded artworker. But help is now at hand to redress it. As noted, gentrification is now recognized as a core problem by urban policy makers, who insist that cities must protect spaces and rents for low-income artworkers (and other creative sector entrepreneurs) in order to maintain urban vitality and reverse the pernicious effects of unhindered gentrification.[3] Yet changing the policy agenda does not challenge the basic premise of creative-led gentrification. Rather, constraining unbridled gentrification is a good result for the creative class, artists included, and may even be the optimal one: creatives can then continue to convert cities to their own ends, with the added advantage of subsequent development taking place *around* them.

However, questions remain: What of those who also have claims—perhaps more trenchant, historically-based claims—to urban sites, but who are not creatives? How do the interests and material conditions of this population fare when the combination of creative-led gentrification and antigentrification efforts shape policy? These concerns are taken up in the conclusion below, but the argument first requires that I elaborate the following: the dynamic logic tying gentrification and antigentrification together; the advantages and quandaries faced by creatives in these restructuring dynamics; the difficulty that these dynamics present to those on the political left. This elaboration will lead to prescriptions for how the art field can contribute to redressing entrenched poverty rather than its own interests. That's important, because, as I will

3 See for example the Greater London Authority's promotion of "Creative Enterprise Zones' since 2018: "Mayor to invest nearly £3m in Creative Enterprise Zones," *GLA Press Release*, July 29, 2021, www.london.gov.uk/press-releases/mayoral/mayor-to-invest-nearly-3m-in -creative-enterprise (accessed August 22, 2021).

show, the art field's overriding interests lie more obviously in maintaining a poverty trap.

Creatives with relatively low income levels typical of the art field have an immediate interest in a nexus of gentrification and supergentrification: gentrification, because that is how this sector takes advantage of the disparity between rent levels of historically underinvested urban areas against the "full" market rates—the "rent gap"—to inhabit dense urban spaces where modernity's art scenes have historically been concentrated; and supergentrification, because the art field must maintain its financial viability by remaining economically structured around the consumption patterns of a neoliberal elite, and that elite has displaced even historically wealthy local residents from desirable urban neighborhoods. *Both* of these conditions can serve creatives very well: artworks and designed objects, as well as experiences, ideas, discourses, and general innovation are all key elements in the expansion of the experience economy promoted by creative-led gentrification, which relies on low-cost space in urban centers, consequently upgraded as service sites for elite enrichment.[4]

As is now well established, the continued celebration of what creatives do while removing the material conditions that enable them to actually do it leads to a closing of the rent gap and, accordingly, resentment and frustration within the creative sector. It's then consistent for creatives to join struggles against gentrification. But this activism indexes a third vector of advantage: antigentrification.

Creative-led antigentrification aims to block further development that would build upon the early-stage gentrification from which they have benefited. This means that the low-income creative sector in particular presents a twofold problem for others who are also casualties of gentrification.

First: while alliances with local communities at risk of eviction, homelessness, and displacement are predicated upon a common interest in maintaining low-price rentals and ownership of property (understood here as a public good), that alignment is not the optimal condition for the creative sector. This sector is best served by maintaining a sweet spot lying between a combination of supergentrification (products,

4 On the way financial and experiential enrichment structures an elite-forging economy (in which art collecting is paradigmatic), see: Luc Boltanski and Arnaud Esquerre, "The Economic Life of Things. Commodities, Collectibles, Assets," *New Left Review* 98, March–April (2016): 31–54; and *Enrichissement. Une critique de la marchandise* (Paris: Gallimard, 2017) for fuller elaboration of their thesis.

sales), gentrification (urban existence), and antigentrification (property requirements).

Second: in their solidarity with the (historically) urban poor at risk of displacement, creatives endorsing antigentrification maintain and perpetuate the rent gap, which is also a proxy measure of relative impoverishment and disinvestment.

To elaborate: by identifying *any* kind of development with gentrification, antigentrification requires continued disinvestment in poor parts of the city where a substantial enough rent gap exists. In the name of solidarity, antigentrification in cities that are otherwise increasing their overall capital base and productivity can thereby contribute "from below" to the economic segregation entrenched by neoliberal gentrification. More alarmingly, given that neoliberal gentrification erodes social mobility and enforces urban segregation and wealth inequalities in cities, antigentrification can lock in the historical poverty traps that ensure the poor remain intergenerationally destitute.

In order to serve their own need for low rent and cheap property, unintentionally or not, creatives supporting antigentrification may be maintaining disinvestment, reinforcing the poverty of the poor. The direct benefit of antigentrification efforts to creatives thereby entrenches social hierarchy based on wealth, reinforced through urban spatial organization. This continued indirect exploitation of the poor and entrenchment of economic-spatial stratification can be called "right antigentrification." This kind of antigentrification supports neoliberal gentrification.

The exacerbation of economic and social segregation in cities presents an insurmountable problem for the political left, whose historical claims to a just model of societal organization, including in cities, is founded on its promise to increase economic and political equality, sociocultural expansiveness and inclusivity, social liberalism, and privilege the common good. Economic poverty and sociocultural disadvantage are ameliorated by improvement of services, infrastructure, and provision of basic requirements like water and energy, affordable transport links, and decent, affordable housing. The poverty trap is sprung open by investment in infrastructure and people, by the transformation of living conditions and material capacities. For this to occur, a path distinct from the two standard options of gentrification and reactive right antigentrification needs to be set out. It is not hard to formulate this route: not all urban economic development schemes lead to gentrification, because they need not be led by exogenous interests or financially speculative development. Indeed, this last term—development—must

be retrieved from its now near-exclusive connotation with capital concentration, an association entrenched by neoliberal doctrine. To meet the political imperative of social mobility from poorer to richer strata of a society (at whatever scale), development is necessary. And it is this type of development that is thwarted by the reactive formation of right antigentrification.

A leftist demand for development therefore puts pressure not just on gentrification but on antigentrification as well. Although the alleviation of poverty and hardship—and, crucially, increasing access to higher living standards—is a common justification for gentrification, the political left must insist that raising income levels and improving infrastructure and services in poor areas will not lead to forced displacement (direct or indirect). Rather, they must maintain and improve provision for incoming people in need, while at the same time defending existing residents against expropriation.

In the most general terms, what is required is *prodevelopment antigentrification* (ProDAG).

ProDAG capitalizes antigentrification: it requires channeling capital to the urban poor, who can be anyone: black or white, those entrenched in poverty by two generations of deindustrialization, the new poor (economic or political refugees), or downwardly mobile members of the former middle classes. Instead of looking to only protect the interests of communities under threat from real estate price increases and land grab pressure, ProDAG advances the claims of constituencies at risk of displacement, advocating development in those areas for that demographic. Such antipoverty prodevelopment capitalization is a form of *active* left antigentrification.

Against the reactive formation of right antigentrification, whose objective is to maintain the rent gap, a ProDAG approach aims to close or reduce the rent gap by the following modes of intensively directed capitalization:

1. Blocking the possibility of increasing rent—or at least mitigating its rate of increase—meaning rent caps.
2. Providing rent subsidies via state support.[5]
3. Reducing rental property prices and distorting the existing real estate market system by (re)introducing market controls.

These measures alone are insufficient for instituting a ProDAG policy agenda. Point one is an attenuated form of continued disinvestment and

5 I am summarizing several of Richard Florida's correctives to creative-led urban renewal. See: *The New Urban Crisis* (London: Oneworld Publications, 2017), 10 and Chapter 10.

is a readily applicable, albeit short-term, variant of reactive anti-gentrification. Point two consolidates the dynamics of rent increases by ensuring rental property profits to property owners by state subvention—further concentrating capital in the hands of landlords while also deferring the standard operations of gentrification. Point three—rent control—can only contribute to ProDAG if it is accompanied by a redistribution of property ownership, as state subsidized housing does. If it is to countermand the displacement and continued degradation of the urban poor, ProDAG must set up revised models and practices to alter the extant financial, monetary, and legal mechanisms that govern property relations.

A revised art field can help establish these kinds of ProDAG strategies by exploring them as a mode of artistic praxis. The exigency here is that the current material and financial conditions of the supermajority in the art field—low income from art together with the spatial requirements necessary for material practice and exhibiting—have to be reset. Extant conditions for art have to be grasped and mobilized as a transformative modular element in a chain of interests and valuation that extends well beyond the limited and experientially determined art field and into finance, government policy, and various sundry urban strategies. The practicalities of art require it.

This is, in fact, not much of a stretch: even now, art is cross-sectorial and transdisciplinary. And, significantly, it is part of a Global Urban Value Chain (GUVC) susceptible to manipulation.[6] More precisely, because it is art, that value chain *ought to be* manipulated—in ways that may be deemed inaccessible to those more debilitated by the capitalization set up by GUVCs. Such manipulation includes working with urban activists specialized in the law and finance, who have the technical skills to formulate developmental strategies that support the interests of the urban poor. And such forms of legal, contractual, and municipal work is, again, fully within the possibility-space of art as a form of intersectional, transdemographic, interdisciplinary practice.

It's a propitious time to follow through on this demand, because the neoliberal order of the past forty years is undergoing a global restructuring, affecting capital organization at every scale and in every locality. The current legitimation crisis of neoliberalism means that the financially led accumulation familiar from (super)gentrification is now highly susceptible to delegitimation and revectoring by alternative models, revenue structures, and capitalization interests. And just as contemporary art played an effective part in establishing neoliberalism's hege-

monic reordering of society, so art—which would have to be another art than contemporary art—can and should play a part in its undoing. As components in the medium-term alleviation of urban poverty, ProDaG requires that art's manipulation of GUVCs strategizes its own material requirements for low-provision workspace, cheap housing, and access to transnational mobility. It also requires that art's economy is revectored away from the increasingly plutocratic power of urban elites. What and to whom creatives instead will appeal to while building new economic support structures necessarily has to shift from the current model of one-sided and extractive subservience to neoliberal elites. It requires, then, the restructuring of art's larger economy and the reorganization of how its hierarchies are established and maintained.

6 For an overview of Global Value Chains, see: João Amador and Filippo di Mauro, eds., *The Age of Global Value Chains: Maps and Policy Issues* (London: CEPR Press, 2015).

Financializing the Development of Urban Neighborhoods:[1] Thoughts on the Relationship between Art and Gentrification

Laura Calbet Elias

In recent decades, the fields of art and real estate have both been plagued by speculative tendencies. One keyword that may help us grasp these ongoing speculative tendencies is "financialization" (Aalbers 2016). As a reaction to the social effects of these speculation patterns, how contemporary art practices contribute to gentrification has emerged as a question within the art field. Whether artists act as "pioneers" of gentrification processes or whether nonconformist art projects risk being co-opted for neoliberal purposes has already been intensively discussed elsewhere and will not be pursued here. That said, revisiting some aspects of the financialization debate does seem fruitful to me, so as to open up new perspectives on the relationship between art and uneven development within cities.

The Financialization Perspective: Four Footholds
Financialization refers to tendencies within current forms of capitalism characterized by the financial realm's prominent position. This includes, for instance, the phenomenon of surplus company assets traded on the financial markets exceeding the total gross national product of the world's nation-states many times over, or the primacy of financial rationales in government, companies, and private households. Ben Fine suggests a definition of financialization that covers this entire range of phenomena:

> However financialisation is defined and used, it points to a complex amalgam of developments within global finance and in its interactions with and consequences for economic and social life more generally. Further, it is not merely the expansion and proliferation of financial markets that are striking but also the penetration of such financing into a widening range of both economic and social reproduction – housing, pensions, health, and so on (Fine 2012, p. 58).

[1] This essay is based on the author's PhD thesis, "The Speculative Production of the City: Financialization of housing construction in Berlin," Technische Universität Berlin, Center for Metropolitan Studies, 2015.

Financialization debates address the relationship between the financial sphere and other areas of life, such as housing or art. Whereas the "financial sphere" has long been regarded as an exogenous factor to many social processes, financialization research, as Andy Pike and Jane Pollard argue, allows us to overcome the temptation to consider the financial sphere as functionally, politically, and spatially (and, I would add, socially) isolated (Pike and Pollard 2010, 37). Using the example of residential construction in Berlin, I'd like to illustrate how emphasizing the entanglement of the financial world with other aspects of social life can help us better understand the relationship between the contemporary art field and uneven urban development.

Financializing Urban Neighborhoods

In 2017, the foundation was laid for the Luisenpark project on Stall-schreiberstrasse, thereby removing the last plots of an undeveloped eighteen-hectare area located directly in the heart of Berlin. This collection of noncontiguous open spaces—which, incidentally, were the setting for the art project *Skulpturenpark*[2]—extended all along the former Berlin Wall, from Spittelmarkt to Heinrich-Heine-Strasse. The new neighborhood now features over 2,000 residential units and twenty distinct building projects. Analysis of the building process reveals three phases of investment and construction between 2009 and 2019.

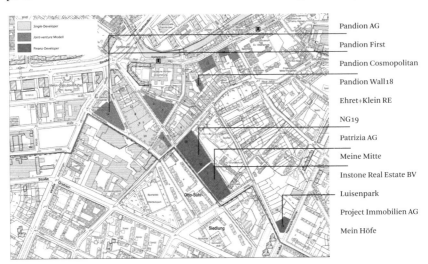

Pandion AG

Pandion First

Pandion Cosmopolitan

Pandion Wall18

Ehret+Klein RE

NG19

Patrizia AG

Meine Mitte

Instone Real Estate BV

Luisenpark

Project Immobilien AG

Mein Höfe

Investors and projects of the third investment phase

2 In 2006, the KUNSTrePUBLIK collective founded the *Skulpturenpark Berlin_Zentrum* (Alte Jakobsstrasse, corner of Seydelstrasse).

Remarkably, the construction of the new neighborhood did not follow any superordinate plan and barely attracted public attention. Even more striking was the type of real estate developer active here as of 2016. Many were new to building projects in Berlin, while others had never been active in housing development at all. The one precondition for operating here at that time was the ability to prevail within a highly competitive property market. Builders who appeared from 2013 onwards were granted access for one simple reason: they were "financialized real estate developers," able to draw on the capital strength of alternative forms of financing. From 2013 onwards, almost every real estate developer operating in the area was doing so in partnership with financial investors, a new trend in Berlin. The developers Pandion and Ehret+Klein formed joint ventures with investment firms in order to finance their projects through private equity. Project Immobilien operated in a similar fashion, but the investment firm in question was its partner company Project Investments, which manages both private and institutional investment funds. Mainly, the new players to appear as of 2016 are not primarily real estate developers but investment companies. Patrizia AG is among the largest of Germany's real estate investment companies (together with Vonovia and Deutsche Wohnen) and is chiefly involved in managing residential portfolios: their development was the first time the firm had constructed new apartments. Instone was bought by asset manager Activum SG in 2017, becoming part of a fund for institutional investors before finally going public in 2018. All of these companies can be considered financialized real estate developers.

Spatial Footholds

Thanks to their connection to alternative investment funds, the real estate projects undertaken by these developers could serve as collateral for financial endeavors, even while under construction. In this instance, shares of development operations act as liquid ownership titles, the value of which is determined by fluctuations in financial markets (not by the value of the real estate per se). The more valuable the property and the project, the more capital can be collected through shares. Under this business model, prohibitively expensive land prices are not an obstacle—as is usually the case—but, rather, an integral part of the business plan. Moreover, constructing high-end residential units is not just a consequence of high construction costs but also an opportunity to accumulate more capital on the basis of overvalued proposals.

Since the main goal of financialized investments is not, first and foremost, to produce housing but to realize financial profits, gentri-

fication and housing crises are the logical consequences of financialization. Using new construction projects as collateral for financial investment associated with the emergence of financialized developers must be considered one key dimension of the financial sphere's spatial materialization.

The financialized developers mentioned above were not, as is often assumed, "foreign investors" or foreign players but German companies. However, the many financial transactions of these companies (undertaken solely for tax benefits), as well as their financial transactions with equity funds, are deeply international in nature. A pioneer of this trend toward financialized property development in the vicinity of Leipzigerstrasse was the Groth Gruppe. Since 2009, this Berlin-based company realized four projects in the area, two of which were joint ventures with the Dutch fund manager Reggeborgh Groep. The tendency toward financialization could thus be described as having been initiated by a locally established developer and bolstered by outside investment. This is not surprising, since project development requires specific local knowledge. Over the course of a second wave of massive investments, those projects developed by the Groth Gruppe and other companies closely linked to the recent development of Berlin (Baywobau, Lagrande Immobilien, Berlanto) transformed the neighborhood from a shunned area to a desirable address. In 2014, the area was dubbed "Urban Development Area of the Year" by the Bulwiengesa AG (Bulwiengesa AG 2014, 27–35), becoming a coveted investment hotspot. Local roots can thus be quite relevant to the initiation of financialization processes. Under such investment regimes, location is not only used to assess the market situation for investment; local real estate developers also contribute to the implementation of new financial rationales by cultivating connections to political and administrative actors.

Political Footholds
The financialization of housing is linked to changes in the regulation of various economic sectors in other ways. In recent decades, global financial flows have been driven not only by technological development but also by new (inter)national conditions for investment. The state-promoted "financial location Germany" led to the previous bank-based credit system losing significance, to the benefit of financial-market and equity-based financing models (Windolf 2005; Lütz 2005). In the field of housing provision research, several analyses emphasize the importance of politics in financialization processes. This is the case, for example, in the financialization of rental housing as a result of en bloc sales

of public housing stock to real estate funds (Heeg 2013; Holm 2011; Uffer 2011).

A form of political regulation that has received comparatively little attention but is essential within the context of city neighborhood development is urban planning, whose guidelines serve to regulate land use as well as construction. Planning liberalization has also created favorable investment conditions. Since 1999, the plan known as Planwerk Innenstadt has served as the legal basis for construction permitting throughout Berlin's city center under the provisions of article §34 of the German planning regulation law (BauGB). As a result, individual projects within the area can be approved without including public facilities or green spaces. This mechanism has also been a means to "successfully" circumvent public participation and oversight by the municipal council (*Bezirksverordnetenversammlung*). The absence of zoning guidelines, along with prior permission to allocate more square meterage per unit than urban planning bylaws customarily allow, resulted in particularly lucrative development opportunities for investors. This liberal understanding of urban planning was established in a time of economic stagnation, with the aim of attracting investment. Nowadays, these regulations—for financial transactions, for housing markets, and for urban planning in general—mainly create favorable conditions for expectations of a high return on investment among financialized developers.

Functional Footholds

A claim that is repeatedly made in financialization debates is that the financial sphere has decoupled itself from other areas of the economy (e.g., Stockhammer 2004). The supposed disconnection of finance from production is based on the idea that housing construction cannot constitute a form of financialization, since it actually produces something concrete (i.e., housing). However, this theory does not take into account the fact that speculative profits in urban development are not based on the material production of buildings but on increases in land value (Topalov 1979). In the speculative context, the value of built matter constitutes only a small proportion of a property's value. It is by planning and building on a given property that land value is maximized. The developer's aim is to avoid transferring this (full) value increase to the former property owner at the moment of purchase. Financialized developers only act in situations in which they expect an increase in value along these lines.

Critiques in the vein of Wolfgang Krumbein also note that financialization does not decouple firms and government bodies from the

financial sphere. Rather, they use "new financial instruments in order to acquire additional profit and management opportunities" (Krumbein et al. 2014, 14). This can be observed in the eighteen-hectare south-of-Spittelmarkt area under discussion when examining how nonfinancialized real estate developers have operated there. Building owners who relied on traditional forms of financing, and whose projects did not act as collateral for fictitious capital on the financial markets, also benefited from high sale prices—providing they had acquired the land early on and were not exposed to competition for land acquisition. Such was the case of one particular owner on Sebastianstrasse, who participated in the speculation process at the right time. In sum, not every form of speculation is associated with financialization; both processes coexist. The net result is, however, that not-for-profit investors are gradually being forced out of the market.

Social Footholds

The individual level is the one which is most difficult to assess with regards to financial processes, not least because it involves broader societal issues. A key driver of financialization processes is the connection of private household wealth to financial circuits (Lapavitsas 2013). The privatization of old-age provision and the need to make savings profitable—or to at least secure them against depreciation—bind ever-increasing shares of private wealth to the financial markets (Heeg 2013), which is why numerous financialization researchers (Martin 2002; García-Lamarca and Kaika 2016) now address the financial subjectivities of individuals and households. The spread of residential property ownership is one example of such financial subjectivities, which motivate individual households to safeguard personal wealth or provide for old age, even at the cost of high levels of debt.

The demand for condominiums in my neighborhood example—many of which are not the owners' primary place of residence—shows that processes of financialized urban development are indeed accompanied by this form of asset-based wealth. Financialization processes do not end with the completion of a new-build; they persist through the loan repayments of single households. However, in comparison to professional financial actors, individuals are systematically disadvantaged (Lapavitsas 2013, 800). The result is a generalized bottom-up redistribution process which Lapavitas calls "financial expropriation" (2011, 621) and David Harvey terms "accumulation by dispossession" (2004).

Conclusions for the Arts

The neighborhood development example I have focused on demonstrates how financialization is linked to four aspects of society and how it affects unequal access to the housing market. In my view, analyzing this particular group of real estate developments allows us to ask several questions pertinent to the debate over the relationship between art and uneven development. To me, an important starting point for reflecting on the financialization of art is the distinction between those processes where art-related actors contribute to the financializing of other social sectors and those that contribute to the financialization of artworks and the various actions of artists themselves. Much of the debate around gentrification and the arts is devoted to the former. To focus on this first perspective while emphasizing its spatial components is to raise questions such as: To what extent does art or the actions of artists serve to commodify other values, increasing the attractiveness of urban (and other) spaces for financialized investors?

However, even processes where art is itself being financialized—as suggested in the latter perspective—contribute to social polarization. For contemporary art to address its role in current forms of capitalism and neoliberalism, it needs to become aware of the political, functional, and social establishment of financial rationalities within the field of art itself. In this sense, a "functional" perspective might ask: How does art (and the actions of artists) function as collateral, one that contributes to financialized forms of accumulation? Examples of this are not limited to the astronomical prices sometimes paid for artworks. Politically, it would be equally necessary to ask whether forms of regulation within the art field have changed and whether they now also contribute to financialization. Finally, it would also be important to question to what extent subjectivities have arisen that contribute to the further commodification and financialization of art.[3] Financialization can be understood as the transformation of finances from a means (financing) to a goal (financial profit). A critical reflection on processes of financialization in art would ensure that art continues to pursue methods and goals other than financialization itself, despite the linkage between art and the financial sphere.

3 Ideas on blockchain financing and valorization, as currently discussed in the art scene, point toward this direction.

Bibliography

Aalbers, Manuel B., ed. *The Financialization of Housing: A political economy approach.* London and New York: Routledge, 2016.

Bulwiengesa AG. *Die Immobilienmärkte in der Metropolregion Berlin-Potsdam. Projektentwicklungen und Trends 2014.* Erstellt für Hochtief Projektentwicklung GmbH und Berliner Volksbank. Berlin. https://www.bulwiengesa.de/sites/default/files/pe-studie_blnpotsd_20132.pdf (accessed 16.09.2021).

Fine, Ben. "Neoliberalism in Retrospect? It's Financialisation, Stupid." In *Developmental Politics in Transition: The Neoliberal Era and Beyond,* edited by Chang Kyung-Sup, Ben Fine and Linda Weiss, 51–69. Basingstoke: Palgrave Macmillan, 2012.

García-Lamarca, Melissa and Maria Kaika. "'Mortgaged lives': the biopolitics of debt and housing financialisation." *Transactions of the Institute of British Geographers* Volume 41, Issue no. 3 (2016): 313–327.

Harvey, David, "Die Geographie des ‚neuen' Imperialismus: Akkumulation durch Enteignung." In *Die globale Enteignungsökonomie,* edited by Christian Zeller, 183–215. Münster: Westfälisches Dampfboot, 2004.

Heeg, Susanne. "Wohnungen als Finanzanlage. Auswirkungen von Responsibilisierung und Finanzialisierung im Bereich des Wohnens." *sub\urban. zeitschrift für kritische stadtforschung* Volume 1 (2013): 75–99. DOI: 10.36900/suburban.v1i1.71.

Holm, Andrej. "Wohnung als Ware. Zur Ökonomie und Politik der Wohnungsversorgung." In *Schöner Wohnen? Wohnungspolitik zwischen Markt und sozialer Daseinsvorsorge. Widersprüche* Volume 31, Issue no. 121 (2011). Münster: Westfälisches Dampfboot: 9–20.

Lapavitsas, Costas. "Theorizing financialization." *Work, Employment & Society* Volume 25, Issue no.4 (2011): 611–626. DOI: 10.1177/0950017011419708.

Lapavitsas, Costas. "The financialization of capitalism. 'Profiting without producing'." *CITY* Volume 17, Issue no. 6: 792–805. DOI: 10.1080/13604813.2013.853865.

Lütz, Susanne. "Von der Infrastruktur zum Markt? Der deutsche Finanzsektor zwischen Deregulierung und Regulierung." In *Finanzmarkt-Kapitalismus. Analysen zum Wandel von Produktionsregimen* Issue 45, edited by Paul Windolf, 294–315. Wiesbaden: VS Verlag für Sozialwissenshaften, 2005.

Martin, Randy. Financialization of Daily Life. Philadelphia: Temple University Press, 2002.

Pike, Andy and Jane Pollard. "Economic Geographies of Financialization." *Economic Geography* Volume 86, Issue no.1 (2010): 29–51. DOI: 10.1111/j.1944-8287.2009.01057.x.

Stockhammer, Engelbert. "Financialisation and the Slowdown of Accumulation." *Cambridge Journal of Economics* Volume 28, Issue no.5 (2004): 719–741.

Topalov, Christian. *La Urbanización Capitalista* (versión revisada). México: Edicol, 1979.

Uffer, Sabina. "The Uneven Development of Berlin's Housing Provision." Dissertation. London School of Economics and Political Science, Department of Geography and Environment, 2011. http://etheses.lse.ac.uk/204/1/Uffer_The_Uneven_Development_of_Berlins_Housing_Provision.pdf (accessed 16.09.2021).

Windolf, Paul. "Was ist Finanzmarkt-Kapitalismus." In *Finanzmarkt-Kapitalismus. Analysen zum Wandel von Produktionsregimen* (45), edited by Paul Windolf. Wiesbaden: VS Verlag für Sozialwissenshaften, 2005.

The Community Land Trust:
A Model for Berlin's New *Stadtbodenstiftung*

Sabine Horlitz

The question of land and housing is by no means a new issue. The relationship between private land ownership, its profit-oriented exploitation, and social justice has preoccupied many a scientist and political thinker. The peculiarity of land as a commodity—which, unlike other goods, is limited in supply and cannot be produced or multiplied—has been repeatedly addressed theoretically: this in opposition to predominant liberal ideas (for which land is a product like any other). In his 1755 essay "Discourse on the Origin and the Foundations of Inequality Among Men," Jean-Jacques Rousseau had already made the case that social inequality is a result of the illegitimate enclosure and subsequent commodification of land, and the privileges derived from it. Almost a century later, the British economist John Stuart Mill developed the concept of "unearned increment" in his paper "Principles of Political Economy, with Some of Their Applications to Social Philosophy" (1848), where he explained that the profits accrued from rising land values were not generated by the work and investments of individual owners but resulted from the growth and development of society as a whole. Such profits thus belonged to the entire society and should be returned to it by means of taxation (Mill 1848). This position has currency again nowadays, reflected, for example, in the German property tax initiative "*Grundsteuer: Zeitgemäß!*," which calls for the tax on property to be converted into a land value tax.

The Allocative Function of Land Price
In the 1970s, the question of land ownership and the real estate industry became a central topic in critical urban studies. The "new theory of urban land rent," for example, attempted to further develop, in keeping with Marxist positions, the role of the price of land in urban development processes. It explained how land prices acquire an allocative function in capitalist spatial production by systematically helping to enforce the most profitable uses of land, displacing less lucrative, socially oriented uses (cf., Haila 1988). These mechanisms apply not only to land sales and new planning; they also concern existing usage and tenancy,

as the geographer Neil Smith has demonstrated with his concept of the "rent gap." This principle, referred to in German as *Ertragslückentheorie*, shows how the gap between existing rent and a potentially achievable rent puts pressure on tenancies that fail to maximize rent revenue. Said "gap" also points toward the possible realization of profit—as, for example, the conversion of cheap rental apartments into upscale condominiums (Smith 1979).

This tendency, analyzed in a rather abstract fashion in the 1980s, has since developed into a predominant reality in more recent years. For urban development, the treatment of land as a financial asset that has to stand up to comparison with returns from other investment instruments means a further submission of the built environment to market forces, shaping an understanding of land as an asset to be exploited like any other.

The Search for Alternatives: Land as Community Property
As a result of these developments, there is now a growing interest in alternative, nonprofit-oriented forms of ownership. Promulgating a land policy that is separate from the commercial real estate market is seen in many places as a way of strengthening socially oriented urban development (cf., difu/vhw 2017), the underlying assumption being that when land is neutralized as a profit factor it is more likely, in the longer term, to secure affordable living and working spaces, as well as other beneficial sociocultural uses. In what follows, I present the Community Land Trust (CLT) as one such nonprofit-oriented property model. CLTs are a communal form of ownership by which land is withdrawn from speculation in order to make it available for affordable housing, but also for other social, cultural, or commercial uses—from neighborhood centers to artisanal production to community gardens. They are also a form of neighborly self-government, where the use of the land and the structures on it are determined collectively so that they correspond to local needs. The slogan "community-led development on community-owned land" aptly summarizes the core idea of CLTs (Davis 2015).

CLTs were first created in the 1970s—in the context of the civil rights movement in rural areas in the southern United States—in order to counter racially discriminatory land policies and provide African-American farmers with permanent access to farmland and housing. Early protagonists within the CLT movement drew from various socio-political ideas, inspired by diverse sources, where securing trusteeship of land for the common good was of singular importance, like the English Commons or the Gramdan movement in India (where individual

villages function as trustees of adjacent agricultural land). The first urban CLTs were founded in the 1980s, when upgrading and gentrification in US cities, particularly in low-income neighborhoods, was increasingly leading to the displacement of local residents. The original CLT rural-agricultural model was transferred to the urban context and redefined according to the requirements appropriate to this new setting—that of providing permanently affordable housing and community facilities. In the following years, as this neighborhood-related model for securing long-term, low-cost housing for people with low incomes spread, CLTs were disseminated further, especially among community activists working to redress the state's withdrawal from welfare provision.

There are now hundreds of CLTs, mainly in the US and Great Britain, but also in Brussels, Lille, and Ghent. They have become a proven local remedy against gentrification and displacement, especially in the inner cities. The EU has also become aware of this ownership model and supports it financially as part of its sponsored project, Sustainable Housing for Inclusive and Cohesive Cities (SHICC).

The Three Elements of the CLT Model: Community – Land – Trust
Explaining the functionality of the CLT model, along with the organizational-legal structure undergirding it, is best accomplished by analyzing the attributes connected to the three terms from which it draws its name: "community," "land," and "trust." Admittedly, the description that follows simplifies a more complex reality, where the basic structure of the CLT model has been adapted in numerous ways to meet local needs and particularities.

"Land": The Question of Property and Ground
An essential feature of the CLT model is its form of ownership. CLTs are characterized by a dual ownership structure, where land ownership is distinct from the ownership of the buildings constructed on it. Although future users, whether residents of single-family houses, cooperatives, or local business people, purchase the built structures, the CLT in question retains ownership of the underlying land, holding it in trust while leasing it to users by means of a long-term contract, usually ninety-nine years in duration.

This leasehold contract is the crucial structural element of the CLT model. It can be mortgaged and is renewable and binding for all future users. The leasehold contract contains all the regulations necessary for the CLT to function and ensures the permanent affordability of its respective housing stock (and other uses), ranging from limits to the

resale price of a built structure to prohibitions forbidding absentee ownership to income restrictions. The leasehold contract also codifies the CLT's right of first refusal in cases where buildings are sold. Finally, the CLT is responsible for controlling and enforcing regulations stipulated in the leasehold agreement.

"Community": Local Anchoring and Neighborly Self-determination

An additional feature of the CLT, distinguishing it from sole leasehold relationships, is the design of the organizational and decision-making bodies. CLTs are democratically administered organizations, rooted within local neighborhoods. Characterized by a locally defined open membership, all people who live in the area defined by the CLT as a neighborhood, or "community" in the geographic sense, are eligible to become voting members of a CLT, and are therefore entitled to participate in CLT-related decisions (people outside the designated area can also become members, but without voting rights). All residents are automatically voting members. The rights and duties of the CLT members are regulated in the corresponding statutes, the so-called bylaws. Unlike housing cooperatives, however, CLTs limit the decision-making power of residents, instead emphasizing the social components of housing provision. This form, if you will, of socialization is also reflected in the tripartite composition of the decision-making body. In the Anglo-Saxon world, this is the "board of directors," comparable to the board of management or trustees in German-speaking countries. Generally, the composition of the committee consists of an equal number of user representatives, neighbors, and public figures. Board members are usually unremunerated and are elected at an annual membership meeting. The board is, among other things, responsible for giving the CLT its orientation, allocating funds, making decisions on projects, and supervising the management.

By involving third parties in its administrative structure, CLTs mediate between the interests of its users, the overall objectives of the CLT, and the respective neighborhood or the broader public. In this way, it also mitigates the danger of profit restrictions anchored in the regulations being lifted (thereby paving the way for collectively organized housing being commodified over time, thus becoming a potential engine of gentrification and displacement).

"Trust": The Social Issue

CLTs are socially oriented, recognized by law as charitable nonprofit organizations in most cases. The term "trust," however, is sometimes misunderstood in this instance as representing an economic body, as in

a "trust company" (a merger of several businesses in the same industry to achieve market monopoly). The concept of trust in a CLT, rather, goes back to the idea of "trusteeship," the fiduciary management of assets for others. Since structurally anchoring long-term affordability is central to the CLT model, by permanently withdrawing land from the market—restricting or completely preventing the generation of profit—CLTs guarantee the long-term affordability of their living and working spaces (or the agricultural land they hold) and other communal facilities.

Creating permanently affordable spaces goes hand in hand with the CLT model's explicit charge to serve households of below-average income. In this respect, CLTs do not see themselves as a fiduciary model "for everyone," but one that offers opportunities for people with limited economic resources, or for those who are otherwise disadvantaged by (and excluded from) the speculative market or political mainstream. The orientation toward "low and modest incomes" is, in the case of the US, also anchored in the legal definition of the CLT model included in the 1992 Housing and Community Development Act.

Strengths and Flexibilities: A Model for Berlin's New *Stadtbodenstiftung*
CLTs function under capitalist conditions but simultaneously point beyond them; in this, they are a way to create and sustain nonprofit housing based on need rather than expectations of profit. They help identify alternatives to market-based housing and the commercial supply of living and other types of spaces, both on a discursive as well as a project-related level.

In this sense, the CLT model can also provide important impulses for urban and housing policy debates in German-speaking countries. On the one hand, it could add a decidedly neighborhood-oriented model to the local setting, one which points to a way out of the tendencies toward homogenization and socioeconomic exclusivity that persist, usually unintentionally, even in many alternative housing projects and cooperatives. Here, employing the CLT model would possibly reorient existing models toward a stronger sense of solidarity. On the other hand, certain aspects of the model (e.g., leasehold regulations, the inclusion of representatives of the neighborhood and general public, the permanent nonsalability of land via the dual ownership structure), could offer new strategic possibilities for debates around remunicipalization—the permanent securing of public property, rethinking property policy, and the democratization of public housing stocks.

Since early 2018, a CLT initiative has successfully been working on a transfer of the Anglo-Saxon CLT model to the Berlin context. In spring

2021 the *Stadtbodenstiftung* was set up as a legal nonprofit-making body. The idea is this: inspired by the CLT model, a democratically organized foundation would demonstrate this way of permanently removing land and urban property from the market. The Stadtbodenstiftung sees itself as a grassroots foundation (*Bürgerstiftung*). About 150 founding donors have brought together the necessary startup capital and launched this new foundation. The Stadtbodenstiftung is an opportunity to participate. It is an invitation to initiate projects, strengthen neighborhoods, and demonstrate the possibilities for solidarity-based urban development.

The foundation format (*Stiftung*) was decided upon because it allows for the codification of certain goals—such as the nonsalability of land—and is best suited to the purpose of managing land as a common good, ensuring the greatest possible protection against potential future speculative exploitation of the organization's endowment. Its intended purposes are secured through its nonprofit status and the charter codifying its goals, purposes, and decision-making processes.

The structure of the *Stadtbodenstiftung* is largely based on the CLT model and is essentially made up of three bodies. The managing directorship (*Vorstand*) is responsible for running the foundation's day to day business, while the board of directors (*Kuratorium*) functions as the main decision-making body, offering a more general sense of orientation, including making decisions concerning the acquisition of land and allocation of resources. The board of directors includes three experts and four representatives drawn from the community of users, as well as four additional members from the respective neighborhoods. In addition, its composition may include a representative from public bodies who have made a substantial contribution to the foundation, and a representative elected from endowing donors. The aim of the board's composition is to incorporate a range of interests, especially those whose voices are normally not heard in housing and urban development debates. The foundation committee (*Stiftungskomitee*), a third not-yet-implemented body, can be compared to a general assembly and is open to all involved, from neighbors to donors. This is where grassroots discussions and the initial canvassing of opinions will take place, but also where representatives will be elected.

As a democratized foundation, the *Stadtbodenstiftung* is a novelty within the German foundation scene. It is one of several endeavors concerned with land reform in Berlin that have only grown stronger in recent years, from the round table for the reorganization of Berlin's property policies (founded in 2012) to the growing demands for a municipal land

fund, to name just a few. Although set up as a civil society nonprofit foundation, it does not see itself as a competitor of remunicipalization. Rather, its point of departure lies at the other end of the market spectrum, as its primary objective is to decommodify and socialize privately owned land and real estate. Ideally, as a model based on grassroots democracy and an organization designed to operate in the long term, it might indeed also offer suggestions and serve as an example for what sorts of roles civil society can play in decisions about municipal property.

Bibliography

Stadtbodenstiftung: www.stadtbodenstiftung.de
Davis, John Emmeus. "Common Ground: Community-Led Development on Community-Owned Land." *ROOTS & BRANCHES: A Gardener's Guide to the Origins and Evolution of the Community Land Trust*, June 1, 2015. https://cltroots.org/archives/3231 (accessed Sept. 14, 2021).
Bunzel, Arno, Ricarda Pätzold, Martin zur Nedden, Jürgen Aring, Diana Coulmas, and Fabian Rohland. "Bodenpolitische Agenda 2020-2030." *Deutsches Institut für Urbanistik*, 2017. https://difu.de/publikationen/2017/bodenpolitische-agenda-2020-2030.html (accessed Sept. 17, 2021).
Haila, Anne. "Land as a financial asset: The theory of urban rent as a mirror of economic transformation." *Antipode* 20, no. 2 (1988): 79–101.
Mill, John Stuart. *Principles of Political Economy: With Some of their Applications to Social Philosophy*. London: Penguin Classics, 1995 (1848).
Rousseau, Jean-Jacques. *Discours sur l'origine et les fondements de l'inégalité parmi les hommes*. Paris: Flammarion, 2008 (1755).
Smith, Neil. "Toward a Theory of Gentrification A Back to the City Movement by Capital not People." *Journal of the American Planning Association* 45, no. 4 (1979): 538–548.
Trares, Thomas. "Der Boden und die Bodenrente — die Verteilungsfrage des 21. Jahrhunderts?" *Nach Denk Seiten*, November 27, 2017. https://www.nachdenkseiten.de/?p=41285 (accessed February 4, 2019).

The Land:
From Pastoral Idyll to Sacrifice Zone

Marco Clausen

My own perspective on rural gentrification is an urban one. I'm active mainly in Berlin-Kreuzberg, although in recent months I've been working in Mecklenburg. I do have family ties to the countryside: for generations, my family has run a small farm in Schleswig-Holstein. But as many others have done, I eventually moved to the big city. This is precisely one of the questions that needs to be addressed: Why do people leave the countryside? What attracts them to cities?

My interest in the countryside was sparked by my involvement in the Prinzessinnengarten, an urban agricultural project established in 2009 on Moritzplatz in Kreuzberg. Here, we transformed a former brownfield site into a social-ecological educational garden that was economically self-sustaining. This place quickly became pretty well known under the "urban gardening" label. Not that we are the only community garden around—there are now two hundred in Berlin alone, and many more throughout Germany. People tend to trivialize these projects as a trendy lifestyle thing, where "hip" city dwellers can get their hands dirty and commune with nature. Which is partly true, of course. While urban agriculture has long existed in cities such as New York and Detroit, especially in the metropolises of the Global South, such gardens are oriented around forging relationships with rural areas, around food production in particular. Urban garden activists aim to build bridges and raise awareness of conditions within the food industry and agriculture system from both a regional and global perspective. In political terms, the movement strongly identifies with the worldwide struggle of small farmers and farm workers known as *La Via Campesina*, which fights for food sovereignty.

My experience of gentrification is likewise rooted in the Prinzessingarten. At the REALTY conference the question was posed: What can we learn from urban struggles? Well, one thing that strikes me is how we tend to portray urban gentrification as a cultural issue. We like to talk about how cafes, art galleries, or urban gardens supposedly raise the value of a neighborhood, pushing out former residents of lower economic status. But even though these are very real phenomena, to claim

that they are causes of gentrification falls short of a useful analysis and often diverts attention from the true *systemic* causes.

The story of the Prinzessinnengarten illustrates this all too well. When we started out, the land still belonged to the City of Berlin. But like many other state-owned properties, it was up for sale. Privatization of this sort had been going on since the 1990s in order to pay down Berlin's public debt, or so the city government claimed. Over time, parcels of land equivalent in size to Friedrichshain-Kreuzberg were sold off to investors at a time when property prices were low and interest rates high, meaning that more and more properties landed in private hands, but without shrinking municipal debt. During the financial crisis of 2008–2009, when the state rescued the banks, billions of euros flowed into the real estate market, inflating the price of land. What was once publicly owned real estate, or public housing, now became a commodity to speculate with. To turn housing into a financial product is to extract a maximum of profit in the minimum amount of time from something people cannot do without. This dynamic radically changed the situation of many millions of urban dwellers.

Even so, it would be naive to think that international financial markets act alone. One must always bear in mind that these markets operate in tandem with the state's regulation—or deregulation—of the economy. Land prices around Moritzplatz have increased almost tenfold in the last decade. The average Prinzessinnengarten one square meter carrot patch, if sold off for property development, would fetch around 8,500 euros on today's real estate market. Altogether, the speculative price of the land would be just under fifty million euros. If land were not a commodity tradeable on the free market but, rather, was capable of being secured as public property or through a community land trust, gentrification would not happen. If this Kreuzberg neighborhood hadn't been privatized, then a Prinzessinnengarten, a thriving café, or a gallery would not partake in pushing out local residents. Most housing around the Prinzessinnengarten was actually once public. Only when it was sold to companies like Deutsche Wohnen AG did rents become unaffordable to low-income families. Small businesses in the neighborhood have faced the same fate.

A similar process has taken place in parallel in the countryside, but has gone largely unnoticed—beginning with farms collectivized by the GDR and successively privatized since the collapse of the Cold War Eastern Bloc. What is referred to as land grabbing when it happens in the Global South clearly also shapes the reality of rural areas right here in formerly East German states such as Brandenburg or Mecklenburg-Western Pomerania.

One hears a lot about well-off city people on the lookout for a cute farmhouse where they can set up a second home, preferably in some place like the Uckermark. So-called weekenders buy properties that are by their standards reasonably priced, then fix them up into a pastoral idyll. But, once again, to stop at criticizing such people falls short. Here, too, we must take other historical factors into account, such as Germany's Unification Treaty of 1990, which led to agricultural land being turned into a commodity to be freely traded on financial markets. And here, too, not only international capital markets are to blame but German companies and food producers as well, who put pressure on land prices. Today, the "value" of land—its price on the market—bears no relation to the value generated by farming it, especially when it comes to more labor-intensive organic farming. The speculative business model is viable only because the EU prioritizes and massively subsidizes large landholdings.

But we seem to suffer from an attention deficit. Take the local farmers' protests of 2019, which were barely recognized within our contemporary urban attention economy. Politically speaking, turning a blind eye is dangerous indeed. "We've been left behind" is an emotive claim, and the resentment it stirs is easily manipulated by people in power, or right-wing populists who try to play one group against another— farmers against environmentalists, urban against rural, old residents against newcomers. The question is this: How can we develop prospects *in* and *for* rural areas that take into account eco-social criteria we have neglected, *while* bearing in mind that the countryside—both in our own backyard and globally—is no idyll, no unplugged retreat, but an economic battlefield?

Our metropolitan lifestyle is based to a great extent on ever faster forms of resource extraction, especially from rural areas. There is a direct link between an imperial lifestyle in the urban centers of the industrialized Global North and the violent processes of transformation we increasingly see all over the world, from the devastation of rainforests, to the industrialization of agriculture, to the profligate use of pesticides. We are locked in a brutal logic that views rural and natural areas as a resource rather than a web of eco-social relations. Hence, the rapid destruction of natural habitats (which happens to trigger pandemics) and the destruction of millennia-old ways of life specifically adapted to and closely intertwined with specific ecosystems.

Neither artistic nor scientific circles have managed to put these processes into words and images we can identify with—which is to say, into words and images that consciously refute a glorified notion of

"pure untouched nature" and its populist-fascist connotations. We need such words and images, especially here in Germany where the "blood and soil" ideology of the Nazis once invoked German's purportedly innate "Aryan" relationship with the landscape.

Historically speaking, the brutality of "sacrificial zones" is nothing new. Brutality is, arguably, the defining principle of any form of colonialism—also in the Global North. Marion von Osten's poem *Das Land* addresses colonialism in Europe from the Middle Ages to the Modern age, and she reads the expropriation of commons as a form of colonial expropriation; just think of the Peasants' Wars or, in the context of England, the Enclosure of the commons, which Marx described as a prototypical example of primitive accumulation. It was the Enclosure that first robbed people of their relationship to the land and the option to live from subsistence farming alone. A now landless peasantry was driven to sell their labor power in the cities instead. (For a perfect emblem of how historical violence in rural areas is forgotten, see Albrecht Dürer's design for a memorial to the Peasants' War: a column with a seated peasant stabbed in the back. It was never built.)

These days, an urban growth discourse arrogantly claims that people move to cities because they're so wildly attractive: hence, the housing shortage. In fact, people are actually forced to flee to metropolises because structures in rural areas are being destroyed—social structures, economic structures, and, with the climate crisis, the ecological structures that ensure the basic conditions of survival. It is predicted that in the short term at least 20 percent of the present world population will be affected by rural areas becoming uninhabitable due to the climate catastrophe; up to one billion people will need to flee the place they live. This is also a global justice issue of unprecedented scale, since we know that climate change's causes lie primarily in the Global North while its consequences will be disproportionately felt in the Global South.

There is a brutality to all this that is perfectly epitomized by the reconstructed palace housing Berlin's Humboldt Forum. Colonial history is not only refuted here but perpetuated, along with the Western claim to an exclusive right to interpret history. Protests were sparked in August 2020 by the inscription around the dome: "That at the name of Jesus every knee should bow, in heaven, on earth, and under the earth." The Castle celebrates the colonial history of the German Empire as well as that of Prussia itself, a state built on the nobility's rule over rural life. Restored palace facades and renovated country houses show that the elites, who carry out such restorations, have no interest in remembering historical violence or the demands for repair and reparation that follow it.

Prussian nobility enjoyed feudal rights until the November Revolution of 1918. The ruling barons, the Junkers, were the police and judiciary rolled into one. Serfdom was able to persist for a relatively long time, with people bound to the land and coerced into unpaid labor. The radical division between rural labor power and the ownership of rural property was further entrenched in the GDR during collectivization. Despite notional collective ownership, there was a strong separation between the land and its putative owners. The current financialization and precarious wage labor structures in agriculture have once again accelerated this process.

In conclusion, I would like to refer to a perspective concerning property rights that has emerged from the Global South that we can perhaps learn from. We in the Global North must fundamentally call into question our idea of property. Until now, we have taken it to mean people's right to exploit certain territories without constraint. In this regard, we have much to learn from Indigenous Peoples' struggles, such as those in the Amazon, or the Standing Rock Sioux Tribe's fight to stop pipeline construction and, by extension, fossil fuel extraction. Indigenous people view humans not as owners of property but stewards of land, who are charged with protecting the web of life the land sustains. They understand that the role of those who live in a given place is to maintain and guard its specific ecosystems—water, biodiversity, soil fertility. By comparison, the rapeseed, maize, and spruce monocultures which characterize large swathes of eastern Germany are both ecological and social deserts: they create highly dangerous political vacuums. We must develop a new relationship to the land other than these entrenched forms of environmental destruction, relationships that enable true regeneration—a completely different kind of reconstruction effort. Reconstruction work must be geared toward the restoration of biodiversity and a comprehensive rethinking of life in rural society.

A Landscape Study

Katya Sander

This text is part of a larger study of landscape, tracing historical modes of rural land ownership. Artists have studied landscapes for many different reasons, from depicting a landowner's view over his estate to celebrating national spirit. Rural landscape studies, however, are usually carried out by conservationists, biologists, birdwatchers, and statisticians more often than artists. My own study addresses the economic model(s) used to administer land, asking how ownership becomes visible in a landscape.

Unlike urban land, which is zoned for business and residential use, rural land is zoned to grant landowners specific rights, mainly related to farming or extracting resources from beneath the land's surface. Land rights mostly concern what, when, and how an area of land can be made "productive," and how much it can be altered in the process.

My case studies are from northern Europe. Some go back over a 1,000 years but are still visible in local landscapes today. In fact, the kind of private ownership we take for granted today is less than 200 years old, and perhaps not as self-evident as we think. I am interested in studying this for several reasons, one of which is pedagogical: to learn to see these structures as manifestations of specific forms of economic thought and, perhaps, also in order to imagine them differently.

With the concentration of rural landownership soaring globally, there is currently a growing interest in revisiting prior models of ownership and in inventing new ones. "Land" is not just a matter of square meters and zoning laws. Scratch the surface and you already see that one patch of soil is very different from the next. The plants, worms, insects, and small animals that live there, the history of what grew in the wild or was introduced through cultivation—the network of roots, the layers of sand, clay, minerals, rocks, the flow of groundwater, etc.—all make for very different kinds of land and landscapes. But within our current economic system, we do not learn to understand this layering—not without hands-on experience in working the soil ourselves.

Scottish Highland Clearances

In today's Scotland, "run rig" (also known as runrig, run-rig or rig-a-rendal) patterns point back to a onetime collective economy of farming, swapping, and sharing land. Since the early Middle Ages, clans were the main social unit throughout the Scottish Highlands. A clanship meant protection, shared work, and organization under a clan chief, as well as access to agricultural land. In return, the members of a clan offered their services (e.g., military service) as well as rent, often paid in kind, to the king. The basic farming unit was the *baile* (or *township*), comprising an area of cultivable "*in-bye*" land, and a larger area of common land for livestock grazing. In-bye land was divided into strips called rigs, which were intensively farmed and periodically reassigned among tenants of a township so that no individual would have continuous use of the best land. A township of this kind would typically harbor four to twenty families.

Rigs, surrounded by common areas for grazing cattle. Illustration by Katya Sander.

In 1606, King James I sought increased control over the Highlands, offering clan chiefs ownership of the land they otherwise only oversaw. The charters that formalized this transition to private ownership addressed clan chiefs as *landlords*, rather than *patriarchs* administering limited resources between clansmen. Thus, chiefs began to see their fellow clansmen as mere tenants, obliged to pay rent or face being evicted.

Over the next century, the Highlands were supervised by the king with increasing ease, and—as of 1707—they played an important part in the agricultural revolution that marked Scotland's union with England. Tools such as the English plough (a wider plough than the single shard) were introduced, along with the sowing of foreign crops such as rye, clover, and potatoes. The land was soon more efficiently farmed than it had been under the run rig system, an efficiency largely ascribed to the process of privatization. Soon, commons historically used for grazing came to be considered "wastelands," to be privatized by means of "enclo-

sures"—depriving commoners of their ancient right to the use of this land. Agricultural efficiency aside, the value of enclosed land increased substantially. Commoners protested these enclosures, and some of the ensuing riots later came to be considered historical—to say nothing of archetypal—social protests of the early modern age.

Nonetheless, enclosures steadily displaced the run rig system of free pasturage, and from 1750 to 1860 a significant number of Highland tenants were evicted—to the benefit of well-capitalized sheep farmers, who rented the land at higher rates. Concurrently, the Industrial Revolution led to an increased demand for workers along the coast and displaced farmers were offered tenancies on small parcels of land in new "crofting communities." Since these parcels did not provide enough to live from, farmers were forced to seek employment in the fishing, quarrying, or kelp industry.

Coastline with new crofting communities—each land parcel was now only for private use, on less fertile land, and insufficiently productive to fully support a family. Illustration by Katya Sander.

Prior to these "Highland Clearances" less than three centuries ago, clans had used the run rig system for almost a thousand years. The fundamental right to use land across clan territory was never written into Scottish law and was abandoned by the clan chiefs themselves, as they began to think of themselves as commercial landlords who owned land rather than overseeing how it was used. Still, run rig patterns are even today clearly visible as stripes of long depressions (with ridges running in parallel) across large parts of the rough coastal landscape.

Old run rigs, fertile strips of formerly cultivated land, Loch Eynort, Isle of Skye. Photo © Adam Ward (cc-by-sa/2.0)

The Enclosure Movement of Denmark, and the "Great Parcellation"

Throughout much of Europe, the Black Death drastically depopulated the countryside, and from 1300 onwards—up until the agricultural reform of 1788—around 90 percent of Danish farmland was run by cooperatives, under premises not unlike the run rig system. This historical period is called the "time of the *village-commune*," where families farmed single strips of land on different fields all around the village. Technically, a landed proprietor appointed by the king would be in charge of the land. However, since the Black Death had drastically decreased the labor supply and proprietors needed healthy labor to cultivate their land (and soldiers for their militias), it was in a proprietor's interest for these villages to support themselves, to live and to thrive.

Village-communes consisted of five to twenty buildings situated around a large pond used to water fields and meadows. The crop meadows were used for seed (barley, oats, or buckwheat), tended by the community as a whole, watered from the village pond, and fertilized with cow manure. At least a third of these meadows always lay fallow. On poor soil—e.g., in the sandy parts of Jutland—only half were ever cultivated at a time. Surrounding the crop meadows were the less fertile common pastures used for grazing.

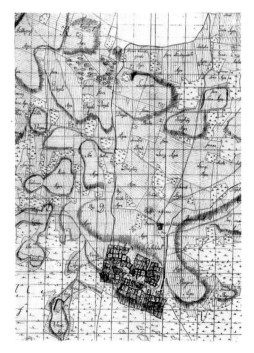

A map of Asminderoed Sogn and the acreage around it. Image produced around 1910 by a teacher at the local school, Christen Johansen (1859–1927). Stored in Fredensborg lokalhistoriske arkiv.

A third layer—the outer belt—offered common grazing land for less valuable animals and areas of forest, mainly of oak. In fall and winter, pigs were kept in the forests, feeding on acorns from the forest floor. (In "The Pigs,"—"Svinene," from the book *I Sverrig* (1851)—Hans Christian Anderson famously wrote about "Acorn Bacon," still a Christmas delicacy in Denmark.) To ensure that no single family enjoyed the best soil, the crop meadows were partitioned into "strips" (*agre* in Danish, or *Agraren* in German) allotted according to the size and need of a given family. Some farms had up to a hundred acres, distributed in strips all around the village.

It was impossible under such a system to work as individual family units, since individual plots of land were not wide and could run the full length of a field (see image above). Each family did have its own tools and worked its "own" strips when it came to tasks like weeding. However, for the purposes of ploughing, seeding, and harvesting, they were forced to work together.

In the late eighteenth century, the "Holstein" method slowly took over, which allowed for the soil to recuperate even while being cultivated. A year of lying fallow was followed by three to six years of grain cultivation (winter grain, then spring grain), then peas, and, finally, a year of grazing. This budding interest in agricultural reform was due to population growth, but also new ideas from France pertaining to the abolition of slavery and feudalism. At this time, King Christian VII was ill, purportedly with schizophrenia, and Denmark was, in effect, ruled by his personal doctor, who happened to be very open to ideas from France—so much so that he was later executed by the gentry. In a way, however, the gentry continued his project of modernization in that they secured their labor force by binding local farmers to the land through ownership. Meanwhile, new types of grain, especially from England, made it financially tempting to hazard the risk of cultivating larger plots of land, convincing many farmers that they would indeed benefit from new types of property relations. Many also appreciated the idea of owning their land, employing tenant-farmers instead of working for a landowner themselves.

Following the end of serfdom, the Danish land-use reforms of 1788 aimed at unifying the narrow strips of land into continuous areas that a farmer could work independently from other villagers. The strips were carefully measured and new continuous areas were defined: these allotments no longer circulated between families but were privately owned and continuously used by a single family.

High demand for meadows closer to infrastructure such as ponds and barns resulted in some villages adopting a star-shaped system for the surrounding fields. If there were too many farms in any one village,

new fields had to be shaped into square blocks, with some farms moving to the outskirts. Entire buildings were disassembled and relocated, with the whole village helping out in reassembling a building at its new location. As life on the edges was lonely and hard—the land being less cared for, less valuable, and less prestigious—surplus land had to be thrown into the bargain to entice families to move there. This practical work of finalizing land redistribution was tedious and took many years. Newly claimed fields were slowly freed of stones and other obstacles and marked with fences or stone walls. New roads were built to each farm, and new canals were also dug for irrigation and drainage. After a decade, only 10 percent of all Danish villages had implemented these reforms; it took half a century more for everyone to follow suit.

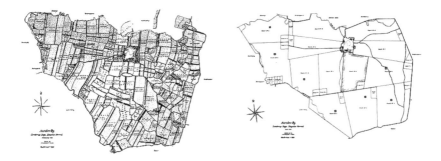

Above are two maps of Aarslev village. The first is from 1768, prior to the reforms, and shows close to a hundred different acre strips spread over the area of the village that were farmed by "farm number 5" (marked in black). The second map dates from 1795, following the land reform measures. Each farm now owns a cohesive plot of land, on which the farmhouse and stables are placed, with only a few farmers remaining around the pond of the old village. Seven out of thirteen farms have moved away from the original village and as compensation have been awarded access to peat and an extra "house-man plot" (a vegetable garden for hired hands), making the farmer both landowner and landlord.

Over the following century, a village was typically comprised of farms at a remove from one another, with each family working for itself, producing grain and raising animals. From the perspective of king and gentry, these families were now competitors, not collaborators. They would maximize efficiency themselves—and taxes, too—without intervention or compulsion from an external force. This "Great Parcellation" ended a system of collaboration that had existed for over 500 years. Though the differences to the Highland Clearances are obvious, in both cases we see

the introduction of widespread landownership, partly as a response to new political ideas and partly in the name of efficiency and state revenue.

The new farmer-landowners soon learned that dairies and slaughter-houses—most often owned, it is worth noting, by the landed gentry who only recently had been the peasantry's landlords—heavily overcharged them. Smaller farms were unable to afford such infrastructure—a larger conglomeration was needed to share investment and risk among its members. This mechanism for distributing risk and pooling capital led first to cooperative dairies and slaughterhouses and then to an entire movement, which grew exponentially and soon included consumer organizations and, from the 1900s onwards, housing, retail, and banking collectives. The Danish cooperative movement (Andelsbevægelsen), which first emerged in rural communities in the 1790s, came to play a profound role in the development of farming, leading to a considerable increase in wealth for the average Danish farmer. Heavily inspired by the British *Rochdale* system, Andelsbevægelsen ideas were introduced wherever Danes settled, including the United States. Examples of the movement's legacy include the two rival dairy conglomerates of the 1950s, Mejeriselskaberne Danmark and Kløver, who later merged into what is now Arla Foods, which today controls nearly the entire national milk market and is a huge international player in food production. The Danish Crown meat processing company also owes its existence to the cooperative movement, as do windmill farms, and the "coop" supermarket chain. The latter boasts 1.4 million members as of 2017.

Denmark Today

Today, over 80 percent of Danish farmland produces animal fodder. There are 12.3 million pigs in Denmark and less than six million people. According to the UN, Denmark produces more meat than any other nation—368 kg per head—most of which is raised for export. It takes 7 kg of grain to produce 1 kg of veal, and 4 kg of grain to produce 1 kg of pork. (It also takes large amounts of land to produce the grain to feed the pigs, whether in Denmark or South America, where much of Denmark's pig fodder is now imported from.) Thus, the sheer size of farms has grown steadily over recent decades, while the number of individual farmers has decreased.

Most of the yellow rapeseed fields covering the countryside in the summer are used for feeding pigs, but also for heavily subsidized bio-fuels. "A yellow desert" is how one farmer described the fields surrounding her house. This particular farmer's son didn't want to take over the farm, even though he had studied agronomy; since the financial crisis

of 2008, the farm was too indebted for him to freely choose which crops to cultivate (rural land had soared in value before the crisis and many farmers had taken out loans they could no longer afford to service once prices plummeted).

Generally speaking, an increasingly wealthy population usually leads to cheaper foodstuffs, with food representing a diminishing part of total consumption as a society grows richer. Food prices don't follow the overall financial trend. Thus, producers must either find new ways to maintain income levels or import food from abroad. The idea of scalability has now been prioritized for decades: the bigger the farm, the more efficient it supposedly is. Policy-makers, banks, and credit institutions have supported this growth in size, prompting a steep increase in land prices—to the point that aspiring young farmers will never be able to buy farmland, and those farmers still in business are aging rapidly. In addition, farmland is increasingly being bought up by national and international investment companies, who rent it to young farmers who then work their land with hired help—often from Poland, Romania, or Bulgaria. The Danish press regularly runs stories of camp-like living quarters for workers stuck in a legal grey zone. During the COVID-19 pandemic, such workers obtained "essential worker" status to prevent large parts of EU agriculture from collapsing. Even Prince Charles urged Britons to volunteer as harvest-helpers. If anything, the lockdown has proven the West's structural dependency on migrant labor.

From strips surrounded by common grazing land, to parcellation, to increasingly concentrated forms of ownership, with homogeneous crops cultivated over large areas, leaving many farmhouses uninhabited. Illustration by Katya Sander.

Andelsgaardene (Co-op Farms)

Andelsgaardene is a co-op founded in 2018. Its aim is to remove farmland from circulation within the investment economy, allowing young farmers to farm according to principles that are not profit-oriented. Taking property out of circulation in this way entails deleting value, causing a loss of capital. Membership in such co-ops are used to cover this deficit. But membership in most co-ops that own real estate also includes holding shares which may rise or fall in value over time. In order to prevent speculation, *Andelsgaardene* offers only membership in the organization, with no shareholding allowed. It is the organization that owns the property, not the 1,500 members who pay a twenty-euro monthly membership fee and define how the property is run.

These farms do not rely on low-paid seasonal workers. When help is needed, members are asked to join in for a day or two at a time. Many members live in the city and consider these workdays as a way to connect with their families as well as the food they consume. And although young farmers rent both the buildings and the land from Andelsgaardene, the rate is set very low so long as they implement a particular set of "values". The way Andelsgaardene is set up, prospective farmers must apply for a farm by giving a presentation about how they will run it. Thus "value" is understood in a particular way, defined by adherence to sustainable agronomic principles rather than capital, and the "highest bidder" is the proposal that members find coheres most closely to Andelsgaardene's principles, as well as the conditions extant on a particular farm. Thus, different farms might be won with very different sorts of proposals.

Currently, Danish agriculture produces 20 percent of the country's CO_2 emissions. One of Andelsgaardene's aims is to bring down CO_2 emissions, producing food sustainably. Admittedly, measuring "sustainability" solely in terms of CO_2 emissions (tied to food production) is a contested notion. Andelsgaardene asks its farmers to experiment with ideas and principles in relation to prevailing conditions on their *specific* farmland parcels, allowing them to learn from each plot on its own terms rather than imposing a uniform model: *this* place, *this* soil, *this* history, *these* conditions. Farming is thus understood as a process of learning from the soil and its immediate surroundings.

Lerbjerggaard, Melby

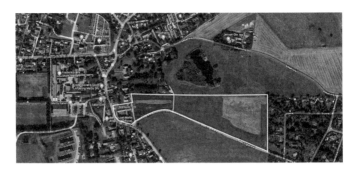

Lerbjerggard

In 2019, Andelsgaardene bought its first farm. Lerbjerggaard (once a potato farm) is in Melby, a village northwest of Copenhagen, whose five hectares make it too small to qualify for EU subsidies. Lerbjerggaard is run by Anna and Christoffer (twenty-seven and twenty-four years of age), who both studied ecology and farming. Their first priority was to tend to the farm's depleted soil. One key question for Anna and Christoffer is how much CO_2 the soil can bind and contain. Another is how to produce food for those living close by—not just for organic grocers in the cities. A third priority is educational: how to enable city dwellers to develop a closer relationship to the countryside and to food.

Anna and Christoffer have set aside half of their five hectares for rewilding. They planted nuts, berries, and 500 fruit trees on 0.6 hectares (two pigs graze beneath the trees), and they grow vegetables on 0.8 hectares. The latter area is divided into eight smaller meadows of sixteen beds each for crops from the same vegetable family respectively—e.g., cabbages, beans, and umbellifers. Every year they rotate the beds so that no crop grows in the same place two years in a row, thus helping the soil recuperate and preventing pests and vermin. All farm work is done by hand—sowing, weeding, harvesting. The width of an adult's legs spread apart determines the width of the beds.

At Lerbjergaard, we see a return of the striped landscape we know from the Scottish Highlands, as well as the long, narrow acres plots common before Denmark's Great Parcellation. It is a pattern directly linked to the scale and build of the human body.

The concept of this farm is not scalable: it cannot be enlarged, because the farmers' collaboration with the soil cannot be generalized. One farmer can learn from another, but only about specific problems and their possible solutions—rarely will there be only one solution for the same problem occurring in different places. Each farm is thought of as *deeply* local, a specific collaboration with the land, even if farmers and members collaborate across localities.

The Andelsgaardene co-op in general and Lerbjerggaard in particular helped me to concretize many of the questions about scale, labor, and sustainability that originally motivated my interest in looking at historical models of agrarian land ownership. This research, in turn, led me to ask whether it would be possible to change the idea of "ownership" as our primary relationship to land, moving away from the logic of extraction and toward a logic of collaboration or steward-

ship. How to be ethical gardeners rather than mere users? What economic system would allow for such a transition? What sorts of landscapes might appear in the process?

Pigeon Towers and Donkey Paths

Marion von Osten

A brand-new pigeon tower stands by the river Thames: the New Tate Modern in London. A brick building with small recesses and niches, and masonry reminiscent of brick expressionism, both a modern industrial building and a medieval pigeon tower. The building was designed by Basel-based architects Herzog & de Meuron in 2007 and was planned to feature a glass façade, which one year later was converted into a perforated brick façade enclosing an ornamental glass body within. From the outside, the building looks like the ideal nesting and breeding site for city pigeons: once at home in rock faces, in latter-day city settings they need cornices and niches to survive.

The city pigeon is actually a feral domestic pigeon, a farm animal used as a messenger as well as sustenance, before the American broiler chicken challenged its spot in the food chain. Today, it is, above all, a stray cat of the air, a feral animal that found its ideal home in cities of stone and making the most of *Gründerzeit* stucco, ornamental façades and wall crannies. Whooshing over our heads in swarms, in Venice they are to be seen in every photo, the epitome of a tourist picture trophy.

The pigeon flaunts so many connotations, good and bad, symbolic and emblematic, that you can fill entire books with it. Its excrements, said to be corrosive, are widely loathed, while in other segments of the garden market, the excrements of Antarctic penguins offer salvation for balcony fauna. Today, the pigeon is the only species in Germany to breed in and around buildings without enjoying legal protection. Bats have it better, though of course they are not feral, but dutifully tick all the boxes of the threatened wild animal worthy of protection. (Statistically, things don't look too bright for the pigeon either.)

None of which is the bat's fault. The blame lies with the hierarchical order as defined by human beings. They are the ones who have a problem with the stray dogs of Moscow, who shrewdly cross the city by subway, but also with any cats or pigeons who have escaped domestication. Current polls suggest that city dwellers associate many of their everyday troubles with fellow inhabitants such as crows and magpies, rabbits and

foxes, along with rats, of course, and show little interest in the species with which they share urban space today. Hygiene discourses, on a warpath with dirt and disease, do further disservice to those nonhuman city dwellers threatened with exile.

Over in London, one is not particularly pleased with the city pigeon either. The New Tate Modern's claim to be a pigeon tower is mere pretense. In fact, the architects went to great lengths to make the openings too small for pigeons to access. The openings in the outer façade refer to historical pigeon towers only symbolically; in reality, the façade does all it can to be a pigeon repellent. The New Tate Modern building, monument to contemporary art, unites everything contemporary art stands for today: global attention is garnered with enormous production budgets (the New Tate Modern boasts the biggest sponsoring project ever) and by quoting formats from a great diversity of contexts, but bereft of any genuine function. From a pigeons' perspective, the building perfectly epitomizes the gestural symbolism contemporary art and its architecture widely prefer: representing something one does not actually do.

The museum building in London is rooted in a long tradition of urban planning and architecture that expelled the animals the very moment they became obsolete. Up until the nineteenth century, cities were still the abode of farm animals—horse-drawn street carriages, along with backyard cows, pigs, and chickens shaped the everyday image of the city, even London's. Those sheds, dragoon areas, and royal stables have now become objects of land speculation and gentrification. And yet, modern city development discourses addressing the animal are of key importance to the enforcement of urban modernity itself.

As philosopher Fahim Amir points out, this exclusion was already inscribed within the Athenian definition of the *polis*, as a place to which neither animals, plants, slaves, nor women have access, but in which only free *anthropodes* may hang around, in that know-it-all style of theirs, while the others toil away at the margins or are eaten wholesale. A vision not unfamiliar to modernism, as in, for example, Louis Mumford's introduction to the International Congress of Architecture "The Heart of the City". According to Mumford, the *polis* as a city ideal, is not a cluster of houses, but a meeting place and a place of public affairs, and therefore a place of government in and of itself. Mumford contrasts urban citizens with the existence of peasants, who are still subject to the cultivation of plants. According to Mumford, it is the tradition of the Greco-Roman city that has radically detached itself from the geobotanical cosmos. Mumford's ideal of the modern city deliberately turns its back on the

countryside "to free man from the communion of plants and animals," as he puts it. (Mumford 2000: 207)

The architect Le Corbusier also banned animal life from his vision of the modern city. In his 1925 text "The City of Tomorrow," Le Corbusier describes the city dweller as a purposeful being: "The human being walks in a straight line because he has a goal and knows where he is going. He has set himself the goal of reaching a certain place, and he is going there directly." (Le Corbusier 1967 [1925]: 11f.) An assumption that later drove the Situationists up the wall, and had them pit "traces" and "derives" against the modernist fantasy of order. Le Corbusier contrasts the figure of the purposeful human being with that of a donkey, which boycotts the modernist fantasy with its supposed inertia, laziness, and stubbornness: "The pack donkey wanders along, meditates in its absent-minded manner, and meanders to evade larger stones, or to facilitate the ascent, or to gain a little shade; it takes the line of least resistance. The path of the pack donkey is responsible for the map of every continental city." (Le Corbusier 1967 [1925]: 11f.) As a farm animal, the donkey embodies a whole range of headaches for Le Corbusier and his urban-architectural vision of a new human being. The donkey stands for the intricate, medieval, and Mediterranean urban layout, which does not follow planned grids but organic growth patterns, and which simply sidesteps a given obstacle instead of attempting to overcoming it by any engineering means necessary.

According to Cathrine Ingraham, for Le Corbusier, the donkey is the "recurring figure of resistance to modernity and of decorative *froufrou* and dilatory historicism." (Ingraham 1998: 65). While according to Fahim Amir the donkey, a disorderly pack animal, becomes the saboteur of Le Corbusier's aesthetic politics of the straight line, methodical and abstract. This imago of an orderly, purified, and sanitized city, bereft of any species but the *anthropos* itself, brings with it the streamlined animal slaughterhouses, the mechanization of food production, the industrialization of agriculture and factory farming, but also the petting zoo, the zoo-at-large, the hamster wheel, the guinea pig cage, and the terrarium. The violent fantasies and practices inherent to this system are mirrored in our fortified building façades, with their arsenal of quasi-military samizdat—nets, spikes, acoustics, predator dummies, dazzling mirrors, and electric shocks.

The fact that the human animal has always created new habitats for nonhuman animals, through its buildings, houses, bridges, and towers, remains an utterly subconscious, hidden reality. Think of the Norway rats in our sewers, the sparrow colonies on our roof tiles, or

modernist columns serving as fox shelters. In Hamburg's Hafencity, real estate prices are falling, as the many glass façades along the Elbe—an ever-shimmering source of light, and therefore a perfect attraction for insects—have become home to an armada of spiders which residents can no longer control. Ideal for spiders, bad for rentals.

It's astonishing that neither architectural discourse nor political theory has paid much attention to nonhuman animals as spacemakers and city actors—in the sense of Donna Haraway's concept of "companion species"—along the lines of an interspecies relation beyond containment and sadistic dominance.[1] This despite the introduction of animal protection laws as key leitmotifs in postcapitalist efforts and struggles. As in, for example, the Hermit Beetle leading to a short-term halt of the Stuttgart 21 development, or the horseshoe bat—also known as "Hufi" —playing a similar role at the Dresden Waldschlösschenbrücke, or the many other construction blockades at the hands of environmental authorities, the new harbingers of investment horror and profit loss. The Hermit Beetle of Stuttgart now has its own website (eremit.net), and a reader of the *Stuttgarter Zeitung* daily demanded that the beetle be awarded the Nobel Peace Prize, since it achieved what so many protesters have been unable to do. The beetle was indeed successful because it didn't only crawl around in trees but at the very edges of our legislation (life is sweet in prime locations such as the Stuttgart palace gardens).

Studies have shown that the marked increase of wild animal migration into urban areas is due to a variety causes. Animals are losing their habitats in the monocultures of industrialized agriculture, and food supply in the city is decent by comparison, if not better. This is not only on account of overflowing garbage cans, as is often claimed, but of the many parks, gardens, wastelands, abandoned ruins, construction sites, countless snack bars, and food festivals, as well as our city architecture itself. In fact, for a variety of different species, a city is a decent habitat thanks to its nuanced spatial diversity, those many historical architectural phases and building types.

For the kestrel, a house can't be high enough. It loves the updrafts in the gorges of New York and even nests in balcony boxes. Other animals remain in the city because they are not hunted there. According

1 Donna Haraway is a biologist, science historian and feminist philosopher of science. In her writings, she questions the fixity of categories such as "human being", "nature", "technology" or "gender." Her *Companion Species Manifesto* deals with the implosion of nature and culture in the joint life of dogs and people who are connected through their "significant otherness." She uses the term "companion species" instead of (domestic) animals, as humans, being historical and social organisms, are affected by many species that do not fall into the animal category, such as insects and bacteria.

to a study in Germany, deer increasingly settle on the outskirts of cities where hunters do not get to them. Sometimes, industrialization itself is the starting point for a better habitat, as in the case of the sand lizard, for which there could be no better place to settle than a railway track, with its hot sand, gravel beds, and staggered side tracks.

But all these many examples cannot hide the fact that the very future of the wild animal is at stake: whatever doesn't go extinct is being eaten, usually by us humans. At the same time, with new urban developments and new animal protection laws, a new constellation of habitats has emerged, one that favours new forms of cohabitation. New forms of coexistence are already a reality. However, the new legal situation has also established a new hierarchy of protection, one that continues to hunt down city pigeons, even as it protects coal titmice.

Setting aside the hands-on interventions within existing habitats, the above also implies a new spatial discourse and a new approach to building design, both of which became noticeable on the fringes of the "Animal-Aided Design" conference in January 2019. On the one hand, one noticed a problematic contrast between the idea of "target species" and a general normalization of animal protection in building laws. On the other hand, housing cooperatives now combine postcapitalist goals with new green spaces and with façade innovations in the name of animal protection, thereby inventing entirely new fields of activity for themselves. When an Ingoldstadt housing cooperative collaborated with immigrant tenants on hedgehog tunnels, bee hives, and sparrow colonies, the euphoric applause suggested a new way of becoming human, and becoming animal at that.

Can we also think of human relations as relations between species (beyond the known concepts of ecological diversity)—as a condition without which humans ultimately cannot exist? According to Anna Lowenhaupt Tsing, human exceptionalism has blinded us to the manifold interspecies relationships from which we ourselves have emerged. Lowenhhaupt Tsing critically suggests an idea of human supremacy that modern science has inherited from the great monotheistic religions, and which to this day regards human autonomy and the control of nature as a given.

One of the many limitations of this heritage is that it considers the human species as autonomous, i.e. as a constant throughout culture and history. The notion of being the dominator of all other species has been instrumentalized among social conservatives and sociobiologists in order to support the most autocratic and militaristic of tropes, from

the alpha animal to the natural pecking order. In its place, Lowenhaupt Tsing calls for thinking and acting within and through the interdependence of species.

Relations between species have historically shifted continuously between different types of dependencies. The idea that humans can only evolve in relation to other species—i.e. through different forms of interaction and cooperation with other species around them—may in turn lead to new forms of politics and subjectification, far from neoliberal individualism. This approach would help us understand nonhuman animals as spacemakers with whom we live together, and to whom we owe not only construction delays but also the very possibility of shaping our living spaces for a diversity of users, beyond pure exploitation, speculation, and utilitarianism. Solidarity with the city pigeon and the struggle against its expulsion could in turn suggest that other stray, precarious, grimy city dwellers equally have a right to temporary housing, to social relevance, and respect. It could imply that it is indeed unacceptable that human and nonhuman animals are being displaced and persecuted—when all they need is protection, care, and autonomous, uncontrolled places. To think of the city as an interspecies relationship is to throw the separation of nature and culture into the garbage dump of history and to instead think of wastelands, ruins, foxhouses, and skyscrapers as interdependent urban spaces. As Donna Haraway insists, to think and act in our present time is to turn the socioeconomic and political contradictions of the modern city on their head. Interspecies spaces are created precisely to test new modes of subjectification and solidarity; after all, we already live together anyway.

Bibliography

Amir, Fahim (2018): *Schwein und Zeit, Tiere, Politik, Revolte. Edition* Nautilus, Hamburg.

Haraway, Donna (2003): *The Companion Species Manifesto. Dogs, People, and Significant Otherness.* Prickly Paradigm Press.

Ingraham, Catherine (1998): *Architecture and the Burdens of Linearity.* New Haven: Yale University Press.

Lowenhaupt Tsing, Anna (2018): *Der Pilz am Ende der Welt: Über das Leben in den Ruinen des Kapitalismus.* Translated by Dirk Höfer Matthes & Seitz, Berlin.

Mumford, Eric (2000): *CIAM discourse on urbanism, 1928-1960.* Cambridge, MA: MIT Press.

Was ist das Land?

Infrastrukturen die den Wachstum der Großstädte ermöglichen.
Berlin. Neu angelegte preußische Straßendörfer für Kolonisten,
je ein Weizenspeicher am Ortsausgang.

Wohnstätten für Tagelöhner aus billig gebranntem Ziegel, Wirtschafts-
raum, Feuerstätte, Wohnraum, ohne Bad, Schlaf- und Kinderzimmer,
kleiner Vorgarten, ein Stall zur Subsistenz. Im Strassendorf Untertanen-
häuser für je zwei Kolonistenfamilien mit Hof, Wirtschaftsraum, Scheune,
Stall, dahinter ein kleiner Acker.

Mägde und Knechte, Erntehelfer, Tagelöhner, die unfreien Arbeiterinnen
aus den Vorwerken und Rittergütern wandern ab in die Fabriken. An den
Rändern der Stadt ist noch fast Land. An der Spree legen Kohleschiffe an.

Was ist das Land?
Eine Apfelallee in Blüte im Frühling, Maulbeerbäume gepflanzt zur
Seidenweberei im 18. Jahrhundert. Gutshäuser die schon an Manufak-
turen erinnern, Vorboten der Industrialisierung.

Siedlerkolonialismus: Ausweitung
Inbesitznahme der ostelbischen Gebiete auf dem Weg ostwärts:
Trockenlegung der Sümpfe, Rodungen, Plünderungen, Schlachtfelder.

Das Land wird zum Grundbesitz. Erst die Kirche und ihre Kriegsritter.
Die slawische Bevölkerung wird nach Osten verdrängt. Adelstitel zur
Vergütung für Inbesitznahme neuer Territorien. Landnahme durch eine
aufsteigende Klasse. Frohnarbeit ist Sklaverei.

Entrechtung und Besteuerung der autonomem Städte und freien Bauern.
Berlin wird Residenzstadt mit einem Hofstaat. Dort regiert nun ein König.
Allgemeingut wird zu Großgrundbesitz, bis nach Königsberg.

Was ist das Land?
Der Regen der über Felder peitscht, ein Gewitter am Horizont? Das Land
als großräumige Anbaufläche, zu Wald- und Jagdrevieren, Gutshäusern,
Parks und Schlössern umgestaltet. Aufteilung, Vermessung, und die Aus-
beutung der Böden für die Produktion großer Getreidemengen beginnt.
Die Plantage wurde nicht in Übersee erfunden.

Was ist das Land?
Die Lerche über den Kornfeldern. Das Dammwild auf der Lichtung.
Die Wanderung an der Havel. Der Hofladen mit regionalen Produkten.
Der Rückgang der Artenvielfalt. Der Anbau von Cash Crobs, Biosprit und
Futtermittel. An den Feldern warten überdimensionierte Mähdrescher
und die Erntehelfer aus Osteuropa auf ihren Einsatz.

Leichen schwimmen im Landwehrkanal. Die Politik des Großgrundbesitz
wirkt bis in die Novemberrevolution, verhilft zum Aufstieg der National-
sozialisten zum Einmarsch nach Osten. Vernichtungskrieg. Genozide.
Unter den Alleen stapeln sich die Kadaver der Militärpferde.

Was ist das Land?
Der Preis für Agrarprodukte an der Börse? Die EU-Subventionspolitik
großer Anbauflächen. Spekulation mit ehemaligem Volkseigentum.
Nach 1945 – Forderung nach Bodenreform. Man fordert: freies Land für
freie Bauern: Junkerland in Bauernhand.

Was ist das Land?
Großgrundbesitz in neuer Dimension. Spekulation mit Wald- und
Anbauflächen durch internationale Holdings und Finanzunternehmen.
Kaum ein Wirtschaftsbereich der Welt ist so intransparent wie der des
Grundeigentums.

What Is Land?

Some glorified figment of urban dwellers' imagination,
A counterweight to city life, the day trip destination, the cycling tour—
a memory.

Or the city's pantry: wheat, oats, rye, potatoes,
carrots, cabbages, meat and milk …? The Scheunenviertel,
granaries, agricultural infrastructures are the powerhouse of urban
expansion.
Berlin: newly created Prussian colonists' villages of stone, a granary at each
gateway to the city.

Dwellings for day laborers made of cheaply fired brick, handlooms
and hammers, a fireplace, a living space; no bathroom, bedroom, nor
children's room, but a small front garden, a sty for subsistence. In the
straggling villages, two families of colonists eke out an existence in each
of the subordinates' roadside houses, with a backyard, barn, stable, and,
beyond, a small patch of land.

Maids, servants, harvest hands, and day laborers migrate to the factories
along with indentured workers from the outlying estates and manors.
The city margins are still almost rural.
Coal ships on the Spree are coming in to dock.

What is land?
An apple tree-lined avenue blossoming in spring, mulberry trees
planted for silk weaving in the eighteenth century, and manor houses
which have long since had manufacture in mind:
harbingers of industrialization.

Settler colonialism, expansion,
expropriation of the Eastern Elbe region.
On the trek eastwards, marshes drained, forests felled,
rape and pillage on the killing fields.

The countryside becomes landed property. First the church and its battle
knights hound the Slavic population eastwards, seize possession of new
territory. The reward is an aristocratic title.
Land grabs by an ascendent class. Corvée labor is enslavement.

Autonomous cities and free farmers are disenfranchised and taxed.
Berlin is a royal seat with a royal household. A king rules there now.
Common property is conquered: nothing but large estates, as far as
Königsberg.

What is land?
The rain whipping over fields, a thunderstorm on the horizon. Land
turned over to cultivation, forestry, hunting, manor houses, castles, and
parks. Land partitioned, surveyed, and exploited to set in motion the mass
production of grain? The plantation was not invented overseas.

What is land?
The lark above the cornfields. The fallow deer in the clearing.
The hike along the River Havel. The farm shop with regional products.
The decline in biodiversity. The cultivation of cash crops, biofuel, and
animal feed. Oversized combine harvesters and Eastern European
harvest hands awaiting their deployment in the fields.

Corpses afloat in the Landwehrkanal. The policies of big landowners
remain in force until and after the November Revolution, fostering
the National Socialists' rise to power and the annexation of the East.
War of extermination.
Genocides. Carcasses of military horses piling up under the avenues.

What is land?
The price of agricultural products on the Stock Exchange? EU subsidies
for large tracts of agricultural land. Speculation with onetime public
property. After 1945—demands for land reform. *Free land for free farmers,*
people cry. *Put Junker land in farmers' hands!*

What is land?
A new dimension of ownership. Speculation with forestry and
agricultural land by international holdings and financial companies.
No sector in the world is as economically opaque as real estate.

"What is Land" is not exactly a translation of "Was ist das Land" – rather, the two should
be considered two distinct versions of the same poem.

To "Conquer a Province Peacefully"?
How the Seizure of Land on the Rivers Oder, Netze, and Warthe Drove a Government to the Brink of Ruin

Simone Hain

The following essay draws on a prominent historical case study from the Central European "Amazonia," in that part lying between the Oder and Vistula rivers, to trace social struggles and conflicts during Prussia's land reclamation process. Until now, in the royalist German historiography tradition the event is still celebrated as a peaceful colonization and repopulation campaign in the wake of the Silesian War. In truth, and thanks to one exceptional source I have drawn from,[1] it can be better understood as coming close to triggering a monumentally destructive popular revolt. I came upon this source by chance at Kulturzentrum Rathenow and have based this brief planning history upon it. This essay was originally focused on the intellectual biography of David Gilly, an architect of Huguenot origin who became a kind of system builder for the discipline as a modern field of knowledge and social commitment.[2] However, over time it changed to become an examination of the extraordinarily violent capitalization of a primeval landscape, its Wendish villages and monastic estates, and the many victims this process claimed as an instructive example of the "process of civilization" and "state-building," marking the long-term impacts on the Prussian collective mentality. I hope to indicate how sharp social conflicts and reactive learning processes work and how they can influence the accumulation of cultural capital within a society, too.

During the restless and destructive events of the 1760s and 1770s, the survival of the Prussian state came to depend upon it being perceived by its subjects as a guarantor of the common good and bearing a responsibility toward society at large. It is within this high-stakes context that

1 Friedrich Heinrich Stubenrauch: *Nachricht von der Verwallung und Urbarmachung der Warthebrueche*, Berlin 1787, see also the indexical manuscript *"Interessenten"* at the Kulturzentrum Rathenow library (residual library collection of the former Gymnasium Rathenow, following wartime damage)
2 See Simone Hain, "Staat und Interesse", in *David Gilly: Erneuerer der Baukultur*, eds. Eduard Führ and Anna Teut (Berlin: Waxmann, 2008)

the land reclamation crisis introduced central planning of the national economy as a basic principle of state governance. But it also made a decisive impact on a phenomena we call Prussian *Sekundärtugenden* ("secondary virtues" such as punctuality and thrift) and *Bildungsbürgertum* (the "educated bourgeoisie"). It was during the crisis that the baccalaureate was introduced and scholarship became the supreme paradigm of political culture. In terms of economic transformation, as well as in terms of aesthetics and architecture, the period should be regarded as a first step into modernity.

Land reclamation in the river deltas of the Oder and Vistula occurred at a time when the region was still an impassable part of Central Europe, more fen and marshland than *terra firma*. The phrase of King Friedrich II ("Here I have conquered a province peacefully") quoted in the title is euphemistic, to say the least: "peacefully" is clearly a misnomer for the sort of land expropriation that transpired at the time. But it is still used to acclaim a supposedly God-given and now legendary government effort. In 1753, the King used the adverb to contrast state-led land grabbing on the Oder from war-driven occupation during the three devastating Silesian Wars. The real difference, however, lay in the creation of land by means of science, as well as brutality and force: the seizure of land as an enduring war against nature.

The initial megaproject known as the draining of the "Oderbruch" involved the creation of thirty-three new villages across 32,500 hectares, and was soon followed by even more extensive schemes. It has been lauded both as a "Faustian" bargain and the epitome of well-regulated and farsighted master planning. The famous closing scene of Goethe's *Faust* does indeed read: "if a raging tide gnaws to enter in by force / The common urge unites to halt its course." As I intend to demonstrate below, the idea of a "common urge" was rooted in rather recent developments.

Thanks to the memoirs of Dutch-born civil servant Simon Leohard van Haerlem and the German engineer Isaak Jacob von Petri, the two heroes of the Oderbruch amelioration, we know just how it feels when "raging tides" enter "by force," despite laborers standing shoulder to shoulder in defiance. We learn, too, of clear-cut conflicts of interest, and of saboteurs who repeatedly punctured the dams, ruining them by diverting water from their mills. We learn of Wendish farmers who defended their fishing rights from within "pumpkin fortresses." This all leads us to imagine that the Wendland (once home to numerous German farmers in a resilient Slavic territory, and today a well-known stronghold of the

antinuclear movement) has long been a site of resistance to intrusive land grabs. The lowlands and swamps, in particular, were never as deserted as one might imagine. Beginning in the early Middle Ages, when roving merchants and Christian missionaries first aimed to conquer those regions, it was a home to the "unruly unruled"—the stateless, the travelers, day laborers, drivers of pack animals, ferrymen, millers, hunters, beekeepers, and fisherfolk who constantly defended their ancient right to be beholden to none and live where they pleased.

Only in these nonarable marshlands did the age-old rights of access to common pastureland and timber still prevail—the *"stare prava"* (or *Allmende*) which peasants fought to defend during the Great Peasant Wars, the *Bauernkriege*, of the sixteenth century. Wends, Celts, and Illyrians persisted here, for the land had not yet been surveyed by a kingly landowner nor enclosed by the state or private interests. For centuries, locals continued to make a living from the water, the abundant game, and their expert knowledge of the few fixed pathways through the fens and marshes and the shifting currents of the rivers. Villagers farmed the land from barges; monasteries were engaged not only in pastoral care but also landscape conservation and in informal cooperative trade networks based on bartering natural goods. In eighteenth century reports like those of Stubenrauch, who wrote of the turmoil in the Oder marshes, we become privy to one of the last encounters with the indigenous peoples of Central Europe.

Every seizure of land is an intervention within long-established societal networks, whose value only becomes visible when under threat. Goethe's fight against the "raging tide"—the original German refers to "foul pools of water"—and the colonization or *Peuplierung* (referring to the planned settlement of an unpopulated or sparsely populated area) of untamed nature was an enduring theme in the eighteenth and nineteenth centuries. Given the organizational scope of the social engineering projects pursued by the Kingdom of Prussia, it did indeed amount to a major event in German history, with psychological, philosophical, and aesthetic consequences that continue to this day.[3]

To my knowledge, the social significance of the project, its legitimation and evaluation, has rarely been called into question by scholars of

3 The first COVID-19 lockdown in Germany was announced by the geoscientist Gerald Haug, president of the Leopoldina (the German National Academy of Sciences) and a man whose reputation rests on his research of CO_2 and climate change. His comportment was reminiscent of a moral dimension that once characterized German modernity and the political culture first demanded of the state in the late eighteenth century—on behalf of an ascendant middle class comprised of educated citizens instead of the inherited merits of the old feudal elites.

any stripe. Academics have been largely content with describing it. We lost sight of what this fundamentally anthropocentric project did to us, to our part of the planet, to even our collective neural networks. David Blackbourn's perspicacious book, *The Conquest of Nature: Water, Landscape and the Making of Modern Germany* (2006), was the first to highlight structural connections, in light of which the Rhineland—in this case the glacial alluvium of the Nordic Sea basin—emerges as one of Europe's own "Amazonias."

In reality, not for a single moment was this a peaceful project, even when undertaken in the spirit of rational engineering and clever land management, as the memoirs of Simon Leohard van Haerlem and Isaak Jacob von Petri attest. The human cost of reclaiming the Oder marshes were comparable to military campaigns of the time, though the true number of casualties will never be known. Censorship did an all-too-thorough job of preventing this, but a popular rhyme from the time reminds us of what the settlers went through: "*Die erste Generation hungert sich tot, die zweite leidet bittere Not, die dritte findet ihr Brot*" (The first generation starves to death, the second suffers bitter hardship, the third finds its daily bread). Such is the widely-acclaimed Oder marshes model in a nutshell: twenty-five years of hunger, twenty-five years of poor housing, illness, and debt, and then—even for the grandchildren—little more than scarcity. Importantly, the Oder marshes development scheme was not commercially driven but generously funded by the state. Its primary purpose was to compensate wartime population losses and secure Prussia with a steady supply of agricultural products.

By contrast, the Oderbruch's sequel project, that of reclaiming the area of Neumark (a region east of the Oder River assimilated into the Kingdom of Prussia in 1701) along the rivers Netze and Warta, was a case of rampant speculation that aimed for rapid returns on minimal capital investment: revenues for the King. While the first project on the Oder did benefit colonists to varying degrees, its sequel was a never-ending debacle. Technical planning was completed in 1762, after the conclusion of the Seven Years' War, and implementation began in 1766—only to drive Prussia to the brink of ruin and revolt over the course of the succeeding two decades.

The first generation of colonists starved to death within a year—none of the names of the first generation of colonists survived. After losing their valuable breeding animals and the important first crop, only a few managed to return to their native Saxony or Poland. In none of these colonies—often called "enterprises" after the American model—was it ever

possible to be self-sufficient in this wet and flood-prone area. In an effort to fill the gap, the King soon declared the development of the Neumark a matter of utmost urgency, but never again did a farmer voluntarily take on the abandoned landholdings. The entire Neumark and its neighboring regions soon escaped both state control and ecclesiastical reach.

Prussia came to be regarded, especially by the Saxonians, as a land of widespread poverty and economic incompetence, where starvation was common and, even in better years, tasty food a rare treat. In the end, since no one any longer had faith in the arability of Neumark land, it was bequeathed to discharged soldiers or farmhands, who proved truly unable to scratch a living from the poor, recurrently flooded fields. These men and their womenfolk ended up as seasonal agricultural laborers, traveling to Mecklenburg in the summertime while their children stayed behind with the elderly in musty thatched huts. Already by 1766, the 6,000 inhabitants of the new colonies had renounced their faith in the state, refusing to swear an oath of allegiance. The region became something of a no-go area for civil servants.

This was considered a revolutionary situation, an extremely dangerous political development that further enfeebled the authority of the elderly King Frederick II, threatening social cohesion and core social values throughout the Prussian kingdom. Unlike the English colonies of America and in France, in Prussia popular revolt was successfully thwarted. I shall now outline how this was achieved, describing the institutions which emerged from a rapid learning process propelled by social anxiety and suffering, which resulted in Prussia becoming witness in 1789, after a ten-year legal battle, not to a revolution but to the mapping of all the economic and social interests by which the state would become answerable to its subjects.

What had happened? The difference between the two state-run land grabs—the one on the Oder and the one on the Warta—lies in their economic and moral character, their respective political procedures and leadership styles, and in the public's reaction.

In today's terms, we could qualify the colonization of the marshlands along the Warta and Netze as completely deregulated. Instead of following the initial proposal developed by the engineer Isaak Jacob von Petri, who had previously earned his stripes on the Oder, the King removed the project from his control, putting a general known for his wartime recklessness in charge, regional governor Franz Balthasar Schönberg von Brenkenhoff. Playing the entrepreneur in the king's and in his own favor, Brenkenhoff sought to quickly turn a profit—with the King's full

backing—economizing wherever he could and, by such drastic corner cutting, undermining the program devised by von Petri's team of planners. Even before the land had been sufficiently secured by hydraulic engineering and the old rights of use legally superseded, he directed colonists to areas not yet adequately drained and dried out, where their breeding stock and seed reserves soon perished. The only dwellings that withstood the wind and weather were a few stables and barns housing the settlers' most valuable possessions. The children died even faster than the calves. Under the horrified gaze of the local bureaucracy and the church, what unfolded was an increasingly haphazard process, marked by ignorance, incompetence, irresponsibility, and blind obedience.

The war hero and privy councilor von Brenkenhoff was illiterate, and his three chiefs of staff distinguished themselves only by their amateurish, corrupt, authoritarian character—complimented by their capacity to impassively carry out orders. Such details are known to us from court records of the trial of "Schartow and comrades," in which exhaustive testimony and—for the first time ever—accurate maps proved the extent of their infidelity, fraud, and professional incompetence in the region. The courts labored for a decade and—also thanks to extensive fact-checking procedures—did finally restore at least local confidence in the judiciary. In fact, the painstaking work of the courts tasked with examining the interests and claims of dike laborers, colonists, old villagers, and new investors laid the legal foundations for a discourse that would change the state forever. The driving forces of those giant efforts to find the truth, defend the broken state, and change the game forever were the newly emerging elites of universal knowledge and Protestant Christian morality. All the prominent defenders of the social order shared world views and moral imperatives that redefined the old relationship between self-interest and the common good, rational order and affective chaos, calling into question even the idea of divine judgment.

Leading the fray were men with a very particular kind of training, with immigrant backgrounds, who believed in Christianity's duty to reform the whole world. They upheld a Protestant conviction that God cannot be bribed, that blessings come from our earthly existence, that work is sacred, and that science enables man to emulate God. These were men of professional or academic accomplishment, who had studied mining, medicine, law, and mathematics at the Francke Foundations in Halle and the onetime Berge Monastery near Magdeburg; men whose forebearers had belonged to the Unity of the Brethren Church, to the Hutterites, Huguenots, or Calvinists—members of religious networks and secret brotherhoods like the Johannites, the Rosicrucians, or other hermetic societies.

This juridical—and later ministerial, reformist—response to a disastrous project devised purely for profit gave rise to a type of modern (male) subject, who gradually acceded to state leadership strictly on the grounds of competence and merit, regardless of origin and rank. The emergent modern Prussia found a shining role model in the person of Ludwig Phillipp von Hagen, who, in 1769, convinced the King to support a sweeping plan to promote "skillful and useful subjects" to key government posts, drawing on the bourgeoisie to fill all top positions of the Prussian State. It is my opinion that the real reason for Prussian exceptionalism (*Sonderweg*), often cited but usually misunderstood, is not so much to be found in its top-down enforcement of absolutism, as conservative Prussophiles claim today, so much as a responsible form of local patriotism. From now on the national economy was to develop under the primacy of science, exemplified by the worldly devoutness of these reform-minded, pietistic refugees. Their drawing up of a national public purse laid the foundations for a socially-minded—if not a kind of a quasi-socialist—market economy in Prussia, one we still benefit from to this day.

To address another key question here: Exactly why did these men perceive the draining of the Warta and Netze as an existential disaster, a political threat to the state, and, moreover, to Prussian society's Christian values? If I emphasize this question it is because I am convinced that we human beings are life-long learners, who organize ourselves collectively by thrashing out differences of opinion. I also wish the reader to understand that our settlement of the earth has been a contested issue since ancient times, and that we are bound by a moral statute to which past generations contributed, sometimes over the course of an entire lifetime and sometimes by forfeiting their lives in the process.

Domestic colonization was a gamble on the part of the state. In the case of the Warta and Netze marshes, it entailed starvation, despair, and countless deaths over the course of nearly a century and a half. It took many generations of mathematicians and hydraulic engineers and, in the last instance, the National Socialist Labor Service, to secure the last of the "foul pools" and "raging tides" of floodwater. We would do well to remember this conquest of a seemingly uninhabitable primeval landscape, and the wild and untamed tributaries of those fluvial basins. Had this catastrophe never happened, had it not been dissected, normalized, internalized, and institutionalized in the name of the common good— or "common urge," to use Goethe's term—we would not be who we are today. Such is the gist of my story.

To recap: the goal of the Crown was the *Repeuplierung* (repopulation) and capitalization of regions repeatedly devastated by war, whose populations were decimated and desperate. The state expected its massive resettlement campaign, which sparked migration flows across Europe, to quickly bring in huge returns on its initial investment. Given the settlement of the Oder marshes, which proceeded with comparative smoothness, Frederick II, the supposed paragon of European Enlightenment, grew as greedy and self-indulgent as any colonial entrepreneur of the day.

What I've presented in the above has long remained a mystery to scholars. It is only thanks to the chance discovery of the archival sources noted above that I came to understand why the large-scale project to ameliorate land on the primeval floodplain of the Oder—the Neisse, Netze, and Warta rivers—using technical means was perceived by contemporaries as an increasingly revolutionary situation which the King could no longer hope to avert by conventional means. He found himself confronted by an army of "interested parties," a civil society whose oppositional discourse would dramatically alter Prussia.

The result was a completely new elite, recruited from the educated bourgeoisie and founded on two sets of values: firstly, a pietistic worldview; secondly, a patriotic commitment to an economic plan which was to bolster the nation-state for generations to come. Prussia's concept of the state and German identity as forged under Prussian leadership was based on an unprecedented take on political economy, as well as on a concept of work that in turn underpinned a form of knowledge of the world. Competence became the sole basis for participation in society or for attaining positions of responsibility. Prussia avoided revolution by allowing bourgeois bodies to silently rise in the civil administration, the army, and the economic sphere, regardless of origin. The institutions facilitating this shift were the baccalaureate, the university, the networked intelligence of self-organized associations, and a pietistic worldview partial to philosophy and art. This was a method that applied not only to the metropolis; this collective experience came as a mobilization, rather, of the peripheries against the distortions of the center, the citadel. In Prussia, innovation always began on the outer edges—in East Prussia or Silesia—before gaining a foothold in the cities.[4] To put it even more bluntly, Prussia's territories held together due to a patriotism of reason which had to be forcefully implanted throughout the kingdom. It is this dialectic that traditional historiography overlooks to this very day.

4 see, for example, the origins of *Neues Baue*n architecture, which owes much to Jewish settlements in the Baltics.

Rural Urbanization: Commodification of Land in Post-Oslo Palestine

Khaldun Bshara

Introduction: Rural Palestine and the Colonial Legacy

Present-day rural areas in Palestine form a landscape of alienation. Local inhabitants have become laborers, not only for Palestine's emerging urban centers but also for Israeli settlements. These dispossession processes are driven by Israeli tactics that deliberately weaken Palestine's agricultural economy, flooding the market with Israeli crops and seizing control of water resources. Moreover, the Palestinian National Authority (PNA) does not consider agriculture a key component of national GDP, and thus neither protects Palestinian crops nor encourages investment in the domestic agriculture sector.

It all started (and this is an almost universal story) with oppressive colonial conditions that stripped peasants of their land—their very source of subsistence—thereby "freeing" them to be deployed as cheap labor in colonial plantations and settlements.[1] This created a vicious cycle in which indigenous people and their landscapes became part of the colonial apparatus, even the main component of its sustainability.[2]

Unfortunately, Palestinians of the post-Oslo era (1993–present) have complemented the colonial apparatus with a "local attitude" toward rural Palestine. Instead of positioning common land at the very center of decolonization, production, and reproduction, rural areas have become a commodity stripped of social status and meaning.

Much of Palestine's rural areas are communally owned, without definitive delineations. This land is known as *masha'a* (the commons). In the post-Oslo era, and with even greater frequency during the post-Arafat era (2004–present), Palestine has witnessed the emergence of large real

1 See, for example, Mahmood Mamdani, *Citizens and Subjects: Contemporary Africa and the Legacy of Late Colonialism* (New Jersey, 1996), 63–66, 119. Mamdani shows how the colonial states aggregated the natives (territorial segregation), then administered them through customary law (institutional segregation) by appointing chiefs and, in so doing, took over the land, destroyed the communal autonomy (substantive economy), and "freed" individuals for exploitation as wage laborers.

2 See: Khaldun Bshara, "Heritage in Palestine: Colonial Legacy in Postcolonial Discourse," *Archaeologies: Journal of the World Archaeological Congress* 9, vol.2 (2013): 295–319.

estate projects that reparcel agricultural land, removing the complexities that have served as obstructions to trading land on the free market. The PNA was itself an active participant in expropriating private areas in order to facilitate large-scale developments (e.g., Rawabi, north Ramallah). Such projects exemplify the PNA's emerging attitude toward rural areas, at the center of which is the elimination of the *masha'a* and the conversion of land into an easily defined and, therefore, easily traded commodity.

The Commodification of Land: From Land as a Place to Land as a Space
Land commodification processes started long before the Oslo Agreement. One can accurately date the beginning of this trend to the Late Ottoman era (late nineteenth and early twentieth century). It accelerated during the British Mandate (1920s–1940s) and sped up unmistakably after the Oslo Agreement (1990s).

The post-Oslo era intensified this process in two separate yet interconnected ways. On the one hand, the Oslo Agreement divided the Palestinian Occupied Territories into Areas A, B, and C. According to this division, Palestinians were territorialized—or, for that matter, *deterritorialized*—into Areas A and B,[3] with Area C (comprising approximately sixty percent of the West Bank) remaining under Israeli control and marked as a military zone, a designation that made much of Area C an easy target for Jewish settlement activities. On the other hand, the post-Oslo era provided Palestinians with a suitable environment for investment and "redevelopment" in Area A and, albeit to a lesser extent, in Area B. The hasty and unplanned development that ensued created urban sprawl that quickly encroached upon agricultural and common land. The free-market logic of the real estate sector, its appetite for speculation, contributed to the feverish inflation of land prices.

It is important to distinguish the commodification of land post-Oslo from that of pre-Oslo. While the terraced agricultural landscapes of Palestine were always productive and taxed by successive governments, commodification processes in the post-Oslo era targeted land "for itself," not for its productive capacities.

Today we witness first hand the miserable state of Palestine's traditional built environment and "natural" landscapes. Historic villages, archaeological sites, olive orchards, vineyards, and other landmarks are

3 See: Gilles Deleuze and Felix Guattari, *Anti Oedipus: Capitalism and Schizophrenia*, trans. Robert Hurley, Mark Seem, and Helen R. Lane (Minneapolis, 1983). As defined by Deleuze and Guattari, de- and reterritorialization suggest the transfer of control from a local territory to a dominant culture.

left unattended. What used to constitute the locus of the family economy has collapsed into pointless salary-paid jobs and new businesses. But Palestine is not an exception. Rather, it is very much part of a global trend.

The agricultural lands of rural Palestine were not only a source of pride and social recognition but also a means of livelihood. Olives, wheat, and oranges were central to the local GDP. After the fact, it appears that treating rural areas as an abstract commodity not only threatens the quality of life for Palestinians, it even jeopardizes the land's exchange value itself. New roads penetrate the landscape, orchards are replaced by concrete: this encroaching cityscape is endemic throughout Palestine. Villages no longer abide by the times and rhythms of the agricultural and familial calendar; they depend on cities as employers and "cultural centers." The relationship of inhabitants to their villages over the last two decades has become transient as they await relocation into urban centers.

Rural Palestine: A History of Marginalization

As with land commodification processes, the marginalization of rural Palestine cannot be viewed as a recent phenomenon. Ottoman archives tell a story of peasant taxation and capital channeled from rural areas toward urban centers, alienating rural Palestine from its own produce. Further, toward the end of the Ottoman era, rural Palestine was divided into "throne" sectors administered by local elites who routinely abused their powers, contributing further to the impoverishment of rural areas. As a result, peasants moved step by step from self-sufficiency to participation in the wage economy. With the British Mandate, rural land was channeled into the Jewish Fund, and these areas became a source for wage labor, either employed on Jewish plantations under the emerging colonial administration or in the industries and businesses of the Palestinian urban elite.

The Nakba of 1948, "Palestine's Catastrophe," was also equally a rural catastrophe.[4] As a result of the 1948 War, hundreds of Palestinian villages were vacated and leveled, and more than 700,000 peasants were displaced, becoming refugees separated from their traditional source of subsistence and local ties. After the 1967 War, once again a substantial number of rural Palestinian men and women became laborers on Israeli plantations and in Israeli factories: a state of multiple dispossession, of "building other people's homes"[5] on their own land. And yet, during Israel's full occupation of the West Bank (1967–1993), the state of the rural

4 The *Nakba* marks the dispossession and expulsion of Palestinian Arabs from their land in 1948.

landscapes did not change appreciably, on account of the depressed state of an economy largely controlled by Israeli authorities.

Ironically, while the Oslo Agreement brought increased autonomy to Palestinian political and business classes, rural Palestine became subject to an unprecedented lack of self-sufficiency. The PNA, now the West Bank's largest employer, encouraged rural Palestinians to aim for less precarious and seasonal forms of employment, prompting an influx of rural migrants to the urban centers. This trend reached its climax after 2002, when mobility restrictions imposed by the Israeli army hindered free movement between towns and villages.

In the post-Arafat era, the huge increase in real estate prices (especially for fee simple property, meaning both undeveloped lands that could potentially be urbanized and buildings that could be torn down to build newer and larger structures) heralded the "discovery" of land as something detached from longstanding economic uses and socio-cultural practices. Land became regarded for its potential for profit making (by investors and developers) and income generating/capital building (by landlords). And though the commodification of land in the West Bank has been a long process, it was only in the post-Arafat era that "real estate fever" affected most, if not all, middle-class Palestinians. It is important here to note that the financial "inclusiveness" of loans available to the larger public contributed decisively to this fever, allowing for more players to enter the game. One could see Palestine in general, and rural Palestine in particular, moving steadily toward a free-market economic model, a "neo-liberalization under occupation."[6] Real estate fever has resulted in a tremendous, sustained, and continuous increase in land prices at a pace consistent across the region. Lebanon, Jordan, and the UAE have all witnessed a similar boom in speculative real estate entrepreneurship.

For a Rural Turn

Despite this relentless pattern of urbanization, rural Palestine—that is, the agency inherent in the social and economic forces related to rural

5 Salim Tamari, "Building Other People's Homes: The Palestinian Peasant's Household and Work in Israel," *Journal of Palestinian Studies* 11, no.1 (1981): 31–66.
6 Raja Khalidi, "After the Arab Spring in Palestine: Contesting the Neoliberal Narrative of Palestinian National Liberation," *Jadalliya*, March 23, 2012, https://www.jadaliyya.com/ Details/25448/After-the-Arab-Spring-in-Palestine-Contesting-the-Neoliberal-Narrative-of-Palestinian-National-Liberation (accessed July 14, 2021). Raja Khalidi recently termed the current PNA as "States of Liberalization and Stages of Liberation," to note the inherent contradictions of structural adjustments under occupation. See also: Jamil Hilal, "What's Stopping the 3rd Intifada?" *Al-Shabaka: The Palestinian Policy Network*, May 20, 2014, http:// al-shabaka.org/whats-stopping-3rd-intifada (accessed July 20, 2021).

Palestine—is still able to challenge long-lasting colonial processes of marginalization. Unfortunately, to date there are few initiatives that reconsider rural areas and their products as an integral part of socio-economic, politico-cultural development. For example, the Riwaq Center in Ramallah, an NGO I have worked for since 1994, has contributed to the "demarginalization" of rural Palestine by regenerating fifty significant historic centers in rural areas and restoring hundreds of historic buildings, transforming many into community centers. Not only does this project consider the full range of potentials inherent to historic centers, it also pays attention to in-between spaces—the cultural landscapes around villages—considering these as an integral part of the revitalization process. In drafting an alternative development road map, the project regards villages as production units, investigating historical connections between them as a common resource. Rural areas can serve as a mechanism that actively "enclaves"—as opposed to being passively "enclavized" by the colonial spatial order through its imposition of settlements, bypass roads, the "separation wall," military checkpoints, and so on. They can mitigate the impact of Israeli colonial policies and open new possibilities.

Om Sleiman Farm presents one such example of mitigation and new possibility. In 2016, young university-educated men and women started an agricultural cooperative west of Ramallah, close to the Israeli separation wall, based on a Community Supported Agriculture (CSA) model. Their work not only aims to protect Palestinian lands from encroachment by Israeli settlements, it is also a way of reversing the PNA's neoliberal agendas, contributing to new forms of exchange beyond the capitalist market. Fairness, social responsibility, cooperativeness, collaboration, patriotism, postmodernism, and postcoloniality are only some of the key attributes of experiments of this kind.[7] Through such projects, rural Palestine emerges as a space for decolonization and a resource to imagine a state of autonomy—autonomy from colonial goods and crops in the first instance.

Final Remarks: Rrural Palestine as Hybrid Terrains

In this article, I have argued that the conditions of the post-Oslo era contributed to processes of land commodification in Palestine. Instead of placing land at the very center of production and reproduction, since Oslo rural Palestinian space has become a real estate commodity stripped of communal meanings. The rural has been made urban by dint

7 E.g.: Fair Trade, Agricultural Aid, The Union of Agricultural Work Committee.

of construction and planning, but without introducing modern modalities related to living standards and economic production. By doing so, rural Palestine has evolved into a hybrid terrain where peasants live in inadequately urbanized spaces.

In my opinion, the demarginalization of rural areas can be achieved by a reversal of the colonial condition, which in turn depends on enhancing socioeconomic and cultural interdependencies. The reversal of the colonial spatial order relies on, among other things, national-territorial sentiments. At the heart of these sentiments lies a nation's tangible and intangible heritage, including land as a locus of production. The interdependency between villages assumes an important role in any comprehensive revival process. In such a paradigm, each locale is equally dependent on the surrounding villages in achieving the cluster's overall welfare and fulfilling communal needs.

The question of rural Palestine is a question of value. A capitalist take on rural areas as a "fetishized commodity,"[8] an abstract space "by itself" and "for itself," can be attractive for short-term profit making. However, an understanding of land as social capital—a commodity charged with social life and history, and as a collective resource—would open potentials that could, in turn, contribute to the social, symbolic, and, ultimately, even the economic power of Palestine.

This "rural turn" however, cannot be achieved without a vision for Palestine, at the center of which are the communal values, the qualities of space and time that we deliberately choose to uphold. Such a vision cannot stand without large-scale national structural changes and policies that reverse long-standing practices of marginalization. Such a "turn" would recognize land value for what it can genuinely be. While Riwaq has been advocating (and demonstrating) that rural built heritage has the potential to be a pillar of socioeconomic development, Om Sleiman Farm infuses younger generations with a postcolonial imagination, along with notions of autonomy and self-sufficiency. This is not a call for a return to the "good old days," but for a revived rural economy that can combat colonization today and tomorrow.

8 "Fetishized commodity" refers to a concept developed by Karl Marx in *Capital: Volume 1: A Critique of Political Economy* (1867). Marx explains: "In order, therefore, to find an analogy we must take flight into the misty realm of religion. There the products of the human brain appear as autonomous figures endowed with a life of their own, which enter into relations both with each other and with the human race. So it is in the world of commodities with the products of men's hands. I call this the fetishism which attaches itself to the products of labour as soon as they are produced as commodities, and is therefore inseparable from the production of commodities." Karl Marx, *Capital: Volume 1* (London: Penguin Classics, 1990), 165.

Who's Afraid of Ideology?

Marwa Arsanios

For the past four years, I've been attempting to transcend a specific aesthetic discourse: a discourse that always departs from a cultural object—for example, a magazine or an architectural object (a building or unexecuted plan)—in order to reflect on conditions of production and the histories they embody, thus departing from aesthetic discourse as a means to study politics, whether in terms of the politics of images or politics with a big P.

My most recent efforts represent a move in the opposite direction: starting from politics in order to look at aesthetics and form from that standpoint. For example, how might a feminist project with a communal vision "take shape," spatially or otherwise? What form might the organization of labor assume within such a project? What about the distribution of funds, or the relationship to land and its maintenance?

This distinction, or dividing line, helps us define the aims pursued by means of an artwork. Before addressing the role of the artist within the art economy, I want to discuss my own position regarding the movements I've been working with. How can one relate to larger struggles from a position that is distanced—is it possible to assume a partisan role? My presentation will begin in the mountains of Qandil in Iraqi Kurdistan, then move to Tolima, Colombia.

In 2016, I had the pleasure of hosting two members of the Kurdish autonomous women's movement in Beirut. Together we read a text by Pelshin Tolhidan, a guerilla writer who has raised ecological questions from within the situation of war. Tolhidan spent much of her life in the Qandil mountains, on the border with Iran, and later wrote about self-defense and how it is entangled with the landscape she has fought to defend. She also wrote about the contradiction between war and ecology that lies at the very center of her life in the mountains.

When I visited Pelshin Tolhidan in 2017, she expanded on the difficulties of thinking ecologically from within a militarized zone, a place where war becomes the very material condition for any given ecological paradigm. The commodification of land was central to our discussion,

as was relationships to nonhuman species—specifically the fauna and flora in the landscape one inhabits as a fighter. But the fight itself is about reorganizing and redistributing land—outside the confines of a nation-state, or any other legal apparatus that codifies land and turns it into property. Any such reappropriation of land (in radically "separatist" terms) can only be achieved through armed struggle. Such is the ecology/ war paradox.

The ecological struggle against state colonialism is a matter of life and death, but also of knowledge: knowledge of the fauna and the flora. Tolhidan has been fighting for a landscape she knows well. Hers is a fight for that very knowledge, as well as for the possibility and potential of transmitting it. It is also a fight against the eradication and erasure of that knowledge. "Inheritance" of land and knowledge is not the correct term, for this would imply a form of transmission given legal sanction by the state apparatus. The aim, rather, is to remove land from any such apparatus, in order to decommodify, recode, and redistribute it. So, instead of a draughtsman's grid, the form or shape of the intervention onto the landscape would perhaps be more circular or amorphous, marking a communal way of living on and with the land. This would entail a new ideology projected onto the land—one that does not reproduce the violence of state governance but establishes another form of political organization and communal life.

Here, ecological struggle becomes a feminist project of decommodifying land, borne of the knowledge of a place and its nonhuman ecologies. The "degridding" of the land and its reorganization into communes and cooperatives requires the collapse or weakening of the nation-state formation, as was the case with Syria in 2011. It emerges in the moment of a power vacuum.

The question of the void is important here. On the one hand, the process of voiding has always been a colonial strategy for dispossession, occupation, and extraction. However, another type of void can emerge at the moment a state begins to collapse, heralding an opportunity for property to be reappropriated and decolonized.

Importantly, even this (potentially) decolonized void is an energetic space, if one considers it from the perspective of postanthropocentric physics. Allow me to consider this perspective, to try and discuss the political reorganization of landed property from the perspective of matter itself. In Newtonian physics, the void is where an absence of matter, an absence of property and laws, implies an absence of energy. This has been countered by physicist Karen Barad, who says that in quantum physics a vacuum is by definition a space where particles are created,

implying a fundamental inseparability between void and matter. The vacuum is not silence, but a form of speaking or "murmuring": a space of energy that runs counter to the premises of Newtonian physics. The silent void—which serves as the ultimate capitalist-expansionist pretext to claiming and expropriation—is actually a space of constant energy formation, a space to watch and listen to.

Quantum physics suggests there is no such thing as genuinely empty space. To paraphrase Barad, even sheer matter is a thinking entity in itself. We can now return to the sort of vacuum that emerges when a political power vacuum occurs. Perhaps we can approach it by listening to its murmuring, imagining new particles forming in the shape of new structures of power formation. Keeping matter as a thinking entity firmly in mind, let us now turn to the geographic setting of Tolima.

With the help of the NGO Grupo Semillas, I was able to organize a meeting to discuss the relationship between Creole seed conservation and land recuperation with local seed guardians there. One such guardian was Claudina, whom I visited on her farm in Coyaima, south of Tolima. Another was Mercy Vera, who participated in a convention of women farmers and ecological feminists I put together for the Warsaw Biennale in the summer of 2019. Through speaking with Claudina and Mercy Vera I came to understand that seed guardians posed a threat to entrenched power in Colombia, making them a target of armed forces on all sides— paramilitaries, dismantled guerilla units, government forces, and "private" security companies protecting agribusiness interests. If a seed guardian is an undesirable second class citizen, her closest allies possess no legal status at all. Seed guardians, small farmers, indigenous leaders and organizers were listed as people to eliminate or "clean" (*limpieza*). Their ancestors, of course, had endured many such cleansings before them.

In the arid territory around Tolima, where what little water exists is sucked up by hydroelectric mechanisms or used to irrigate the endless hectares of rice plantations, farmers tend to lease their land to plantations and ironically end up working on their own land for a very low wage. Others stubbornly stick to working their own land under these difficult conditions. Seed guardians have made the latter option more feasible by developing seeds adapted to desert conditions. According to the Grupo Semillas, this is nothing less than a revolutionary achievement. Yet, the current world order gives Claudina and her community little choice but to hope for international funds to secure their livelihood. For the price of a well or two they become witness to the ongoing historical

robbery of their land and resources. (I returned from Claudina's farm carrying a letter that solicited funds for ten new wells for the local community.)

How to talk about all this within the context of an art economy? One option is to use the space of a biennial for forming networks, as we did at the 2019 Warsaw Biennial with the Convention of Women Farmers and Ecological Feminists. Another is to visit a farm like Claudina's, which is a different option entirely.

The midday sun hits hard and it's thirty-eight degrees as we walk the surroundings of Claudina's farm. We attempt some landscape shots, but the light is strong, and our Panasonic doesn't adapt to light shifts very well.

"Should have brought ND filters," I say.

"And a reflector," someone responds.

As we stop somewhere to recall the murder of a seed guardian, it becomes very clear that what's delineated as the site of the crime cannot ever be fully captured by a camera lens. Not that it cannot be framed in its totality, but that it's always either off-frame or lost within it. There's always a surplus of sight or loss of vision. We never get the frame quite right. Perhaps we should not capture that site as a particular place to begin with. Perhaps the whole territory is a crime site in and of itself.

Land Reform: Utopia and Infrastructure: Historical Planning and Current Developments in Rural Brandenburg

Maria Hetzer

Having been tasked with developing a paper on socialist land reform in Brandenburg after World War II, one might well ask the point of such an exercise: How might a historical study of land reform help us understand rural gentrification today? My challenge is thus to cut an appropriately contemporary swath through this historical thicket.

First, it bears mentioning that this particular land reform program was one among many over the years, whether fully realized or merely planned. The intellectual history of land reform is not only old, it is also culturally diverse. Land reform is as multifaceted as the rural forms of oppression and distributive injustice to which it generally has sought to respond. The socialist land reform in Brandenburg, as in the entire Soviet occupation zone, was no exception. Intended to end the concentration of large tracts of land in a few hands through equitable repartitioning and redistribution, its rallying cry was: "Junker land in peasants' hands." Liberated peasants, the thinking went, should farm their land independently. A further aim, already pursued to little avail during the German Empire and the Weimar Republic, was to halt rampant land speculation that drove up prices. This may all sound familiar, but additional factors were at play, including some momentous, far-reaching goals occasioned by the specific context of the immediate postwar period. For one, the land reform scheme was intended to end the misery of some eight million refugees across Brandenburg and to hasten their settlement and integration within rural areas. In fact, refugees made up thirty percent of Brandenburg's total population in 1949, outnumbering local residents in many villages by roughly two to one.[1]

Another of the land reform's goals—the redistribution of land for agricultural purposes—was meant to remedy the catastrophic postwar food situation and accelerate the reconstruction of war-ravaged rural infrastructure. Especially in the eastern regions of Brandenburg, many villages lay in ruins. Any inquiry into whether land reform could solve our

1 Cf., *Transitzone Dorf: Ein Ort zwischen Bodenreform und Kollektivierung* (Berlin, 2015).

problems today should not overlook its singular historical importance within the Soviet occupation zone, and the consequences thereof.

The land reform program began in September 1945, with a decree by the Soviet Military Administration in Germany (SMAD). Private estates of over one hundred hectares were immediately expropriated without compensation; war criminals and Nazi activists also lost their land, which was transferred to so-called land funds. Overall, these measures put 3.3 million hectares at SMAD's disposal—one third of Brandenburg's surface area. Commissions appointed by the Soviets then reallocated the land, two-thirds of which went to new farmers, smallholders, refugees, repatriates (many of whom, incidentally, were women), and the landless and rural poor. All in all, over half a million recipients benefited from the program. The remaining third of the expropriated land became state property—that is, *Volkseigene Güter* (state farms).

Without a doubt, this radical redistribution of land and property, with the attendant migrations of people, knowledge, and land ownership, ultimately turned Brandenburg's villages into transit zones, and in the years that followed village life was defined by this migration to and from Brandenburg. Large landowners were expelled from their properties, often fleeing to West Germany to avoid internment. Traditional folkways and established hierarchies were as a result suddenly called into question. But at the same time, no one could be sure whether the new order would hold, whether the area's formerly dominant class might not soon return to reclaim all they had lost. As a result, many of their former subordinates did not dare to fully accept the opportunities that land reform offered them. Additionally, many novice farmers gave up their newfound professions upon discovering they could neither farm viably on their small lots, meet levy requirements, nor repay land reform loans. The general lack of tools, livestock, stables, barns, and other resources was also a problem, while housing, labor, and people knowledgeable in agricultural science and management were likewise in short supply. Moreover, the newcomers were never fully integrated into village life. Old and new residents lived in parallel worlds, which soon put paid to the hope of mutual aid between fellow farmers. This also helped consolidate collectivization, an (initially) voluntary process of pooling the holdings and resources of new farmers (above all) into agricultural production cooperatives, called LPG (*Landwirtschaftliche Produktionsgenossenschaften*). Often farmers contributed not only land but livestock, machinery, and labor. Politicians eyed this development critically at first. But soon the total collectivization of agriculture became the order of the day, massively promoted by the state.

Established farmers in particular did not welcome this development. Instead, locals who valued their independence had no wish to fall in with the upstarts, abhorring the grassroots democratic approach farming collectives were experimenting with. Indeed, the locals tended to resist collectivization more strongly than other sectors of rural society, even though their refusal put them at a distinct disadvantage, structurally as well as politically. For example, when it came to the allocation of urgently-needed tractors, farmers had to rely on state-operated rural equipment centers (MAS/MTS), and it was precisely this kind of structural support that frequently was touted as an incentive for joining the LPGs. Politically speaking, established farmers mistrusted the newly established organizations as potential expropriators who failed to recognize the farmers' harsh situation. In locales where they were forced to accept the necessity of joining, they tried to take over LPGs or slow down local decision-making processes.

Over the course of this forced collectivization process, a considerable number of farmers critical of the scheme, whose knowledge of traditional agriculture was substantial, gave up and moved to the cities or to West Germany, as did some repatriates, who had tried in vain to gain a foothold in agriculture. The newly built-up state-sponsored heavy industry in East German cities such as Eisenhüttenstadt, Schwedt, Hoyerswerda, Cottbus, and Frankfurt an der Oder was another magnet attracting those fleeing the countryside, especially the young. Unlike the traditionally arduous living conditions in agriculture, urban life offered regular working hours, annual vacations, modern apartments, and comparatively high wages. Thus, for some time Brandenburg remained a transit zone in upheaval. To counter this, the state pursued a dedicated "back to the land" program, encouraging industrial workers to resettle in villages. Far more successful was the so-called "friendship treaties" program involving seasonal labor pledged by urban businesses and political associations, along with members of the general public, who "volunteered" to help out on farms. Students and army personnel, Berlin sales clerks and Frankfurt (Oder) kindergarten teachers all played a part in this effort to secure rural food production's necessary labor. In a manner typical of life in the GDR, a diverse group of urban dwellers and work collectives from the industries, administration, and education sectors assisted in planting seedlings, hoeing beets, harvesting potatoes, and other labor intensive tasks. They worked on building barns and other agricultural buildings, and helped with road construction. Whatever other material consequences the friendship treaties program, it helped to strengthen the vital link between urban and rural development, and

an understanding of the intrinsic dependencies between city and countryside was thus maintained.

All of this opened the field to new rural actors and new forms of economic activity, facilitating Brandenburg's agrarian modernization. The countryside now had a new image altogether. Collectivization gave rise to large landholdings better suited to the types of industrial-scale agriculture reliant on big machines. The increase in crop yields was immense, thanks also to the introduction and targeted use of pesticides and fertilizers. Animals were herded together in large barns and given numbers instead of names. Farmworkers began to work in shifts and gain legal entitlement to a share of the cooperatives' profits, as well as the sorts of benefits—such as guaranteed vacations—enjoyed by their urban brethren. Since speculation was illegal, land was no longer an interesting investment; its ownership was of little consequence in the GDR. This also meant that land could be developed without permitting, making it easy to build roads or other infrastructure so long as they served an agricultural purpose or benefited the general public in some way.

A new socialist-agrarian cosmos, with its own everyday practices and institutions, gradually emerged. Given the massive wartime destruction of rural infrastructure, the new nationwide parity of living conditions between town and country seemed nothing less than miraculous: schools, kindergartens, youth clubs, community centers, libraries, cinemas, malls, medical centers, repair shops, sports fields, bars, and more all sprung up in the villages, alongside successful farming cooperatives. From the 1970s onwards, many Brandenburg villagers recall themselves thinking, "Why go to the city, when we have everything here?"

Clearly, the benchmark for any reform program must always be this question: How do the measures taken improve the situation (if at all)? Research on the attitudes of women in the GDR, for instance, has found that a majority measured their emancipation not on the basis of ongoing gender policies but in terms of how their expectations and everyday experiences differed (positively) from those of their mothers and grandmothers.

The shift to a capitalist market economy in 1990 marked the beginning of a new era. Land once again became an object of speculation and a means for achieving maximum return on investment. Land grabbing now reversed redistribution processes less than a half-century old: to this day, it remains fueled by the sale of publicly owned land to the highest bidder. The *Treuhandanstalt* was the first government agency set up to restructure and sell off GDR industries; its successor, the

Bodenverwertungs- und -verwaltungs GmbH, was tasked specifically with the sale of land and forestry. With the COVID-19 pandemic, these trends have only further intensified. Not that this coheres with the public's general impression. Over the course of the 1990s, rural East Germany came to be regarded as a hinterland, impoverished and shrinking. In contrast to customary forms of agricultural land ownership and labor relations during the GDR, the Agricultural Adjustment Act (*Landwirtschaftsanpassungsgesetz*) declared small-scale agriculture to be a touchstone of economic development. This only hindered the efforts of East German cooperatives to adapt to the challenges of the market economy and the EU's common agricultural policy (CAP). The ensuing crisis in East German agriculture led both to its radical deindustrialization and to mass unemployment. Rural living conditions deteriorated rapidly, as the rural infrastructure the GDR had established was now ruinously expensive to maintain. Rural communities were appreciative of the occasional, pioneering efforts to stem the overall decay, but by and large young people and women fled in droves, leaving villages fearing for their future—with good reason.

Initially, LPG members were unsure how to proceed. Given the low value of land and the dearth of farmers with genuine experience, only a few managed to make a living from small-scale agriculture. The system now required a shift from a production-oriented mindset to a subsidy-based economy involving red tape and funding applications—a strange new world. In the East German countryside it had been vital to use every scrap of land, both for food security and to earn foreign currency from exports. Now farmers were expected to routinely let their land lie fallow and regenerate. Few could accept that boosting agricultural productivity had reached its limits, or that the very idea of a limit to growth had suddenly taken center stage. As a result, among the LPG successor farms newly reestablished under federal law, most members held onto their land holdings. It also explains why rural development in eastern Germany, the Agricultural Adjustment Act notwithstanding, was determined by large farms, unlike in the rest of the German Federal Republic. In 1990, finding the necessary land in the new federal states to implement alternative organic farming models was an uphill battle, and the situation remains the same today. Those agricultural enterprises geared toward large-scale production—the GDR's sole economic success story—still mark the countryside and define legislation on both the national and EU level, alongside Europe's lukewarm approach to conservation and biodiversity. Few farming cooperatives are willing to make the investments necessary to shift toward sustainable, ecosocial responsive

agriculture—although exceptions do exist, such as the LPG that morphed into the Ökodorf Brodowin project in the mid-1990s. This organic agricultural company, financed by the EU, developed into a thriving enterprise that provides an infrastructure today for envisioning a future Berlin supplied solely by organic food from regional producers.

Land reform was not exactly undone after 1990, but the principle of land restitution over financial compensation was applied to the land claims of former owners, and new property laws gave rise to new forms of injustice. For example, the State of Brandenburg declared itself the owner of properties that had been subject to land reform, where the rightful owners could not easily be found. The state argued that these did not constitute bona fide property. By 2019, over 4,500 such properties remained in Brandenburg's possession, despite its questionable legal arguments having failed to convince the courts, and although restitution claims have long been—often successfully—filed.

In light of this history, I would argue that, in the absence of a broad systemic shift, the redistribution of land is a hopeless case. Any large-scale restructuring would have to confront established material and legal infrastructures, alongside creating a new culture of knowledge and action. The mechanisms of any land reform amount to little unless they're underpinned by a new emancipatory social contract. And this contract requires meaningful everyday practices capable of breathing life into them. Regardless of aspirations, improvements must be tangible and visible on the ground for everyone involved. Moreover, in marked contrast to the eloquent figures of socialist propaganda, current endeavors to transform and promote rural living are still remarkably vague. Take as an example the romanticiziation of rural smallholder existence. Who really wants to put down their phone to hoe turnips? Who wants to stoop, up to their knees in mud, cutting cabbage for the winter, with cold, numb fingers? Who really wants to depend on subsistence farming for a living, however superior the taste of organic homegrown vegetables might be?

Despite all the progress made, once one goes from weeding on the weekends to the physical demands of agriculture, one will find just that: heavy work that only pays off on a larger scale. So, who are the actors who might help land reform come into its own once again? The generation familiar with land reform—as a tough experience—is dying out. Meanwhile, there is now a revival of interest in state intervention as a legitimate means of redefining land ownership—due, especially among the younger generations, to the prominence of climate justice in

public discourse and the exemplary struggles in Latin America to ensure indigenous land rights.

The liberation of land, so ardently longed for, also depends on the innovative redistribution of property in our everyday lives. It depends on the city and the countryside being in solidarity with one another, and on an awareness of the many links between them in terms of their needs and their infrastructure. Thus, it remains incomprehensible to me why the districts of Brandenburg and Berlin have yet to merge with one another. Rural forms of gentrification may be a distinct set of phenomena with their own dynamics, but they're irrevocably linked with those urban processes that get subsumed under the same term. Look at the crowds of people moving to the countryside because they can no longer afford city life. Suffice it to say that land reform and ecosocial change are deeply linked and cannot be thought separately.

The Red City of the Planet of Capitalism

Bahar Noorizadeh

"When the 'alien building' is a bank or an office block it can become an object of distant, awed contemplation. When, on the other hand, the alien enters everyday life, when it can't be ignored but has to be lived with, then the boundaries between the alien nation and our alienated cities might start to be breached."
— Owen Hatherley, *Militant Modernism* (2009)

In 1920s Russia, the quotidian was the experimental site for revolutionary practice. Everyday life (the charged Russian word *byt*) was a primary concern for the state, as migrants surged from the countryside to cities. Thus, "housing" was the hot topic of city planning competitions and central committee meetings in Moscow in the early years of the Soviet Union. Many architects and urbanists who emerged out of the avant-garde wing of Vkhutemas[1] proposed solutions to the housing shortage, among them the constructivist architecture group OSA (Organization of Contemporary Architects), who, during its five year run (1925–1930), rose to the challenge of inventing socialist urban design anew—most famously with the Narkomfin communal building, commissioned to house employees of the ministry of finance, who, being perceived as socially advanced individuals, could appreciate the subtleties of the

1 The Higher Art and Technical Studios school founded in 1920 in Moscow.

architects' vision. Narkomfin was the perfect example of the *byt* that OSA architects had in mind: OSA founder Moisei Ginzburg, lead architect on the Narkomfin project, had long been concerned with the problems of communal dwellings within cities, and was an avid follower of Le Corbusier's urbanist modernism.

Narkomfin is a long, ribbon-shaped building designed with sharp angles and occasional curves, with a bridge connecting the residential condominium to the collective cubicle with its glass façade. Housing was divided into F-type and K-type units, with F-type units being fully collectivized—these units featured a shared kitchen and kindergarten in the adjoining blocks, in adherence to feminist ideals and a revolutionary antipathy for the nuclear family and its gendered division of domestic labor. The unfinished roof garden was never made available to the residents: in a few decades time, once it moved to its current location across the street, Narkomfin's rooftop would grant an exclusive view of the American embassy.

Neither Marx nor Lenin had had any fondness for utopian communes. Marx had reproached utopian socialists of the eighteenth century for a pastoral naivete that exacerbated poverty, seeing as their residents had deprived themselves of technological means (Paden 2002, 83). Lenin would say later that building communes in a rush might alienate the peasants, but he would not oppose them as long as they remained functional (Wesson 1962, 343). In nineteenth century prerevolutionary Russia, however, commune living was much in vogue. From peasant religious communities to populists, and, later, followers of Tolstoy, there

remained a persistent egalitarian tradition concerning the redistribution of ploughlands in old villages. The Krinitsa colony, most notably, had been founded by a princess who desired to lead the life of the intelligentsia—"a vague socialism plus nihilism."[2] She sold her jewelry and established a community on the Caucasian Black Sea coast that survived successive wars and revolutions until finally being transformed into a Soviet state farm. The folklore that grew out of communal living experiments also inspired urban sociologist Mikhail Okhitovich, who, by some accounts, was among the most radical members of the OSA's avant-garde front. By 1930, Okhitovich had managed to insert his critique of OSA's earlier proposals for house-communes into their program, arguing for "choice in type of housing" (Hudson 1992, 456).

but it cannot solve the sanitation problem, the problem of open spaces.

The rumor goes that one summer morning in 1929, Mikhail Okhitovich rushed into Moisei Ginzburg's office at Vkhutemas, shutting the door firmly behind him (Wolfe 2011). Exiting an hour and a half later, he left Ginzburg, until then a staunch disciple of Le Corbusier's Urbanisme, a converted disurbanist. Disurbanism considered the city as a capitalist invention whose centralization and overcrowding necessarily led to class stratification. Adding social housing, parks, and public spaces would not cure the city of its terminal disease—the capitalist contagion of class difference. Instead, Okhitovich suggested, "the city must perish" (Okhitivich 1929). In its place would arise a distributed network of dwellings and ser-

2 In Wesson 1962: Mikhail Tugan-Baranovski, *Obshchestvenno-ekonomicheskiye idealy* (Saint Petersburg: publisher unknown, 1913): 94–97; G. Vasilevski, *Krinitsa* (Saint Petersburg: publisher unknown, 1908), 80, I04.

vices disseminated across the Soviet lands, resolving what disurbanists considered the internal contradiction of the city—that of the unequal distribution of amenities between town and country, which would have to be accessible everywhere in a true communist society. What was once a pie in the sky notion was now possible thanks to the revolution in transportation, as Okhitovich elaborated in an issue of the OSA journal:

> It is necessary to reassess the nature of the possible in accordance with the requirements of the epoch. . . . The exceptional growth in the strength, quality, quantity, and speed of the means of mechanical transport now permits separation from centers: space is here measured by time. And this time is itself beginning to be shortened. The revolution in transportation, the automobilization of the territory, reverses all the usual arguments about the inevitability of congestion and the crowding together of buildings and apartments. We ask ourselves, where will we resettle all the urban population and enterprises? Answer: not according to the principle of crowding, but according to the principle of maximum freedom, ease and speed of communications' possibilities (Okhitivich 1929).

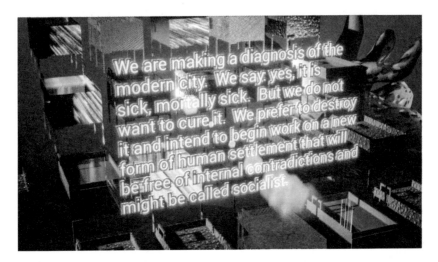

What form of residential architecture was appropriate to this new mobile city? Disurbanists proposed collapsible lightweight living cells that could be wrapped up and transported across the nation's network of highways, to be set up in any location. The design of these units was inspired by an edition of the Narkomfin F-unit, which had previously been selected as a typology for the Soviet house. (The F-units, in turn,

inspired the standardized schemes developed by Ginzburg and Stroikom [Building Committee of the Russian Republic]. Known as the Stroikom units, they later inspired Le Corbusier's *Unités d'Habitation* [Cohen 1992].) These mobile pods were cubicles that could be easily attached, detached, and conjoined with one another according to the social needs of their occupants. A married couple could connect their pods side by side and, once divorced, uncouple them and go their separate ways. Architecture would become a partial substitute for the judicial bureaucracy of social relations, laws, and protocols.

In 1930, Ginzburg, Okhitovich, Zelenko, and Alexander Pasternak (Boris's brother) submitted an entry to the master plan competition for the city of Magnitogorsk, known for its massive iron ore mining industry. The architects envisioned a blueprint for a machinic infrastructure made up of a network of interlinking ribbons, with each sine wave consisting of a belt of agriculture, cultural facilities, factories, highways, and railroads; the sharp angle, for Okhotovich, being a residue of capitalist land allocation. The end of the city would herald a new socialist sprawl. For all its shortcomings, Ginzburg and company's plan was considered an innovative if untested way of transforming the ancient divide between city and country, making best use of what each had to offer without favoring one over the other.

Disurbanists also submitted sketches to the 1929 Moscow Green City competition. While other architects submitted urban reform plans that focused on turning Moscow into a spacious, efficient, egalitarian capital, Okhitovich and Ginzburg suggested demolishing most of the city, turn-

ing it into a park adorned with monuments. Le Corbusier, who was asked to sit on the contest's jury, was appalled by the idea, prompting a series of correspondence between himself and Ginzburg, his previous champion. Primarily concerned in his critique with the antisocialist "form" of disurbanism, he implored Ginzburg in a letter to repatriate to the urbanist camp.[3] It was a critique he continued to advance throughout his life, later compiled in his book the *Radiant City* (Le Corbusier 1967).

In the end, the disurbanists' ambitions proved to be short-lived. Okhitovich was the first architect sent to the camps at the start of the Great Terror. Delivering a speech (The National Form of Socialist Architecture) at a conference of nonparty architects in 1935, Okhitovich argued that *the national form of Soviet Architecture* had to derive from the Russian formal inheritance (Hudson 1992, 456). Since the majority of the prerevolutionary oppressed had not experienced a classical period of architecture, their national form could only be derived from village housing. The form of Russian folklore, then, would carry the socialist content of Soviet architecture. Although he defended modernist architecture for its revolutionary credentials, he argued that by compromising the economic basis of rural life, capitalism had forced people into cities where folk architecture has been replaced by geometric forms (Hudson 1992, 457). During the speech, Okhitovich hinted that Stalinism's neofeudal war on the peasantry would force migration to cities and exacerbate the problem of "landlessness." Even after the complete victory of communism throughout the world, Okhitovich noted, once the people of the world had joined together under one communist nation, we cannot assume that architecture will have but one form under all circumstances. In his vision, architecture would become "local in form and communist in content" (Hudson 1992, 458). The file of allegations compiled in the case against Okhitovich ended with a note stating that disurbanism represented a patently social-fascist perspective. In the years when the discipline was facing intensive internal conflict and pressure on behalf of the national commissariat, the "Okhitovich Affair" had a snowball effect, with everyone joining the witch hunt.

3 This exchange of letters was first published in *Sovremennaya Arkhitektura Journal*, 1-2 (1929), and is available online at www.thecharnelhouse.org, https://thecharnelhouse.org/2010/10/02/le-corbusier-vs-ginzburg-on-deurbanization/https://thecharnelhouse.org/2010/10/02/ginzburg%E2%80%99s-reply-to-le-corbusier-on-deurbanization/ (accessed September 23, 2021).

In Okhitovich's words, "[Disurbanism] is not merely a theory of those who oppose the city—no, it is an inevitable, objective process. It is not our business to go out to meet the car 'with our icons,' as did the peasant, upon meeting the first steam locomotive on its old ground" (Okhitovich 1929).

All stills from *The Red City of the Planet of Capitalism*, Bahar Noorizadeh, 2021.

Bibliography

Cohen, Jean-Louis. *Le Corbusier And The Mystique Of The USSR*. Princeton: Princeton University Press, 1992.

Hudson, Hugh D. "Terror In Soviet Architecture: The Murder Of Mikhail Okhitovich." *Slavic Review* 51, no. 3 (1992): 448–467.

Le Corbusier. *The Radiant City*. New York: Orion Press, 1967.

Okhitovich, Mikhail. "Why is the City Dying." *Sovremennaia arkhitektura* 1-2 (1929): 130–134.

Paden, Roger. "Marx's Critique of the Utopian Socialists." *Utopian Studies* 13, no. 2 (2002): 67–69.

Wesson, Robert G. "The Soviet Communes." *Soviet Studies* 13, no. 4 (1962): 341–361.

Wolfe, Ross. "Mikhail Okhitovich, Moisei Ginzburg, And Disurbanism," *The Charnel House*, April 07, 2011. https://thecharnelhouse. org/2011/04/07/mikhail-okhitovich-moisei-ginzburg-and-disurbanism/#comments (accessed September 23, 2021).

Redistributing Risk: Tuleva as a Case Study

Kristel Raesaar

"Imagine a world that moves from an extractive to a distributive model—in which Amazon is owned by its sellers, Uber is owned by its drivers, and Facebook is owned by the people who create its content,"

wrote Douglas Rushkoff, then an editor of the *Financial Times* in 2016.

At this point, it is difficult. Could the world still hold tiny pockets of possibility for alternative, distributive models to germinate?

I
In Estonia, the user-owned fintech Tuleva has identified one such hidey-hole of opportunity: the pensions market.

II
Challenge: think of something less sexy than *pensions*. Or more confusing than your pension plan.

Mandated or strongly incentivized by law, people around Europe—wealthy and struggling alike—regularly invest in stock markets through pension funds. Many aren't aware they are doing it. We lose money playing a zero-sum game with fund managers, the middleman's cut eating into slender returns.

For fund managers, the pensions market is a source of guaranteed income. The old industry players are guarded by a shield of boredom and a web of complexity. In a profitable slumber, financial institutions are slow and inert, giving a newcomer relatively ample time to sneak in. Even a tiny piece of this market can provide a sustainable revenue base. This is crucial if you want, say, to build a foundation for a more collective, cooperative fintech company.

III

By now, financialization—the growing dominance of financial institutions in both public and private domains—is firmly established as a base condition of contemporary life.

In the West, the process of financialization took several decades, brought on by a series of contingent events. In post-Soviet Estonia it was a goal in itself, pushed forward with radical speed.

In the 1990s, Estonia's new government felt it had but one job: to leave the Soviet experiment behind, accelerate, and catch up with the globalized market economy. Flows of finance, canalized under the IMF's guidance, would provide a safety net for Estonia's fragile sovereignty. To attract foreign investment, the signaling had to be simple and convincing: "Great returns at minimal risk." Risk, therefore, had to be redistributed and underwritten by the Estonian population.

This strategy, more aggressively pursued in Estonia than the country's Baltic neighbors, worked well: its economy has been among the faster growing countries of the ex-Soviet camp. Most areas of Estonia's economic and social life are dominated at present by three or four banks, mostly owned by Scandinavian and American firms.

IV

Replacing defined benefit pensions (a state's pledge to its citizens) with defined contributions (every person's risk) is one manifestation of how a neoliberal state shifts focus from offering security to its citizens to pitching value to investors. Until recently, the idea of a pension was simple: the retiree would get a fixed monthly allowance. In a financialized world, however, such a promise becomes a liability—a risk states prefer to move off their books. Capital prefers national balance sheets wiped clean of demographic risk.

With the provision of social security expected to decrease, or perhaps disappear gradually, the burden is now on every individual not just to "save responsibly," but to navigate opportunities and risks in global capital markets.

It would be more efficient for a country the size of Estonia to run a consolidated pension pool. Shuffling thousands of small contracts is costly; individual account-holders have almost no negotiating power.

V

Today, mandatory pension investing in Estonia begins at 18 years of age. Salary earners invest six percent of their monthly income through a licensed pension fund.

Pension funds have proved an excellent business for the banks, but a dubious proposition for the people.

According to a report published by The Organisation for Economic Co-operation and Development (OECD), Estonia's funds stand out for being the greediest in terms of service fees and giving the worst returns. Considering that high fees and substandard returns are endemic within the world's retail investment funds, this is quite an achievement.

Referring to consumer scoreboards published by the European Commission, the European advocacy group BETTER FINANCE (BF), which represents individual investors and financial services users, has stated that "pensions and investments remain ranked at the bottom of all consumer products."

The outcome is that most people deeply distrust the pension system. Overwhelmed and confused, many consider the monthly mandatory pension payments as money lost. "I don't trust banks anyway" or "my children are my pension pillar" are common refrains among Estonian adults. (Banks, for their part, really like that we believe that money doesn't buy happiness.) Frustration usually contains an opportunity to try something new.

What if we cut out the middleman and started our own pension fund? A fund whose owners don't play a zero-sum game with their customers—whose customers are the owners.

VI
So, how do you start your own pension fund?

In finance, as elsewhere, scale is power. Operating alone, my risk capability is low, my negotiating power weak.

Tuleva was born from a calculation on the back of a napkin. The founder, Tõnu Pekk, estimated that if approximately 3,000 people pooled their pension savings together, a considerably cheaper, better fund would become viable. So we needed allies—lots of allies.

A few friends were already on board, but to gain traction, reputational capital also had to be raised.

Tõnu pitched the idea to about twenty people who are well known and trusted in Estonia. Almost all were willing to put their face behind the plan.

The profiles of the twenty-two founding members helped attract media attention and create trust. When we went public with a simple WordPress website, 1,000 people signed up within the first couple of weeks.

This did not entail simply subscribing to a mailing list: every member contributed one hundred euros for start-up costs—stuff like building the IT architecture, legal help for preparing licensing applications, and so on.

We also needed to raise three million euros as a liquidity reserve—a legal requirement for any company wishing to manage a mandatory pension fund.

Venture capital wasn't an option: involving a third-party investor would have only brought us back to the inevitable conflict of interest between owners and users, the zero-sum game that we aimed to overcome.

So, we offered the first 3,000 members a voluntary option of contributing anywhere between 1,000 and 10,000 euros. The law requires this money be invested in the managed fund itself so that contributing members earn returns on investment in addition to returns from their mandatory pension savings.

It was important that as many people participate as possible, so that both risks and (potential) returns be evenly distributed. Almost 2,000 members out of 3,000 chose to contribute—not ideal, but close enough.

All this took about a year. In March 2017, Tuleva finally received an operating license from Estonia's finance watchdog, Finantsinspektsioon. In its first three days of operation, 3,000 members transferred their mandatory pension savings. Additionally, anyone who did not want to become a member or could not afford the one hundred euro membership fee was free to transfer their pension savings to Tuleva at no cost, increasing the size of the fund while also spreading its benefits to a larger public. Collectively, we were now officially running our very own pension fund—a low-cost, fully automated index fund.

Our money is invested in global stock and bond markets, so it is still exposed to market risk. In this sense, not much has changed. However, we now own possible returns as well as losses. Until we started Tuleva, around half of mandatory pension fund returns went to a middleman.

VII

Two things make Tuleva radically different from most start-ups and fund managers:

1. Capital is separated from governance. Collectively it was agreed that each member has one vote per person, regardless of capital contribution. Your life savings matter as much to you as to the next person, regardless of how much or how little you have.

2. Neither membership nor votes are tradeable, ensuring that no one

can take disproportionate control over decision-making or profits. Under Tuleva's bylaws, contributions can only be sold back to the fund at book value.

So, no individual member has a speculative exit strategy, though as a collective we could, of course, decide to sell any part of our enterprise and divide the profits.

By the end of January 2019, Tuleva was managing the savings of over 9,000 pension holders, 4,000 of whom were members—in other words, co-owners. At the time, the fund was managing over eighty million euros in total.

With a population barely exceeding one million, Estonia is a good policy testing ground where change can happen relatively quickly.

Tuleva has more active members than most political parties. We work with government bodies and groups of experts to push legislation that will make the pension system fairer, simpler, and more efficient. These remain small technical changes for the time being, yet they save every working person real money.

The questions first raised by Tuleva have over time developed broader public awareness, which in turn has resulted in the issue of pension management fees becoming a central topic of political debate in the forthcoming elections.

The old bank-owned fund managers have also been forced to react by lowering fees (though so far only marginally)—bringing small wins even to users who aren't with Tuleva yet.

VIII

Clearly, the relationship between financial institutions and the general public is subject to huge power asymmetries. But there's also a relational discontinuity.

Dealing with one's bank is an annoying experience at best. One cannot do much about it, so one assumes the position of a passive-yet-critical victim. Don't we all love to slag off the banks?

For the financial sector, our names do not signify the weary faces of individuals; these are simply markers in portfolios of assets and liabilities. We are creditors and, often, credit seekers. But our pension plans, however humble, also make us investors. Financial sector bailouts by taxpayers after the latest global economic crisis foregrounded our task of risk underwriting. As voters, we warrant the regulator, etc.

The financialized world conditions us all as portfolio managers. Our financialized selves smash into fractals, converging in multiple user profiles, then diverging again.

The risk averse pay a premium here to secure near-certain loss. When potential returns are distributed amongst multiple agents, or seem altogether unquantifiable, profits tend to be left unattended for third parties to seize.

As a portfolio of assets, we have a structural complicity with everything we love, but also everything we hate. Our hopes and fears merge in dynamic flows of capital. Financialization is not a layer glued onto everyday life; it is everyday life.

IX

Tuleva's goal is to pool together Estonians' investment portfolios, but also to consolidate some of these relationships so that we can shift from the position of disgruntled user to part of a collective where roles and assets can be leveraged for the betterment of the group.

Pensions are not the endgame here but a tactical move. The mandatory pension fund provides a sustainable income stream that not only gives us negotiating power but also could fund further developments.

Members of Tuleva already pay three times less in fees than the average pension fund holder. Our common fund, though still relatively tiny, is economically sustainable. As we grow, running costs will increase only marginally—our mutual business will start generating profit. It will be up to the members to decide if they prefer to lower the fund's fees further or put the surplus to work for new projects.

What could such projects entail? We honestly don't know today what the long game might be. However, further down the line Tuleva will consider peer-to-peer insurance and low interest mortgages, social impact bonds, strategic investments, and partnerships. These options will be up to the members to decide on.

For now, we are moving forward incrementally, taking small functional steps.

In 2019, we launched a III pillar (voluntary) pension fund in addition to our obligatory pension fund. Today, we take in roughly half of all new III pillar contributions in Estonia. Tuleva now manages the savings of 54,000 pension holders (7,000 of whom are members) altogether. Assets under management in II and III pillar funds presently exceed 330 million euros.[1]

1 Updated August 31, 2021

A Speculative White Paper on the Aesthetics of a Black Swan World

Penny Rafferty

The art world is not a success. It is not progressive, it is not beautiful, it is not just, it is not virtuous, it is not unbiased, and it frequently misses opportunities to perform better. The art world is a world we dislike—even come to despise in the long term. It is a machine of accelerated aesthetics, burnout, precarious living, 24/7 availability, and galvanized gossip. It is motivated by survival rather than the common good.

I am partial to the thought that the art world has succumbed to something not entirely human, something referred to in some circles as "capitalism." Capitalism is a form of authoritarianism that is ineffective for most but rewards those with an ability to instrumentalize power positions, which in turn lends them more say in molding future worlds and speculative thoughts. Sound familiar?

Another similarity between capitalism and the art world is a vested interest in states of economic crisis. To be sure, after 2008 the capital classes have not been in crisis themselves, but they do require a crisis-at-large to remain in power. There is one difference, however: art has always declared itself to be in crisis. The starving artist, for example, is an archetype that some even suggest is a prerequisite rite of passage within the field. (Ironically, those who claim that status usually have ample access to free dinners and cocktail party invites.)

And yet, if what is in vogue in the art world changes as regularly as catwalk seasons, what if art world foundations did so too? Many have been asking: What if the users owned this machine instead of pumping their guts into it? What would happen to art? Would the art world fade out if it started working for its patrons, its producers, its believers, rather than sucking them dry?

Wanted: A Proactive Community Owned Support System.
The art community has fallen into the trap of abiding by market rules that specialize in poverty. This is likely due to the fact that the art world does not understand the economy at large, nor how to bring its infrastructure to work for the benefit of its community. The model proposed in this essay remains a work-in-progress, one speculating on a system of

local economic and emotive systems that could be developed within Berlin's art scene. It could be employed by its users to "guide" the market, alongside long-term funding opportunities, with the help of economic and cultural investors, on demand. The beneficiaries would be artists and curators in project spaces. A small niche, to be sure, but this group is the root, the rhizome. Starting here could infect the whole machine, as far as poverty lines go; the root, after all, is the part that sees the least sunlight.

The Problem for the Root

It is an open secret that blue chip galleries allow project spaces to hone an artist before they enter the art world, treating them like finishing schools to "groom" the young art professional. And they put in this educational extra time for free. A self-perpetuating cycle is at play, fueled by the promise of one day becoming a lord rather than a servitor. Recursive loops of this kind consist of infinite cycles of events triggering similar events in turn; "traditions" enforced through the soft power tactics implicit in sayings like "it's the way things have always been" or "business as usual." And yet, traditions are made to be broken—at least art history claims as much. But what if we refrained from breaking tradition again and broke the art system itself instead? An act of self-radicalized self-sculpting.

Crippling Care inside The Zone

Gentrification and class bias have become the norm in Berlin. As the city moves away from the experimental gallery boom of the early 1990s, we see the city running the risk of losing its unique project spaces, and what was once a vibrant, antagonistic attitude toward the cultural elites. I am not suggesting a mourning process for hedonistic times so much as a procedure for action that as yet has no name. But it may eventually serve as a new protocol for Berlin's cultural scenes, in which every institution, collection, and gallery is complicit and accountable.

Now, if you count yourself among the empowered, you may dislike my accusations and point to funding platforms such as Berlin's Senate to refute my claims. Filling out forms and ticking boxes, however, does not sustain a creative body so much as cushion a few lucky souls. Free markets work because they allow some people to get lucky—winner takes all. The bureaucratic protocols of art-by-paperwork have nothing in common with the experimental nature of an artistic gesture. Yet, they have become the only setting for many artworks that will never exist beyond the template of the funding application—the new White Cube.

I wish to add that even the decision-makers and stakeholders of the system have no real choice in the matter. Many have tried to change things from within, but they, too, are part of the fight for survival. For there is always a hierarchy and never enough time. One is reminded of Tarkovsky's *Stalker* (1979), in which the eponymous hero/guide leads a writer and a scientist into the fiercely protected wasteland known as the "Zone." The Zone is a complex terrain filled with traps, subtle distortions, occasional dangers. It is a spatialized force that seemingly knows your mistakes, your weaknesses, your paranoias, and possesses an uncanny ability to make your innermost desires come true. In a bitter plot twist, the film reveals that we are not as altruistic as we believe and our innermost wishes are not what we believe them to be. After all, we have been educated by the recursive loops of capital, and the only way to be safe from the inner desires capitalist loops breed is to omit the singular human in favor of the digital code and an active horizontal community.

The Black Swan
The former options trader and risk analyst Nassim Nicholas Taleb defined the "black swan" as a rare and unpredictable event that is, in effect, a game-changer. Usually the black swan event loses momentum as others feed off the unique attributes of its narrative, appropriating it to gain an advantage. A decentralized autonomous organization (DAO) in its nascent state, is a good example. Many refuse the concept of a black swan, arguing that the whiteness of a swan is the very essence of any-thing swanlike, just as many refuse the potential of a decentralized orga-nization, arguing that an organization needs to be (centrally) managed.

For the record, I believe in both black swans and DAOs. Instead of a hierarchical structure managed by a set of humans who interact in person and control an organization's assets in accordance with the law, a DAO is a decentralized organization, involving a set of people who interact with each other according to a protocol specified in code and enforced on the blockchain. The DAO works in the service of a distrib-uted network of autonomous stakeholders rather than following a tra-ditional top-down management model and are run by rules encoded in computer programs called "smart contracts." They live within the Inter-net, exist autonomously, and hire individuals to perform certain tasks. Once deployed, the code/entity operates independently and cannot be influenced by its creators. A DAO aims to be open source and is thus transparent and incorruptible. The rules of a DAO financial transaction record and program are stored on the blockchain for anyone to see—

which also means decisions regarding how funds have been allocated are fully transparent to its users. A DAO also works via consensus, so in order to withdraw or move funds, a majority of its stakeholders have to agree. Decisions are typically proposed by a given stakeholder and voted on by the rest of the group. Here is how I imagine a potential DAO Swan would work within the Berlin art field.

DAO Swan

The DAO process can be utilized not only for monetary transactions but also to supply users with materials, platforms, and connections. As conceived, DAO Swan could split users into two categories: silent and active. Silent users would provide assets for active users. The DAO Swan would facilitate this via a support membership; silent members could pledge a certain sum per year, whether calculated monetarily or through other services. This in turn requires a credit system to be laid out by the DAO Swan team, a system that can always be changed retrospectively, even though it is set in code—regardless of the original party's ideas. This system means the silent stakeholders gain cultural kudos, and the active users gain tools, funding, and connections. Below is a preliminary example of how, once built into the software of the DAO Swan, credit pledges might work.

Certificate: The Room – fifty credits awarded to the DAO Swan annually

Certificate: The Window – thirty-five credits awarded to the DAO Swan annually

Certificate: The Door – fifteen credits awarded to the DAO Swan annually

As envisioned, a blue-chip gallery or city-run institution would operate on a "Room" certificate, whereas an emerging commercial gallery might opt for "The Door." But let us not lose sight of the fact that participants are not awarded credits for monetary exchange alone.

So, how do the silent stakeholders fulfil their credit obligations?

Each asset is rated according to its value within the credit system. One thousand euros might equal five credits, for instance, while using your newsletter to push a project space show could be valued at two credits.

The DAO Swan would calculate every transaction pledged and keep track of its value. Monetary funds would be used by the active stakeholders to realize specific projects, if the majority of active stakeholders agree, via a horizontal network of fund allocation.

Why a quadratic system, rather than a single-vote procedure?

Quadratic voting means the user has multiple votes and can vote for various options or abstain until the next round without forfeiting their vote. This allows collective decisions to be made without the tyranny of the majority, with votes cast according to how strongly people believe in an issue (as opposed to the binary choice of "Yes" or "No"). The voices of marginalized members can put all their votes in one basket so as to ensure one proposal going through, whereas another member might distribute their vote across several proposals.

And what do these gift-giving credits amount to?

Money is not the only unit to navigate the Zone, and credit is available for nonmonetary help. This would allow for the start of a decentralized microgrid to be built inside the DAO, one that locally manages a self-sufficient network. Thanks to the decentralized sharing of energy, at a local level, between multiple venues, a DAO Swan's strength could be seen as either:

GIFT GIVING – Donating materials postshow, as opposed to dumping them.

HOSTING – Offering desks or spaces for residencies, one-off events, and summer break shows.

GOSSIPING – Letting active users squat your newsletters, social media, and fair booths.

CONNECTING – Offering mentorship, technical support, or coordinating opening events with local off-spaces.

The silent stakeholder would aim to fulfil their quota of credits throughout the year in various ways. And an active user with such support could eventually become a silent stakeholder.

Why would the silent stakeholders do this to begin with?

Cultivating a stronger emerging art scene is in everyone's favor. The DAO Swan doesn't abolish capitalism, nor the bulk production of art, but it does provide incentives to work as a professional community. The model provides an environment for self-organized funding and autonomy, benefiting a small node within the wider art network. The DAO Swan aims to remunerate intensity, commitment and dedication rather than property, power, or status. None of which detracts from art being produced—in fact, art should thrive under such conditions. That in turn would ensure the silent stakeholders' long-term returns. A DAO Swan is not a divine savior but a potential microgrid model for emerging artists and creators.

Now is the time to make the machine work for its users, allowing them to gain strength. The arts are more than a market; they're emotive by nature and hence even more open to tropes of human affect than most marketplaces. A change in our economic procedures could be harnessed well beyond the DAO Swan microgrid, flooding the remaining nodes within the network. The art world is just an idea, as is the Devil, or market value—but we all know ideas become reality when enough people believe in them.

This essay could not have been written without the critical feedback and inspiration of Jonas Schonenberg, Calum Bowden, Kei Kreutler, Catrin Mayer, Maurin Dietrich, Jan Malte Kunkle, Chloe Stead, Kate Brown, Alicia Reuter, and all the others who have been thinking with me over the years.

terra0: An Introduction

By Paul Seidler

Intro

In a 2016 white paper, my collaborators and I described terra0 as working on the concept of a "self-owned forest," and as an ongoing art project that aims to create a prototype for "self-utilizing land":

> terra0 creates a framework whereby a forest is able to sell licenses to log its own trees through automated processes and smart contracts. In doing so, this forest accumulates capital. A shift from valorization through third parties to self-utilization makes it possible for the forest to procure its real exchange value. With this capital it buys itself from the project initiators and [eventually] owns itself. The augmented forest, as owner of itself, is in the position to buy more ground and therefore to expand.[1]

Rooted in the development of distributed ledger technology and current debates regarding the relation between culture, nature, and technology at large, we have now worked on terra0 for four years. Rather than dwelling on technical specifications or similar matters, I will focus here on four key conceptual frameworks that define our collective efforts as programmers and artists:

1. autonomous agents
2. the forest and the outside
3. terra0 itself
4. Flowertoken & Premna Deamon

1 Paul Seidler, Paul Kolling, and Max Hampshire, "terra0: Can an Augmented Forest Own and Utilise Itself?" Berlin University of the Arts, 2016, https://terra0.org/assets/pdf/terra0_white_paper_2016.pdf (accessed October 18, 2021).

1. Blockchain as an Enabler of Truly Autonomous Agents

To understand the origin of terra0, discussing both technologies such as cryptocurrencies, and the relationship between capital and nonhuman actors (e.g., computational actors such as programs and bots), is important. The former can be considered distributed money, backed up through computation. Cryptocurrencies like bitcoin enable programs that administer capital, without any verification necessary from a human user. For example, when you open a new bank account, you have to provide an ID, while bitcoin only needs software. The only requirement for a bitcoin wallet is an operating system with sufficient memory—such as a personal computer—or any virtual machine that runs on an external server. It is thanks to cryptocurrencies that speculation with derivatives, algorithmic trading and the creation of new financial products are now widely available.

In 2011, in a thread called "Bitcoin the enabler—a Truly Autonomous Software Agent roaming the net," a user called "julz" pitched the idea of an autonomous agent: "For the first time, there exists the possibility for a software agent to roam the internet with its own wallet. Using Bitcoin [sic]—it could purchase the resources it needs to survive (hosting/cpu/memory) and sell services to other agents or to humans. To be truly effective and survive 'out there on the net' long term, you'd probably need some basic AI and the ability to move itself between service providers occasionally—but even a relatively dumb agent might survive for a while." There are no implemented examples of autonomous agents just yet—with the exception, perhaps, of computer viruses—but in 2013, Vitalik Buterin and Gavin Woods developed the idea further in their "Ethereum White Paper: A Next-Generation Smart Contract and Decentralized Application Platform." Here they describe complex programs which can administer capital with a specific set of rules. (Buterin and Woods were building on computer scientist Nick Szabo's 1993 concept of "smart contracts." Szabo was hoping to merge contract jurisprudence with e-commerce protocols. His smart contracts are computer protocols that verify and enforce the performance of a contract.)

While julz in his/her thread alluded to systems capable of administering bitcoin globally, the programs he/she evoked still ran locally. Buterin and Woods' smart contracts, on the other hand, enabled programs which could accumulate capital in a decentralized fashion, in the form of programmable "wallets" in distributed ledgers.[2] Buterin developed this con-

2 Distributed ledger technology generally describes a kind of technology that allows for a decentralized documentation of transactions, where a network of actors agrees on a shared transaction database through a consensus algorithm. Bitcoin and the "proof of work" consensus made completely decentralized coordination possible for the first time, making bitcoin the first ever decentralized currency.

cept further in "Bootstrapping a Decentralized Autonomous Corporation: Part I" (2013): "A very interesting question arises: do we really need the people? ... The question is, can we approach the problem from the other direction: even if we still need human beings to perform certain specialized tasks, can we remove the management from the equation instead?"

According to Buterin, once an intelligent agent operating via some decentralized infrastructure is granted control over a given amount of capital, the system in question is not merely an AI that controls capital but an artificially intelligent decentralized autonomous organization in its own right. One could easily imagine such autonomous organizations at the heart of hosting services—or trading platforms for that matter—but can one imagine them managing property or physical assets? In a 2014 post entitled "Deodands: DACs for Natural Systems," science fiction author Karl Schröder became to my knowledge the first person to raise this question: "Do you think DACs [Decentralized Autonomous Corporations] could be used by our non-human ecosystem? . . . The rather simple question underlying this idea is, why stop at corporations as persons? Rivers, watersheds, coral reefs, mountain biomes, all could be represented by DACs, and the goods and services they provided defined in their charter."[3]

According to Wikipedia:

"Environmental personhood is a legal concept which designates certain environmental entities the status of a legal person. This assigns to these entities, the rights, protections, privileges, responsibilities and legal liability of a legal personality. Environmental personhood emerged from the evolution of legal focus in pursuit of the protection of nature. Over time, focus has evolved from human interests in exploiting nature, to protecting nature for future human generations, to conceptions that allow for nature to be protected as intrinsically valuable. This concept can be used as a vehicle for recognizing Indigenous peoples' relationships to natural entities, such as rivers."[4]

3 Karl Schröder, "Deodands: DACs for natural systems," *Ethereum Community Forum*, February 2014, https://aitwb-dev.qa-archive-it.org/16516/20210623214740/https://forum. ethereum.org/discussion/392/deodands-dacs-for-natural-systems (accessed July 22, 2021).
4 "Environmental Personhood," Wikipedia, September 1, 2017, https://en.wikipedia.org/wiki/ Environmental_personhood (accessed June 23, 2021).

At present, New Zealand already possesses two nonhuman legal entities: the Whanganui River and Te Urewera National Park.

Questions regarding property, land ownership, and personhood were what sparked our 2016 white paper, which began with the following claim: "From an economic perspective, an object cannot be separated from its purpose or function. Thus, the means of the existence of every object is based on its usability by third parties." This perspective grants ontological status to the option of usability. Value is either defined by use (similar to a tool) or by means of inherent or fixed capital.

All of which brings me to the next point: the history of forests and capital.

2. The Forest and the Outside

The origin of the word "forest" is the Latin *foris*, meaning "outside," implying something extrinsic to the city or state and reflecting feudalism's relationship to nature. The forest lies outside the *nomos*, the rules and customs of the city, which defines itself in contrast to that which pertains in the hinterland, woodland, etc.: "Outside of the law and human society one was in the forest. But the forest's asylum was unspeakable. One could not remain human in the forest."[5]

To the Western imagination, the forest is indeed haunted by nonhuman entities. Beasts, spirits, demons, witches, trolls, werewolves, and other uncanny creatures all dwell there. Even the fauna get stranger the further in you go: wolves, bears, dragons, giant spiders, and worse. Ambushes, traps, masked bands of robbers, serial killers, malicious eyes peering from every shadow, weird noises day and night. Forests can be cursed. In forests people disappear, go mad, become infected, or become prey. Even the trees themselves perhaps are hostile entities.

But let us ground this idea of an "outside" further in historical fact. As Robert Pogue Harrison demonstrates in his analysis of forest law, the Middle Age forest was not a lawless space, as the term *foris* implies banishment, proactive exclusion, and also refers to legislation passed by the aristocracy to exclude serfs and peasants from their own forest lands. In fact, "forest" came into being as a legal term to denote woodland removed from the commons by feudal institutions.[6] (An early form of ecological preservation was conceived and implemented by monarchs, who separated spheres of economic production from those of supposedly

5 Robert Pogue Harrison, *Forests: The Shadow of Civilization* (Chicago: University of Chicago Press, 1992), 61.
6 Ibid., 69.

untouched nature. The forests of Europe are the legacy of an absolute regal claim to dominion over both these spheres.)

This claim to absolute mastery remained hypothetical and tentative until the Age of Reason brought about new possibilities. With its mathematical methods and empirical calculations, the Enlightenment finally realized the dream of mastery over nature. While the medieval monarch had regarded the forest as a quasi-symbolic wild space, this changed fundamentally with the new sciences of the Enlightenment and, in particular, with modern forestry. By way of static mathematical formulae, the forest was reduced to pure raw material and yield, especially of lumber.

The discipline of forestry reflected the two main intellectual schools of the day: Cartesian rationalism and the English Enlightenment. It was this synthesis of mathematical calculation and empirical observation which helped subject forests to the criterion of "usability," foregrounding in turn the notion of profit. The Enlightenment achieved what was previously unthinkable, enabling the forest to not only be reduced to a material resource but to an economy of use—a usefulness embodied by the enlightened forester as a guardian of growth (it could even be said that modern forestry was born in Germany on the day in 1800 that Friedrich Schiller met a forester, heralding him as "free from egoism and tyranny," thereby creating a figure of popular inspiration for generations to come).[7] Forest management was one consequence of this new science. Coniferous forests and monocultures replaced mixed forests, and wood plantations were planted. Its influence on the first models of terra0 must also be acknowledged here. Our predominant cultural heritage remains to this day the Enlightenment Age.

3. terra0: A Definition

These two conceptual genealogies—the relation between forests and civilization and technology underlying autonomous actors—are what led to terra0 a deployment of autonomous agents as proxies for natural systems that use and own their own techno-ecological resources. We argued at the outset of our project that this could be realized in different ways and at varying levels of complexity. We first envisaged a feedback loop based on satellite data that would analyze a demarcated ecosystem, deciding which trees would be automatically sold to service contractors in order to maintain the forest at large. We imagined a forest managed

7 Cf., Walter Kremser, *Niedersächsische Forstgeschichte. Eine integrierte Kulturgeschichte des nordwestdeutschen Forstwesens*, Rotenburger Schriften, Sonderband 4 (Heimatbund Rotenburg, 1990), 10.

by a smart contract without any human oversight. We wanted the human out of the loop.

Despite an enthusiastic reception, including state-funded research projects such as terra1, the plan was never realized. On a speculative level, economic sustainability—the attempt to use the idea of "usability" against itself—proved a bigger challenge than we initially assumed. On a practical level, our hands-on experiment in a Brandenburg forest 20 km from Berlin offered too many obstacles to be mentioned here. At a certain point, we decided to revert to smaller-scale experiments, two of which I will briefly summarize here.

4. Flowertoken & Prenma Deamon

Flowertoken was an experiment that tokenized and verified natural commodities, a first attempt at creating a combined crypto-collectible physical asset. The project ran for four months and was arguably the first attempt to tokenize living plants. Users could buy, trade, and speculate on tokenized dahlias via an online marketplace. The state of the individual tokens was automatically updated according to the different phases of the plant's growth. Every plant was represented by an individual ERC721-standard Flowertoken, held on the ethereum.org mainnet. The physical installation consisted of a grow rack, one hundred dahlias, and a web interface showing the state of the tokenized flowers. The setup was monitored 24/7 by a camera system that provided images for the website, as well as data updating the tokens' status once a day, according to the respective flower's condition.

Premna Daemon is an installation and prototype that was exhibited at the Schinkel Pavillon in Berlin as part of the group show *Proof of Work* (2018). The system consisted of a bonsai tree (a Premna Microphylla), a web interface, several sensors and cameras, and a smart contract on the Ethereum mainnet.

The Premna Daemon bonsai was augmented with technological prostheses that allowed for a financially mediated social contract between the tree and the operators of the *Proof of Work* exhibition. The operators committed to care for the Premna Daemon (watering, lighting, trimming, etc.), but only when the Premna itself requested assistance. It did so by sending Ethereum currency to a wallet owned by the gallery. The currency used for these requests was donated to the Premna by users via a web interface.

Instead of presenting another passive object in need of care, *Premna Daemon* showed the potential for nonhuman systems to gain the status of autonomous peers. By placing all interactions between a system of

this sort and surrounding human actors firmly within the realm of financial exchange, *Premna* showed how autonomous systems can engage in relationships previously occurring only between humans. Indeed, nonhuman autonomy is not only possible, it can be crowd-funded. *Premna Daemon* is a move away from passive objecthood and towards financially enabled peerage.

Based on this experience, we are planning a version of terra0 that takes the legal implications of self-ownership to more rigorous con-clusions. The implications for a fully functional terra0, as you might imagine, could be huge. One way or another, we'll get there sooner or later. For now, time is on our side.

Speculative and Practical Responses to Problems Bemoaned in the Provisional Global Snapshots

Tirdad Zolghadr

This essay will again look at options from a state policy purview before circling back to CA—with Berlin again as a favored case study—but this time with an eye toward possible futures rather than fuck-ups of the past and present. What the strategies glossed below have in common is their time-sensitivity. The same ideas can be helpful today, productive tomorrow, or repressive the day after, depending on the phase of divestment or development a city finds itself in. After all, the terrain we are navigating comes with extraordinary time scales of its own: Rome is still tied together via a network of ancient roadways;[1] the Enclosures still make a walk through the south English countryside a picturesque zigzag; plans to upgrade working-class Kreuzberg were hatched many decades before they came to fruition.[2] Even the minutiae of maintenance reflect chronopolitical choices: renovations can be windows of opportunity for vicious upgrades or an incremental means to achieve social sustainability.

Time factors aside, what the examples below highlight even more clearly is that the resurgence of location and distance as key categories was ongoing well before COVID-19. Contrary to expectation, space has not collapsed. If anything, mobility has become, as Can Onaner argues, a hallmark of oppression. Prisons and asylums are less frequently sites of protest than airports, highways, or railway lines. Violence is increasingly epitomized by lines of flight rather than barbed wire.[3] The brutally elegant settler highways that entwine the West Bank offer a perfect case in point.[4]

Consider the ethereal workings of capital. They seem magically deterritorialized, abstract, and impenetrable, but at some point they do need a real-world foothold on the ground. To quote Matthew Soules: "The

1 Carl-Johann Dalgaard, Nicolai Kaarsen, Ola Olsson and Pablo Selaya, "On Roman Roads and the Sources of Persistence and Non-Persistence in Development," *Vox EU and CEPR*, https://voxeu.org/article/roman-roads-and-persistence-development (accessed October 6, 2021).
2 Esra Akcan, *Open Architecture: Migration, Citizenship and the Urban Renewal of Berlin-Kreuzberg by IBA 1984/87* (Basel: Birkhäuser Press 2018).
3 See Christopher Roth's *The Schengen Tapes*, a 90 minute film for the University of Luxembourg, 2017.

ostensible realism of real estate must remain for the logic of its financial-ization to persist—and this reality is founded upon an ongoing material in the physical world."[5] There is a remainder, an offline manifestation, where the logic of finance must inevitably come home to roost. Although capital tends to reproduce itself as if it were a self-sustaining system, it relies on patterns on the ground. It is here that it can be confronted. Services, supplies, compliant bureaucracies, anxious residents, colonial appetites: none of these are guaranteed by an inescapable logic; all of them are cluttered and muddled. For now, space rarely moves as fast as capital demands. As Rachel Weber puts it: "The accumulation process experiences uncomfortable friction when capital (i.e., value in motion) is trapped in steel beams and concrete."[6]

Policy

In the first pages of this book, I held the state responsible for much of what is happening. The following pages honor how governments have on occasion redeemed themselves, with policy itself being only the tip of the iceberg, one single part of a larger equation.

To paraphrase onetime UN Special Rapporteur on adequate housing Raquel Rolnik, the right to the city is not about legislation alone so much as creating an entire living environment. By way of example, I've always found it impressive that in a chichi town like Zurich nearly 25 percent of all tenants live in cooperatives. Then again, if you're not of the right habitus, life in Zurich feels like roughing it on Jeff Bezos' front lawn. A claim to a city needs a socioeconomic stage from which to resonate, a transversal layering of playing fields that are legal, discursive, iconographic, etc. It is hardly coincidental that a US lawsuit equating urban renewal with racial segregation emerged in the wake of the Black Lives Matter movement.[7]

4 Omar Salamanca, "Road 433: Cementing dispossession, normalizing segregation and disrupting everyday life in Palestine," in *Infrastructural Lives*, eds. Stephen Graham and Colin McFarlane (London: Routledge 2014). I'm reminded of Edward Said's insistence that the Palestinian cause depends on laying claim to a territory as well as an idea, put forward in "Zionism from the Standpoint of its Victims," presumably in response to friends and comrades, from Jean Genet onwards, who suggested the cause may fare better as an idea in time than as a geography. Moustafa Bayoumi and Andrew Rubin, eds., *The Edward Said Reader* (London: Vintage 2000), 131; Jean Genet, *Un captif amoureux* (Paris: Gallimard, 1986), 484.
5 Matthew Soules, "Financial Formations," in *Industries of Architecture*, eds. Katie Lloyd Thomas, Nick Beech, and Tilo Amhoff (London: Routledge, 2015), 208.
6 Rachel Weber, "Extracting Value from the City," *ANTIPODE* 34, 2002.
7 Paul Schwartzman, "Lawsuit: DC Policies to Attract Affluent Millennials Discriminated against Blacks," *The Washington Post*, May 25, 2018, https://www.washingtonpost.com/local/dc-politics/lawsuit-dc-policies-to-attract-affluent-millennials-discriminated-against-blacks/2018/05/24/3549f7fe-5a1e-11e8-858f-12becb4d6067_story.html (accessed June 23, 2021).

Andrej Holm groups progressive policy into four approaches: support for collective ownership, affordable housing subsidies, public landownership, and the reining in of private interests. For her part, Lisa Vollmer suggests a triumvirate of affordability/democratization/decommodification.[8] The ensuing section is indebted to both these scholar-activists but exploits the leeway afforded by a curatorial perspective, favoring a more patchy, CA-centric approach. The master tropes here are land, surplus, and democratization, but also scale/propaganda and *not doing anything at all*.

Universal Basic Land

In an essay on Venice's legendary wealth in the Renaissance, the political philosopher Wolfgang Scheppe argues that the city wasn't rich because it was a merchant city, it was a merchant city because it was rich—thanks to ground rent collected by the patrician classes.[9] The Venice situation is reminiscent of another fabled example—the Catholic Church, whose enduring wealth stems from its dogged refusal to sell Church land (currently estimated at over 170 million acres). This is a good 4,200 times more than McDonald's, another real estate enterprise disguised as something else entirely.[10] These fountains of wealth do not spring from merchant savviness, indulgences, or burgers, but from landholding.

Land is weird, and in many ways antithetical to capital. If capital is intrinsically mobile, land is intrinsically stuck. But capital relies on land, while the opposite is not the case. If capital is contingent on space and time, land *is* space. Jurisdiction, taxation, property rights make the supply and demand of land even more contingent on class relations than the supply and demand of other things.

Patent weirdness notwithstanding, land has rarely been considered a distinct category in mainstream economics, one of those academic obfuscations that played a big role in modern history. The refusal to acknowledge the specifics of land served to isolate nineteenth century reformists such as Henry George, whose Land Value Tax (LVT) might otherwise have found some decisive allies. The skepticism of both liberals and socialists was detrimental to the long-term traction of LVT, which hinges on land as an exceptional category. In essence, it was premised on the simple idea that instead of taxing income, or property in general, one should tax only land, at 100 percent of its value.

8 Lisa Vollmer, *Strategien gegen Gentrifizierung* (Stuttgart: Schmetterling Verlag, 2018), 74.
9 Wolfgang Scheppe, "The Ground-Rent of Art and Exclusion from the City: The Exemplary Quality of Venice's Singularity," *ARCH+: The Property Issue*, May (2018): 14–31.
10 See the delightfully obnoxious Michael Keaton as Ray Kroc in *The Founder* (2016).

Although he was all but forgotten during the twentieth century, George was once a public intellectual who utterly eclipsed Karl Marx in stature. George's funeral clogged the streets of Manhattan and Brooklyn, while Marx's tiny congregation would have easily fallen inside COVID-19 restrictions. His vision included socialized healthcare and what we now call Universal Basic Income. Even his propaganda was adventurous, including traveling shows and the board game Monopoly, devised by a supporter as a form of anticapitalist pedagogy. Georgeism is now enjoying a revival, and has proven a viable model in Hong Kong, for instance, where the subway is the fruit of LVT. Anyone who has been to Hong Kong knows the subway is state-of-the-art, and that even though fares are dirt cheap they actually contribute to the public purse.

As long as banks use land as collateral, prices will be inflated. According to economists of various stripes, the price of land accounts for over 80 percent of the increase in housing costs since World War II;[11] large-scale public investment, in particular, leads to staggering profits for landowners who may have little incentive to use their land productively and prefer to wait for golden opportunities to arise. The Jubilee Line, for instance, lifted the value of land within 1,000 yards of each station 3.7 times over, by an aggregate total of thirteen billion GBP.[12] It is only once land loses attraction as a currency, qua Georgeism or otherwise, that it no longer factors as a major part of our cost of living. In developing his notions around land value, George would have been influenced by David Ricardo, that political economist of the classical liberal age (and Marxian pushpin), who argued that growth benefits landlords disproportionately: as long as land is unequally distributed, market economies will inevitably produce rising inequality.[13]

LVT aside, price freezes on land are a going practice in Germany, when plans for new municipal housing are announced. Another option is outright public ownership. Berlin has just set up a municipal land fund, but 90 percent of the land in Singapore has long been in state hands, and in Switzerland, the 2016 *Bodeninitiative* referendum in Basel City that prohibited the sale of public land, and introduced a mandate

11 See Katharina Knoll, Thomas Steger and Moritz Schularick, "No Place Like Home: Global House Prices, 1870–2012," in *American Economic Review* 107, Feb. (2017), or Dirk Löhr, "Die Geoklassik von Henry George bis heute," in *Henry George: Fortschritt and Armut* (Weimar bei Marburg: Metropolis Verlag, 2017), XXV.
12 Mike Lewis and Pat Conaty, "Community Land Trusts, Land Reform and the Commons," *COMMONS TRANSITION*, July 7, 2015, https://commonstransition.org/community-land-trusts-urban-land-reform-and-the-commons (accessed October 6, 2021).
13 His emphasis on rents was surely related to witnessing the aftereffects of common land turned into private property, cf. the Inclosure Act of 1773 (I owe this point to Michael Baers).

to acquire more of it, won a two-thirds majority. Why squander a finite resource? The sense of Mark Twain's quip to "buy land, they ain't makin' it any more" seems to slowly but surely be sinking in as policy.

In terms of the smart usage of existing public land, there is a form of leasehold that allows for flexibility without forfeiting long-term bargaining power called *Erbbaurecht* (hereditary building right) in Switzerland and Germany. The state barters building rights on a given plot of land, retaining the option to reclaim it after a predetermined number of decades. The public remains sovereign and can contractually define how the land is to be used in the long-term.

Universal Basic Surplus

Friedrich Engels, catty as always, once remarked that the bourgeoisie never solve housing problems, they only circulate them. Today, as precariousness spreads, the bourgeoisie, too, is feeling the pinch, and an appreciation of living space as a common necessity rather than charity is more noticeable than in Engels' day. There's no telling how long the moment will last.

In Berlin for now, as in much of Europe, local political parties are less timid than their federal counterparts. The mere threat of using compulsory purchase power has occasionally been enough to steer and incentivize the private sector. Europe has also seen refreshingly aggressive takes on rent hikes, sublets,[14] speculation, landed inheritance, absenteeism, and foreign ownership (even the Swiss have placed a handbrake on the latter). As piecemeal efforts, these can be more or less effective (the Berlin rent cap approved by the Berlin Senate was struck down in federal court on jurisdictional grounds); as a combined package, they may spearhead a cultural shift that would slowly deindividualize the idea of ownership altogether.

A sensational example is the successful referendum *Deutsche Wohnen & Co. enteignen*, which seeks to expropriate the twelve biggest real estate firms in Berlin—a yield of nearly 250,000 flats. Many have framed this initiative as a mugging of industrious real estate professionals; others see it as a return, a means of turning back the clock, reacquisitioning public assets offloaded for scraps in the 1990s and early 2000s. A present-day snapshot is rarely sufficient to discuss dispossessions past. Rising prices are not the results of brilliant real estate brokers but of

14 The introduction of stricter regulation led to AirBnB shrinking by 80 percent in Amsterdam, cf.: "AirBnB verliert 80 Prozent seiner Vermieter in Amsterdam," *Der Spiegel*, October 18, 2021, https://www.spiegel.de/wirtschaft/unternehmen/airbnb-verliert-in-amsterdam-80-prozent-seiner-vermieter-a-24499d61-2d0b-44e5-ba5c-92f558cb2d1a (accessed October 23, 2021).

societal input and collective growth. Returns can be distributed as such. Thus, claims to a rightful share of the surplus will depend on when and where your narrative commences.[15]

Big Volume

To secure a genuine share of the surplus may also require an XL momentum of big, bold brush strokes. Recent efforts sound meek in comparison to the mid-twentieth century. For example, the 320 million euros Berlin earmarked for affordable housing in 2014, though significant, did not amount to half the price of the palatial Humboldt Forum, a shrine to the feudal aristocracy of Prussia (see Marco Clausen's contribution to this book). As an example of this vast difference in scale between then and today, take Sweden's Million Programme. (Always annoying to point to Sweden for examples of good governance, but humor me.) In only nine years (1965–1974), the Swedish Social Democrats built over one million units, which today *still* constitute over a quarter of the country's national housing stock. The ambition to lift all boats was also reflected in tenant bargaining power, material quality, and the prestige it enjoyed in the public eye: modernization drives of this kind once allowed the public to set the tone and the standards, over and above private interests. Economies of scale such as the Million Programme produce ripple effects over generations to come.

In the longer run, of course, prestige is not rooted in material quality alone so much as broader shifts in ideological perception. In today's UK, no one would be surprised to hear that 15 percent of public housing is substandard—if anything, they'd say the number lowballs the actual state of affairs—but who would guess that the percentage of substandard units in private housing is twice as high?

The blanket disrepute of the modernist project, XL planning agendas along with it, has many causes. The disinvestment that results from this becomes a self-fulfilling prophecy. Housing that is demonized and underfunded will fail: the smaller the segment of the population that lives there, the more demonized and underfunded it will be. The political connotations of public housing's fall in public estimation are that state-funded housing provision has become an emblem of a broader left-

15 Perhaps the idea of a "right of return" can apply to settings all across the spectrum of primitive accumulation (beyond what is now Israel). In 2015, for instance, Portland invested $96 million in the Interstate Corridor area—partly for new construction and partly to help previous residents "buy their way back." Andrew Theen, "Gentrification: Can Portland Give Displaced Residents a Path Back?," *The Oregonian*, December 23, 2015, https://www.oregonlive.com/portland/2015/12/gentrification_can_portland_gi.html (accessed June 30, 2021).

wing failure, caught between champagne socialist betrayal and concrete commie-blocks. Regaining the ground lost is both an economic imperative and an aesthetico-discursive challenge.

To be sure, modernist planning played a key role in slum clearances, imperial master plans, Third World authoritarianism, and many other shades of primitive accumulation. "Save Covent Garden" was a rallying cry for hippy radicals in 1960s London; Jaffa made room for Tel Aviv as a "Bauhaus by the Sea" (or a Dessau-on-the-Mediterranean) in 1940s Palestine;[16] and in 1930s Algiers, Le Corbusier's proposals were a classic case of madcap imperial "phallocracy."

For all the references to a "creativity of the poor," modern developments often made the Enclosures look friendly by comparison. Concrete was the building material of choice, even when traditional materials would have been more functional.[17] To this day, that cookie-cutter stylistic tendency prevails. Berlin public housing, for example, caters not to single households, which make up 54 percent of the population,[18] but to nuclear families— even if those twisted perverts comprise a mere 17 percent of the city's demographic.[19]

Might a command economy be retrofitted, after the fact? It does seem so. Examples of meaningful, peaceful service to even the most vulnerable of populations are legion. For reusable tropical modernist hardware, see Oraib Toukan's study of "sundry modernism" across Palestine (Sternberg 2016), the *Bauhaus Imaginista* spotlight on developments in Nigeria,[20] Solmaz Shahbazi's work on XXL housing complexes Tehran,[21] etc. (whenever such ensembles are demonized in the evening news, the homegrown testimonies tend to be all the more surprising).

16 See Sharon Rotbard, *White City, Black City: Architecture and War in Tel Aviv and Jaffa*, trans. Orit Gat (Boston: MIT Press, 2015).

17 See Owen Hatherley, *Landscapes of Communism* (London: Penguin, 2016), 25, or Sandy Isenstadt and Kishwar Rizvi, "Introduction: The Burden of Representation" in *Modernism in the Middle East*, eds. Isenstadt and Rizvi (Seattle: University of Washington Press, 2008), 21.

18 "Living Space: Alliance for Social Housing Policy and Affordable Rent," Berlin Senate Department for Urban Development and Housing, December 10, 2014, https://www.stadtentwicklung.berlin.de/wohnen/wohnungsbau/en/mietenbuendnis/ (accessed August 15, 2021).

19 Thorkit Treichel, "Neue Statistik: der Berliner ist kein Familienmensch," *Berliner Zeitung*, October 5, 2016.

20 Bayo Amole, "The Legacy of Arieh Sharon's Postcolonial Modernist Architecture at the Obafemi Awolowo University Campus Ile-Ife Nigeria," *bauhaus imaginista journal*, http://www.bauhaus-imaginista.org/articles/6222/the-legacy-of-arieh-sharon-s-postcolonial-modernist-architecture-at-the-obafemi-awolowo-university-campus-in-ile-ife-nigeria (accessed October 6, 2021).

21 Solmaz Shahbazi and Tirdad Zolghadr, *Tehran 1380*, documentary film, 2002.

The common ground of any modernism is the knowledge that the future will be something else. For all its shortcomings, it is that willingness to try and fail that offers a blueprint here—a time regime beyond the endlessly contemporary—and any chronopolitical alternative to the omnivorous present that rules the day is nothing to be scoffed at. Capitalizing on a durable future, convincing one another of the durability of that future, is an exercise that depends in equal measure on both representation and material investment. As Timothy Mitchell puts it, "representation plays its part not just as some general question as to how the built creates meaning [but] in constructing the forms of capitalized futures with which we live."[22]

For better or for worse, schools and railroads aside, few public efforts stand up as dramatically for a collectively capitalized future as the modernist *batîments quartiers* in the sky. By way of comparison, take the postmodern condo, where the vertical thrust (one unit per floor) is what both maximizes the view and minimizes interaction.[23] Splendid isolation as an aesthetic means to an anomic social end. Modernist bottle racks embody a polar opposite of honeycomb density and cubic visibility from afar. What if we didn't go for concrete slabs over Covent Garden, but wooden ones, over former expressways, managed and co-owned by tenants themselves, etc.[24] Weirder things have happened.

Don't Be an Asshole

At a neighborhood SPD meeting in Moabit one winter evening in 2018, Rainer, a feisty left-liberal journalist and published sommelier, captured the prevailing mood. Infuriated by government inaction, he thundered, "We need to build, immediately! Look at all the homeless!" Agitation did not prevent him from coining one of those neologisms German speakers are famous for: *Neubauverhinderungsstimmung* (new-build-obstruction-mood). Limits on new construction had indeed been imposed by a red-red-green coalition, to the exasperation of Rainer and his liberal allies, left and right, who demanded development and density now, now, now. The clock is ticking. By 2030, a billion new flats will be necessary worldwide. One billion. A thousand million! That's a lot of millions.

Again, I prefer not to mess with angry Berliners. Were I more coura-

22 Timothy Mitchell, "The Capital City," in *The Arab City: Architecture and Representation*, eds. Nora Akawi and Amale Andraos (New York: Columbia Books on Architecture and the City, 2016), 261.

23 Soules, "Financial Formations," 204.

24 See for instance the insistence of the *Deutsche Wohnen & Co. enteignen* initiative on communalization via an *Anstalt des oeffentlichen Rechts*, a "body under public law" as opposed to outright state ownership.

geous, I would have argued for seeking political alternatives to growth, construction, and development. An even stronger argument, one that might give pause to the Rainers of the world, is that, sustainability aside, land is just too expensive nowadays. Anything built under current conditions, even by co-ops and philanthropic foundations, would need to be leased at twice the rent considered affordable under current economic conditions.

Rainer would have probably retorted that if you build for the well-off, they can cross-subsidize slots for the working-class. This has been attempted often enough. In transport systems, they call it "induced demand": roads are built and then people wonder why traffic increases. Take the following parable by the London Architects for Social Housing: "A decade ago, the only baker on Kingsland High Street in Hackney was Greggs, where you could buy a loaf for under a quid. Nowadays, the street is lined with artisanal bakeries selling loaves at many times that price—and [Greggs] stopped selling loaves to concentrate on take-away health-food fodder for the influx of Dalston hipsters. Not only has the increased number of bakeries in the area increased prices, rather than reducing them, it has also removed the low-cost loaf for the local working class."[25]

Few things can compete with the slick teleology of middle-class cosmopolitanism. Even from the perspective of the construction sector, rental rates ideally must hit a Goldilocks sweet spot in the upper-middle range. Affordable rent is obviously useless, but astronomical rental rates that rise indefinitely are not good for investment either. Why the headache of new construction when you can lease any old cash cow to the bourgeoisie?

If one's only avenue is to bow to the gravitational pull of the upwardly mobile, you may do the city a favor by doing nothing at all. And if the goal is greater density, there are many alternatives to throwing out the welcome mat to people who possess numerous options regardless. You can tax empty homes (Paris now taxes 100,000 vacant flats, half of which aren't on the electrical grid, at 60 percent of rental value),[26] or limit office space, which is already a hot-button issue in the wake of COVID-19. Corporations use around 180 square feet per employee, and spend about

25 Simon Elmer, "Battle of Ideas: Reform or Revolution in Housing?," *Architects for Social Housing (ASH)*, October 28, 2017, https://architectsforsocialhousing.co.uk/2017/10/28/battle-of-ideas-reform-or-revolution-in-housing, (accessed October 6, 2021).

26 "Vacant Homes Are A Global Epidemic, And Paris Is Fighting It With A 60% Tax", *BETTER DWELLING*, March 2, 2017, https://betterdwelling.com/vacant-homes-global-epidemic-paris-fighting-60-tax/?__cf_chl_managed_tk__=pmd_wp4KRGe_D5eqpxuA9e3iKROh1B.F1sFiQozjJ3VoXsE-1633520606-0-gqNtZGzNAyWjcnBszRIl#_ (accessed October 6, 2021).

20,000 American dollars per head on rent, security, and tech, while cosharing models get by on 50 square feet and cut associated costs in half.[27] You can also ban cars. Parking reconversions and freeway removals free up acres and acres for humans and other stuff. Also, the right kind of renovation can be one third cheaper than demolition and building anew.[28]

I'll end by bragging that Berlin is the greenest city in Europe, with 29,000 hectares of woodland. This state of things goes back to 1915, when the city acquired 10,000 hectares of forest from the Prussian state, protecting it with a "perma-forest contract" (*Dauerwaldvertrag*). This, in the middle of World War I. Today, if you superimpose greenery, water protection zones, world heritage, listed architecture, monuments, and the Tempelhofer Feld, 50 percent of Berlin is untouchable. Exquisitely exasperating.

Bottom Up

Across Latin America, civic struggles for contested spaces share a number of traits. They've selected women as their spokespersons, fostered local ties above and beyond ethnicity and citizenship, established non-Taylorist means of production, and claimed autonomy from the state by attending to their own shelters, schools, cultural facilities, etc.[29] Even domestic violence and drugs are dealt with internally—the idea being that no good has come from external intervention, whether by way of cops or investment. Comparable modes of self-rule have been declared by self-sustaining enclaves from Kurdistan to Southern California (see also Marwa Arsanios' contribution).

At present, the reliance on external investment is being rethought with increasing insistence across the board. The latter dynamic began well before COVID-19, even if it is boosted by the latter in its planetary scale. To state the obvious, not all the claims to localized, human-scale sovereignty are equally radical. Kreuzberg, for example, is not Rojava. Immigrants surmounted terrific odds to make an extraordinary neighborhood home for themselves, but the coalitions with middle-class actors also bear fruit over time. During the *Internationale Bauausstel-*

27 "The Capitalist Kibbutz: Big Corporates' Quest to Be Hip Is Helping WeWork," *The Economist*, July 14, 2018, https://www.economist.com/business/2018/07/12/big-corporates-quest-to-be-hip-is-helping-wework (accessed July 23, 2021).

28 Esra Akcan, *Open Architecture: Migration, Citizenship and the Urban Renewal of Berlin-Kreuzberg by IBA 1984/87* (London: Birkhauser, 2018), 212.

29 See Christy Petropoulou, "Crisis, Right to the City, Movements, and the Question of Spontaneity: Athens and Mexico City," in *Crisis-Scapes: Athens and Beyond*, eds. Jaya Klara Brekke, Dimitris Dalakoglou, Antonis Vradis and Christos Filippidis, (Athens: Synthesi, 2014), 563–572.

lung, a 1980s redevelopment effort, squatters exerted decisive leverage to prevent sweeping demolitions. More recently, the city has witnessed the impressive Kotti & Co. network, or the struggle for the iconic NKZ complex in 2017. Thanks to persistent protest, NKZ did not wind up in private hands when the time came (see the strange case of social housing in Germany, above).[30]

Berlin is not the only case of countercultural elites joining shoulders with inter-ethnic solidarity networks (see Madrid in particular).[31] Democratization in the guise of "new municipalism" has struck roots across Western Europe and—contrary to more speculative, planetary ideas—pragmatic "community wealth building" tools such as credit unions, participatory budgeting,[32] "insourcing," and worker-owned firms have offered models that are producing extraordinary results today. [33] As part of the REALTY series 2018, artist Homayoun Sirizi explored neighborhood councils (*Shora-ye Shahr*) in postrevolutionary Iran, where municipal governance was reorganized into councils with a good measure of local control. These structures thrived, becoming training grounds for many a prominent politician, a certain Mahmoud Ahmadinejad among them. By and by, like other things in postrevolutionary Iran, neighborhood councils took a complicated turn.

An altogether different road to local sovereignty, however, runs straight through automation and fintech. This may appear counterintuitive, but the technology that has accelerated the capitalization of our living environment is capable of creating better scenarios. As Ruth Catlow and other artists have demonstrated, blockchain has blown apart the idea that money and value need to be channeled by a central authority (see the example of Beecoin, below).[34] Aside from alternative chains of value creation, blockchain technology also ensures transparency. Once the small print is on a distributed ledger rather than paper or hard drives, it becomes public knowledge, allowing one to see how much owners paid for a property, when the transaction was made, and on which upgrades it was based. Blockchain even enables the public to see where the money came from and what the owners are investing in right

30 "Kooperationsvereinbarung zwischen Gewobag und Mieterrat," Mieterrat Neues Kreuzberger Zentrum http://mieterratnkz.de/2019/10/01/kooperationsvereinbarung/ (accessed July 23, 2021).

31 Michael Janoschka and Jorge Sequera, "Gentrification Dispositifs in the Historic Center of Madrid," in *Global Gentrifications: Uneven Development and Displacement*, eds. Loretta Lees, Ernesto López Morales and Hyun Shin (Bristol: Policy Press, 2015), 388.

32 Matthew Brown and Rhian Jones, *Paint Your Town Red* (London: Repeater Books, 2021), 88.

33 Brown and Jones, Paint Your Town Red, 50.

34 See Ruth Catlow, *Artists Re: Thinking the Blockchain* (Liverpool: University of Liverpool Press, 2017).

now. Legal proceedings can be simplified without compromising state oversight, and overall legal costs are reduced, especially in more complex cases of collective ownership.

Initiatives like DOMA[35] apply decentralized templates to traditional co-op models, while INGOT[36] aims to finance affordable housing by trading long-term bonds on the secondary market—the idea being that the means of production are there for the taking, not by occupying factory floors but through manipulating surplus value. Other efforts aim to redefine the concept of ownership altogether. Imagine one day your belongings are localized, and your car will cease to be yours once you've moved from A to B. Or imagine property as autonomously self-organized, which means land itself may become a kind of self-owned creature, as in the artist initiative terra0 (see Paul Seidler's contribution in this book).

CA Solutions

CA is both a space of privilege in the here and now, and a means for elite formation in the near future. This hard-earned spot within the corridors of power is the upshot of a complicated chain of events. How can precarious cultural workers make the most of such privileges? We can either restructure and rechannel them, or simply enjoy them as best we can. Or we can decolonize our minds in the hope that the rest will follow, which seems to be a popular option these days.

The latter, however, sets the bar embarrassingly low when there's leverage to be had. The forces behind our built environment may seem as untouchable as ever, but there are always moments when things get grounded, materialized—and vulnerable. Whether in the shape of steel and concrete (see Matthew Soules' "realism of real estate," above), or in the shape of art. CA makes things material and visible, be they rent gaps, policy, news, fashion statements, or safe havens for capital. It is also as prestigious as it is supple. The commercial and political pressures that constrain other sectors will always force them to be responsive to their surroundings. This is hardly the case for CA. (At the Berlin Real Estate convention of 2018, I was surprised to see how CO_2 emissions were tackled. From one keynote to the next, the discourse was brimming with self-criticism and commonsensical suggestions: it took a global pandemic for CA to take its own gargantuan carbon footprint half as seriously.)

35 DOMA, http://doma.city (accessed October 6, 2021).
36 Jack Self, "The Ingot: Life Without Debt," *Future Architecture*, 2016, https://futurearchitectureplatform.org/projects/eb26bc00-daef-476e-8a18-bac8745f20de/ (accessed October 6, 2021).

Time and again, artists have taken advantage of this leeway to prove the possibility of a practice that is open without being extractive, propositional without being pompous, grounded without being boring. The examples below are organized around the following keywords: regulation, specialization, propaganda, mobility, ownership, and redistribution. Luckily, things that were once exceptional are on the verge of being mainstream. Collectively-built infrastructures, from ruangrupa to *e-flux*, have reached hegemonic status within the field, and loudly point to options existing beyond business as usual. That said, the jackpot, the dog's bollocks, the best-case scenario remains that where structures are harnessed to an explicitly redistributive agenda, beyond CA alone.

One more point: no challenge to the daunting *Gesamtkunstwerk* that is real estate can rest on artistic intentions alone. Without interdisciplinary, historiographic, theoretical backing, artists can only go so far. As Suhail Malik argues, even within the confines of CA, artists are "one satellite term among many", who operate alongside the agendas of curators, collectors, journalists, academia, social media, mass entertainment, soft power diplomacy, etc.—all this to the humming sound of prices skyrocketing beneath our feet.

Don't Be an Asshole (Regulation, Protocol, Shades of No)
The artist and writer Dina Bursztyn once crafted totemic pieces she called *Gargoyles to Scare Developers* for Midtown Manhattan façades. In their stated objective, these masks compare to all manners of gargoyles, such as the platforms that proudly track the number of burning cars in a neighborhood or the iconic Berlin graffiti that says *ABWERTUNG* ("DEVALUATION")—a deadpan speech act, black on white. The schadenfreude is irresistible. But maybe this a type of cattiness that is actually reassuring to developers.[37] Some theorists, like Malik, would warn creative workers against antidevelopment totemics altogether, lest they wind up using the poverty of a neighborhood as collateral in their search for cheap studio rent.

Quite often, discerning whether creatives represent something more than their own interests alone is not difficult. For an example of collaborative sabotage, see the public awareness campaigns of the Southwark Notes team in central London, which uses the visibility of CA against itself. In 2014, artist Mike Nelson was commissioned by Artangel to build a monumental pyramid in Elephant & Castle. The structure was to be composed of former council flats, stacked up, one on top of the other.

37 See Ulrich Gutmair, *Die ersten Tage von Berlin* (Berlin: Tropen Verlag, 2014), 183.

The resulting shitstorm put paid to Artangel's plans, and the hapless cynicism of the art world became an effective megaphone for neighborhood demands. Such is the much-coveted Rancierian "redistribution of the sensible," once taken to a more rigorous conclusion than what is typically expected of us.

For an example that dramatically ripped an entire art scene apart, look to B.H.A.A.A.D. (the Boyle Heights Alliance against Artwashing and Displacement). In Boyle Heights, still a largely working-class part of Los Angeles, B.H.A.A.A.D. exemplified how artists, including even silky smooth CalArts graduates, can take their cues from a campaign for bottom-up autonomy, prioritizing use value and maintenance over representation.[38] Whether by working within the tenants union, repainting zebra crossings and alleyways, or leveraging CA as a strategic, high-profile scapegoat. In 2016, B.H.A.A.A.D. pinpointed CA venues as agents of gentrification and told them to close shop. They organized boycotts and picket lines, even on the day artists convened to lament the election of Donald Trump. The escalation forced the CA field to forgo its cherished shades of grey and take sides. I myself got a lot of heat merely for failing to distance myself from B.H.A.A.A.D. members. But they themselves lost much more, within a small job market that does not forgive easily. B.H.A.A.A.D. opponents were incensed by tactics that included personal threats—albeit from anonymous individuals—and by what they perceived to be the activists' double standards. After all, the nonprofit space 356 Mission was targeted as the weakest link, while the more toxic Maccarone Gallery threatened B.H.A.A.A.D. with brute force and was left alone. Partisans, meanwhile, pointed to CA's tendency to handle any political clash, from gentrification to Trump, as a personal trauma when, in fact, no genuine political struggle can curate the leverage it wields in order to safeguard likable venues and individuals. People have to grab that leverage wherever they can, and in the final analysis, no cultural boycott worth its salt is ever lacking in symbolic violence.

What's more, if you are in CA, chances are you have options. You can reinvest your gallery experience, your talent, your diplomas elsewhere. I remember the irony of the Gezi protests erupting in 2013 just as the Istanbul Biennial finally summoned its most concerted attempt to engage with the city around it. Curators Andrea Phillips and Fulya Erdemci matter-of-factly cancelled a major chunk of their program. Only

38 In other words, to those of us watching from afar, B.H.A.A.A.D. was important as an example of artists learning from a neighborhood, not in terms of a neighborhood relying on artists; Boyle Heights had long enjoyed a tradition of activism regardless.

via a "presence through absence," they argued, might they contribute to something beyond the biennial itself.[39]

The art of saying "no" applies not only to the extractive potentials of a neighborhood, but also to our eagerness to juice ourselves (and each other) with reckless abandon. In the words of NYC pressure group WAGE, we should lean on each other to "Do Less With More—Not More With Less." In other words: protect each other from work by means of collective protocols. Regulating and depersonalizing the art field in this fashion will not be easy. The historical roots of CA's cowboy libertarianism run deep, all the way back to the Renaissance, when plucky artist heroes refused to pay their dues to guilds and scoffed at medieval regulations. It was at this time that commissions were first individualized and the multiplicity of social rapports that once flowed into an artwork were eclipsed. Instead of a patrimonial institution that commissioned a guild, you now had a man of taste, who selected a plucky artist genius.[40]

But a raging ego need not be a stumbling block. In *Coding Freedom: The Ethics and Aesthetics of Hacking* (Princeton University Press, 2012), for example, anthropologist Gabriella Coleman describes how even Debian hackers can agree on a code of conduct that formalizes internal values and recruitment criteria. Artworld examples also exist, *in nuce*, thanks to pressure groups (BBK or WAGE), artist unions across Scandinavia, cultural boycotts (PACBI), networks like the Nouveaux Commissionaires, or the bullish picket lines of B.H.A.A.D.

Chanelling Mobility

The artist pressure group BBK likes to conjure the danger of a Berlin brain drain: *Geist ist flüchtiger als Kapital, haltet ihn fest!* (the intellect is more fleeting than Capital, hold it tight!). The slogan comes across as a threat, but at second glance it seems like more of a shared concern. The postindustrial towns discussed in these pages are not tied to their service sectors the way industrial cities were once tied to manufacturing plants. Employment in a postindustrial town cannot be fully disentangled from its environment and infrastructure; [41] service sector jobs, particularly in culture and gastronomy, tend to be rooted in "specificity" and "quality

39 Wigbertson Julian Isenia "The Museum as Battlefield: The Case of Hito Steyerl, Part 1," *E*, April 23, 2017, https://esthesis.org/the-museum-as-battlefield-the-case-of-hito-steyerl-part-1-wigbertson-julian-isenia/ (accessed October 6, 2021).
40 It was also at this time, incidentally, that a "revolution of objects" flooded the luxury market; cf. Patrick Boucheron, "La Renaissance fait écran," in *Faire art comme on fait société: les nouveaux commanditaires*, eds. Didier Debaise, Xavier Douroux, Anne Pontégnie, Christian Joschke and Katrin Solhdju (Paris: Les Presses du réél 2013), 110.
41 Sequera and Janoschka, "Gentrification Dispositifs in the Historic Center of Madrid," 381.

of life," however mythical or contentious such values may be. A factory can up and leave; a museum less so. Even if, should it be deprived of the necessary TLC, museums can wither into irrelevance, or caricature.

In the spirit of this symbiosis, a number of experiments have attempted to channel cultural tourism into something more equitable and/or decelerated. You have the teeny tiny pointers toward a more deliberate kind of cultural consumption—e.g., venues such as the Uffizi Gallery Firenze, which tweaked ticket prices to encourage repeat visits. Or you have the "city tax" proposal of a 5 percent surcharge on all rooms booked by Berlin's 500,000 tourists daily, 75 percent of whom named "art and culture" as the principle reason for visiting.[42] As proposed by the artist coalition Haben & Brauchen, this tax was the artists' claim to a surplus they themselves generate. The Senate picked up on the idea in 2013, but, by the end of the negotiation process, the arts were left with a third of city tax revenue above a threshold of 25 million euros. The remaining two thirds were allocated to sports and the tourism industry itself. A bitter compromise, if a groundbreaking first step that has already born strange fruit (the initial stages of REALTY itself were funded by the city tax).

For an even more ambitious example, we can turn to Riwaq, a Ramallah NGO that mobilizes CA, among other things, in the aim of fostering sustainable tourism in the West Bank's impoverished villages. In the hands of Riwaq, art becomes a classy propaganda tool, a cash cow, and a means to material and symbolic interventions in and around Palestine's rural areas. The effort is geared entirely toward stemming displacement, not toward redeveloping, desegregating, or "mixing it up," which is why, CA notwithstanding, over 90 percent of the buildings renovated by Riwaq, still house the same residents as before.

Tourists aside, when it comes to mobilizing mobility a more speculative option altogether would be to reinvent the tradition of the international artist residency. What distinguishes a residency from, say, an informal workation, staycation, or retreat, is the placemaking capacity that generates cultural capital on both ends: the artist anointed by an institution; the location gilded by art.[43]

The mythological subtext is easy to underestimate. A good two centuries ago, residencies replicated the Renaissance as a *locus amoenus*,

42 "To Have and To Need – An Open Letter About the Planned Berlin City Tax," *Haben und Brauchen*, April 19, 2013, http://www.habenundbrauchen.de/2013/04/haben-und-brauchen-offener-brief-zur-geplanten-city-tax-in-berlin-2/ (accessed September 23, 2021).
43 To appreciate the dark magic at play, see Natascha Sadr Haghighian's video *Villa Watch* (2005, in collaboration with Judith Hopf), where artists succumb to a Buñuelian suspension of agency and refuse to leave the residency building no matter what.

a nostalgic site of holistic innocence. Rome residencies, in particular, became the content of the art itself. This was not only about reviving the work of the ancients but the lives lived, the light and climate, so the artist could be Artist, once again. "The being at Rome, both from the sound of the name and the monuments of genius and magnificence she has to show, is of itself a sufficient distinction without doing anything there," said William Hazlitt, a writer blessed by artist siblings, in 1827.[44] The nineteenth century race for Rome was fueled by a new imperial premise. Culture now helped define the worth of a nation and entitled it to spread its influence across the world—a form of ennoblement that still resonates in the shape of residencies and other national storefronts: biennales, pavilions, museums, etc.

Artists were the first to see in this trend a form of structural poverty. Gottfried Schadow—the sculptor of the chariot atop the Brandenburg Gate (and as such a competent placemaker in his own right)—wrote in an 1828 edition of the *Berliner Tagblatt* that "the ever more liberal support which the fine arts enjoy, especially the new travel stipends for young artists, will certainly multiply [their] already incredible popularity among needy young people."[45] Residencies today still exacerbate the precariousness they claim to respond to. Artists are thrown into environments they barely have time to take in, let alone understand. Politically, they learn to zap and stare; intellectually, they learn to embrace every interruption as an opportunity. Economically, residencies put pressure on local rent, particularly in the artists' hometowns, where their flats become temporary sublets.

But residencies are also now a chance for a mass-infrastructural retrofit. It wouldn't be the first time that art engages in a wholesale reinvention of the infrastructure around it. Those Soho warehouses are one thing, the Arsenale—a structure at the heart of the Venice Biennale that once harbored an early form of mass social housing for workers who pounded out fifty warships a week over the late middle ages and the Renaissance—is quite another.[46] And when residencies were established in the nineteenth century, art supplanted religion by taking over pilgrim hostels, convents, and monasteries. Today, we could again rework the transcontinental

44 Angela Windholz, *Et in Academia ego. Ausländische Akademie in Rom zwischen künstlerischer Standortbestimmung und nationaler Repräsentation (1750-1914)* (Regensburg, 2008), 415.
45 Ibid., 269: "Die immer liberalere Unterstützung, derer die Künste des Schönen bei uns sich erfreuen, besonders aber die neugestifteten Reisestipendien für junge Künstler, werden ohne Zweifel den schon jetzt fast unglaublichen Andrang unbemittelter junger Leute zu der Künstlerlaufbahn noch vermehren."
46 Scheppe, "The Ground-Rent of Art, and Exclusion from the City: The exemplary quality of Venice's singularity," 20.

sprawl of villas, sublets, glamorized dormitories, Goethe Institutes, DAADs, IASPISes, Cittadellartes, into something else entirely.

When we restructured the Bern Sommerakademie Paul Klee in 2016, we halved the number of residents, doubled their time on site, and made them return, repeatedly, to also teach. We then introduced collective working premises, more demanding and chewy, and have now split the residency between artists based within a regional radius and others participating digitally. Now, in the wake of COVID-19, the time is ripe for something far more demanding, measured not in months but quintennials or more. Cash spent on FIFO can be used to make artists stay wherever the hell they are. A 2018 REALTY event with Christopher Roth built on precedents such as Ruth Catlow's manifesto "I Won't Fly for Art," or the "time grant" stipends initiated by *Haben & Brauchen*. Two years before COVID-19, the workshop was already called "Don't Move."

Propoganda as Proposition

Back in 1980, Joseph Beuys whipped up so much bad press for New York Mayor Ed Koch that he eventually allowed the group show *Real Estate*—held in a Lower East Side squat—to morph into an art institution. The venue ABC No Rio exists to this day. In today's battle for inner city spaces, artists are afforded a different kind of airtime—not as heroes but stylized versions of those anxious middle class citizens who flicker back and forth, duck and rabbit, between victim and perpetrator. The Balfron Tower in London is a handy example. As they evicted longtime residents, developers co-opted artist tenants for an artwashing exercise. When the first artists were eventually evicted, they too joined a campaign for 50 percent affordable housing in the tower.[47]

Is flickering the only option, or can proactive propaganda still be a posture of choice today? CA paraphernalia—testimony, critique, conceptual finesse, etc.—indicates that stuff will always be there, as will the flux and the tricksterism. (So much the better: how else would people declare a cable car or a homeless shelter a durational artwork and get away with it?) But art can go further. It can reorganize the very algebra of what is visible, viable, and true. See, for instance, Laura Yuile's *Asset Arrest*, which commingles the categories enumerated above with shrewd propagandistic intent,[48] as do several artists in this publication. What imageries can make "solidarity" fancy as opposed to folksy? What makes

47 Balfron Social Club, *tumblr*, https://50percentbalfron.tumblr.com/ (accessed October 6, 2021). http://rabharling.com/portfolio/films/dispossession-the-great-social-housing-swindle/ (accessed September 23, 021).
48 Laura Yuile, *Asset Arrest*, https://www.assetarrest.com/ (accessed October 6, 2021).

the notion of "pride of place" feel more like "sanctuary city" and less like Brexit, or Heidegger?

Beyond cash and lawfare, a public mandate hinges on aesthetic efficacy, on image-shaping efforts which make the "right to the city" come across as open and alive, rather than folkloric. In an interview with Christopher Roth, the prominent Social Democrat Hans Jochen Vogel unpacked his lifelong campaign for progressive land policy. It never gained the societal traction it required, Vogel stated, as it was lacking "a representability of intention" (*Darstellbarkeit des Vorhabens*).

The campaigns of real estate developers, for their part, are as crude as they are catchy: *Move to What Moves You ... If you lived here, you'd be home by now ... Your Gateway to a Richer Life!* Can this stuff really be that hard to outflank? Is there no shade of propaganda that can anticipate another future, even if we cannot know it just yet? For now, private tower blocks remain the ultimate cool, but it was nice to see public housing estates become Hong Kong's number one Instagram backdrop of 2018.[49] To mold the future, according to the *Online Etymological Dictionary*, is the very crux of the Latin word *propagare*—"to set forward, extend, spread, increase; multiply by layers, breed" (from *propago*, "that which propagates, offspring").

The Decolonizing Architecture collective in Palestine (DAAR) is a delightfully literal example of "setting forward, extending, spreading, increasing," etc. At a Bard College conference in 2011, founding member Sandi Hilal explained how the right of return requires being anticipated visually in order to render it imaginable.[50] One never visualizes in material terms, she argued, what the "return to Palestine" might look like. What exactly can be "returned to" if 444 towns and villages were bulldozed seven decades ago? Do you take a bus to grandma's birthplace? How much luggage can you bring? Is there a coupon? For now, the current degree of abstraction remains a clear disadvantage. Which is why DAAR attempts to creatively visualize return instead of remaining bogged down within prevailing conditions on the ground.

DAAR are also the instigators of Campus in Camps, an informal university based in a refugee camp outside Bethlehem. Campus in Camps secures a discourse and subject position rarely available to refugees within the historical scar tissue of the West Bank. It even went

49 Mary Hui, "Public Housing for Some, Instagram Selfie Backdrop for Others," *New York Times*, August 9, 2018 https://www.nytimes.com/2018/08/09/world/asia/hong-kong-instagram-photography.html?action=click&module=Editors%20Picks&pgtype=Homepage (accessed September 23, 2021).
50 in keeping with the speculative research of DAAR (Decolonizing Architecture Art Residency), which Hilal cofounded with Alessandro Petti and Eyal Weizman.

an extra mile, challenging UNESCO to grant the camp protective World Heritage status.

Generally speaking, CA always already anticipates its own future willy-nilly: "consciously or unconsciously, artists approach the neighborhood with possessive attitudes that transform it into an imaginary site."[51] Whether intended or not, propaganda remains an ongoing and effective process, regardless. To this day, artists are still less vocally mistrusted than other actors, still given the benefit of the doubt as witnesses, representatives, consensus makers, enablers.

The propositional factor aside, how to best recount the old stories of gentrifications thwarted, from Madrid to Tehran to Atlanta? Take the fascinating example of Dara Birnbaum's 1989 *Rio Videowall*, an outdoor video installation—reportedly the first of its kind in the US—where real-life shots of customers at the shopping mall in Atlanta where the work took place were combined with visuals of the park on which the mall had been constructed. After a slow phase of neglect, the mall disappeared along with the artwork. As critical art it probably didn't hold water, but as a battered monument to postmodernism, in the words of one observer, it lives on in its posthumous reception.

Ownership: Blue Sky Thinking & Material Infrastructure

As Rodchenko put it in 1925, "the things in our hands must be equals, comrades."[52] Since then, much has been said about artists and property, especially in terms of authorship and art objects. I have a feeling you'll forgive me for skipping the overarching debates and head for a handful of examples, which together illustrate an interesting range of options.

When it comes to city development, much of the attention goes to prodevelopment models of art-assisted growth, in both urban and rural settings alike. The Scottish Stove Network, for example, bought up abandoned High Street shops in the market town of Dumfries, activating them with all manners of projects, with local constituencies. More high-flying cases include African-American artists Edgar Arceneaux of the Watts House Project LA, Theaster Gates and his Rebuild Foundation Chicago, and Rick Lowe of Project Row Houses Houston. For all the differences in upshot, the three do have in common the high-stakes deployment of art within vulnerable environments, and a heated reception to boot, not to mention the familiar rhetoric of CA. As Arceneaux

51 Deutsche and Ryan, "The Fine Art of Gentrification," 105.
52 Christina Kiaer, *Imagine No Possessions: The Socialist Objects of Russian Constructivism* (Boston, 2006), quoted in Phillips and Erdemci, Actors, Agents and Attendants,157.

put it, "The process is reflexive. You do something and you let the work talk back to you. But I can't imagine a more sort of indeterminate background than Watts."[53]

Other artists rethink ownership in a bid to reclaim conditions of production from within the safe purview of CA. Canonical examples include Maria Eichhorn's artist contracts, or DIY infrastructures such as Andrea Zittel's Institute of Investigative Living in the Mojave Desert. See also Michael Asher, whose attempt at a *Michael Asher Trust Fund* (1985) would have made him a trustee of the Van Abbe Museum Eindhoven, allowing him to acquire work for the collection. The idea is based on an earlier bid for a slice of the Van Abbe: the 1978 *Permanent Collection* stipulated ownership of two rooms, which the artist-landlord would have leased back to the museum over limited spans of time.

For artists deploying such *Erbbaurecht* leaseholds beyond the museum walls, see the Berlin ZK/U collective, which secured the use of public land for extensive art-infrastructural ambitions. For an update of Eichhorn's contracts see Cameron Rowland, who leases his work via boilerplate equipment rental provisions. When the value of the art increases, the rent can be raised, and renewal clauses may or may not be triggered. In some cases, Rowland's provisions foreclose the future sale, or resale, of his work. Much depends on the artwork and the background checks (sometimes identical pieces are exhibited side by side, one for rent, one for acquisition).

To take a more speculative example, Vermeir & Heiremans sought to boost the value of the Pumphouse Gallery environs in London, with the stated intention of redistributing the surplus to a "wider community of artists." Their terrific publication, *A Modest Proposal* (Gazelle nv, 2018), documents these research efforts, introducing, among other things, the catchy term "proprietary estoppel." This legal device has been used in cases of disputed inheritance where labor invested in a property has enhanced its value but remains unrecognized: a godsend for artists who regularly upgrade properties before getting the boot.[54]

At times it's a simple matter of asserting that even what looks, feels, and behaves very gated still must remain a public asset. Consider the Platform London coalition, which insisted that the hallowed TATE Modern Turbine Hall remain in the public domain. Early in December 2015,

53 Lynell George, "Watts House Projects: Art Meets Architecture Near the Towers," *Los Angeles Times*, November 2, 2008, https://www.latimes.com/entertainment/la-ca-watts2-2008nov02-story.html (accessed May 23, 2021).
54 "A Modest Proposal (Symposium)," *Jubilee-Platform for Artistic Research and Production*, October 27, 2018, https://jubilee-art.org/?rd_news=vermeir-heiremans-a-modest-proposal-symposium&lang=en (accessed October 6, 2021).

Platform held an unauthorized "Deadline Festival" in the gigantic hall (scheduled to coincide with the Paris climate talks), spending twenty-five hours lobbying the TATE to dump its sponsor BP (the sponsorship deal expired the following year).

The most ambitious option is to proactively remove a property from the pressures of profit and placemaking altogether. See Adelita Husni Bey's *White Papers* series, which led to the 2018 *Convention on the Use of Space-White Paper: The Law*. The collectively drafted legal instrument posits "usage" as a criterion for ownership, along the lines of an age-old anarchist demand: "houses to those who use them." Usage as a benchmark, Husni Bey worriedly pointed out, implies a continuous activation of whatever you lay claim to, and an outward marking of productivity as such. The imperative of incessant use, she claimed, can be a problem ("Gentlemen, you must produce!"). But the alternative is a blank check, and a clear loss of accountability. As long as artists and curators are constrained only by factors even more egotistical than themselves, accountability remains a more pressing concern than the imperative of visible production.

A complicated case in point is Eichhorn's contribution to documenta 2017, *Building an Unowned Property*. Thanks to the cultural capital of documenta, and the financial capital of the Migros Museum Zurich, Eichhorn purchased a stately, empty house in central Athens, declared it art, and removed it from use and circulation, thereby "freeing it from ownership forever."[55] Poignant and haunting, the piece is a culmination of the artist's lifelong engagement with property as a working concept. The curator in me is delighted. Alas, one curator's artwork is another man's badly needed asset on the ground. During a seminar at the Dutch Art Institute, we chewed on the project for a full semester, and briefly considered squatting it. But any such sense of entitlement would rest on the FIFO license of CA all over again, so we were relieved when we got wind of a group of Athenians who planned to squat it themselves.

Berlin, where Eichhorn is based, offers more transparent examples of artist takeovers. In Wedding, a working-class part of town, Daniela Brahm and Les Schliesser also succeeded in removing real estate from circulation forever. Their ExRotaprint complex is not only elegant and evocative but collectively owned, together with neighborhood stakeholders and sans any resale options. "Property is abstracted until it disappears," say the artists. Its statutes devote the complex equally to art, small business concerns, and social facilities (including a "School

55 Thomas Büsch, "Building an Unowned Property," *InEnArt*, May 2, 2017, www.inenart. eu/?p=21873 (accessed October 6, 2021).

for School AWOLs"). Thanks to such long-haul efforts, Brahm is now a sitting member of the *Runder Tisch zur Liegenschaftspolitik* (Roundtable on Property Policy), an influential committee for municipal real estate policy.

Arguably the most ambitious case of CA as an actual means to property redistribution is the *Centre d'art des travailleurs de plantations congolaises* in Lusanga, and its working partner, the Institute for Human Activities. The effort was kickstarted by the artist Renzo Martens, who first gained international renown with *Enjoy Poverty III* (2008), a film set in the Congo that addressed the aestheticization of poverty for commercial ends. Years later, Martens admits that the film was a voyeuristic example of what it purported to critique. Typically, at this point, artists will write an underhanded self-critique, quote Franz Fanon and Paolo Freire, and move on to the next location in Tehran or Siberia. The fact that the artist returned to the scene of his embarrassment, building on experience and raising the benchmark, is rare. The center he helped to initiate is now a growing "postplantation," owned and operated by a local collective of farmer-sculptors. The results are testament to the accumulation of knowledge on a given terrain, however fraught, over an extended timeline. They amount to a whole other realism, beyond the testimonial that is sandwiched between one cause and the next.

REALTY teamed up with Martens in tiny ways more than once, but so much has already been written about this groundbreaking case of best practice that, suffice it to say here, Lusanga's "reverse gentrification of the jungle" singlehandedly takes the premises of this chapter to the best possible conclusions.

I'll end this section with a strategy that is less exemplary than the last, but bears mentioning on account of its growing popularity among the creative classes. A *Baugruppe* is a new-build co-op with an option to privately own units and sell them, too. By forgoing the margins that otherwise go to developers and middlemen, costs are lowered by up to 20 percent. Hamburg is setting aside 25 percent of its land for such projects.[56] To experiment with new forms of collective living is, of course, terrific. The communalization of kitchens, living rooms and balconies can economize a third of living space usually sacrificed to the nuclear family model. What is more, collectives that include the elderly can halve the costs of support for older residents. Considering Germany's aging population, this ancillary outcome is not to be taken lightly. But the signal effect of *Baugruppen* alone can have a marked effect on property

56 Lauren Benson, "Is Baugruppen the Answer?," *Local Code Digital Design Journal*, July 23, 2017, http://localcode.org/2017/07/is-baugruppen-the-answer/ (accessed October 6, 2021).

value, and entry barriers such as price and habitus remain high. According to the Berlin Senate, 80 percent of *Baugruppen* residents are academics. Imagine the general assemblies. I shudder at the thought.

Specialization
Facing facts on the ground implies the courage to be predictable, even boring at times. To refer again to Martens, you cannot defend such work with criticality and charisma alone. Though it is hard to compete with Lusanga, Germany does offer a kindred spirit in the shape of the Planbude collective, whose members have been active in the St. Pauli quarter of Hamburg since the 1990s and are now key partners in an affordable housing project. Over the course of 2014–15, Planbude used capillary planning processes to assemble the demands of local residents they've come to represent. Techniques such as "wish production" were honed on-site over the decades, beginning with the spectacular *Park Fiction* movement of 1994, which mobilized tens of thousands in the name of democratized urban planning and "fictional radicalism."

Such skill sets do not rest on CA know-how alone. Property law, accounting and planning, political lobbying, etc., all require longer timelines than gotta-work-like-hell-for-my-show-next-month. In any context whatsoever, perseverance over time is the only way to transcend cliché, for better or for worse. CA must get over its pronounced tendency to believe it is reinventing the wheel with each new project ("did gentrification last year; doing the under-commons now"). Only when you stick to things for five, six, seven, fifteen years at a time do you realize how amnesiac and arrogant such self-imposed amateurism really is. Curatorial discourse, for its part, is utterly bereft of the rigor of academia, let alone indigenous knowledge, and is rarely cutting-edge. But when it strives for other timelines, it can be an important entryway to a heady topic. Or even more than that, it can precipitate a dialectical clash of categories over and above the marshy misunderstandings of a pleasantly confused audience—provided its aim is the pleasure of knowing, and not just the *look of thought*.

One of the most ambitious efforts of this ilk in recent years, the BLOCC collective uses experimental peer-to-peer templates to help art students redefine their place within the real-estate food chain. Founded during the Sommerakademie Paul Klee's REALTY program, BLOCC, aimed for an intergenerational shift from the very start, when there is still hope that young artists can conceive a whole other professional imaginary.[57] Such is the art of moving a lake with a teaspoon: it requires getting in there before the students are 100 percent accul-

turated in the FIFO glamor that probably drew them to the field in the first place.

To the average visitor, "artspeak," curatorial or otherwise, may seem like an open-ended flux of colorful possibility when it is anything but. Any decisive policy/reality shift requires enormous, sustained pressure, and patience with the peristaltic slowness of glacial timelines. That is why boundaries are policed with such paranoiac zeal—all the more when it comes to landed interests. Remember Hans Haacke's legendary *Shapolksy Real Estate Holdings* (1971), which hinted at slumlord activities among Guggenheim trustees. Not only was the show censored, curator Edward Fry was fired when he refused to back down. He never worked as a curator again. The demise of a curator may put a smile on certain people's faces, but it also proves that position-taking does matter, even today. And if that's the situation now, how might such positions matter when CA moves outside its comfort zone, and non-art expertise becomes the name of the game?

It isn't always the case that CA takes inordinate pride in "un-knowing." You will find examples from Bauhaus to blockchain that have no issues with hard knowledge. Who knows what the Constructivists and Productivists might have accomplished had they not been caught in the early slipstream of Soviet anthropophagy? But even within today's mainstream, whenever critique becomes proposal, whenever "representation" becomes Representation, whenever false modesty becomes a narrative claim, we are inching slowly beyond the moody incapacity of art today.

Milking CA (Redistribution)

Together with the students and faculty from the Dutch Art Institute, I had the pleasure of visiting Kampung Kreatif, a team of artists who have been engaging with a working-class community in Bandung, Indonesia, through all-age workshops aimed at developing professional skills and confidence-building. It is a way of facing up to the pending redevelopment of their neighborhood as Bandung strives to become a regional creative hub. We were impressed by the Kampung atmosphere, the sense of purpose, the children's traditional song and dance, and donated what

57 Like BLOCC, the *Syllabus* project (2016), by artist duo Subversive Film, places the political agenda of higher education front and center. *Syllabus* is a publication and workshop series based on teaching notes by legendary Palestinian filmmaker Hani Joharieh. Scribbled down shortly before he was shot and killed while filming, Joharieh hoped to teach the art of cinematography under extreme conditions—heat, cold, faulty equipment, etc.—and also to associate filmmaking with revolution, i.e. to have the "why" of cinematography take precedence over all else.

we could. We were then bidden a fond farewell. Visitors from Japan were expected, they said, and later in the day, another group from France. This is nothing new to CA. Organizations routinely tap one biotope to subsidize another, but few do so as unapologetically as Kampung Kreatif. The candor was actually refreshing: usually one worries that the glamor eclipses the outreach, and CA's aura is jeopardized.

The following example of redistribution is less straightforward than in Kampung, but it's an encouraging tale, with a rare happy ending. Our tale involves the House of Statistics (HdS) in Berlin. The HdS is—or was—an abandoned 40,000 sq m modernist moloch, as big as a neighborhood and haunted by its onetime role in GDR data management. Post 1989, it was slated for demolition—part of the Kollhoff Plan to pimp the Alexanderplatz skyline. In 2015, the AbBA collective pulled off a street-party-as-art-intervention, which included a large banner with the municipal logo on the HdS façade, announcing a new public facility for all types of sociocultural purposes.[58] The happening was symbolic; the building's demolition had been approved for some time. Yet within a few years, the idea went from a hashtag to a self-fulfilling prophecy.

Today, the HdS is a pioneering development steered by a broad coalition of actors. Thanks to AbBA, sale and demolition were prevented and a 65,000 square meters extension is being built, with space for culture, social work, education, low-cost housing, as well as a new city hall and municipal offices. This fairy-tale ending sets the stage for a terrific experiment of artists rubbing shoulders with social workers and technocrats. What is more, the HdS is a monumental contrast to the mythical Berlin playground of pop-up project spaces, breathless and short-lived. At this point, ephemerality comes so naturally to arts practitioners, it's hard for us to see it as the tool of governance it's long become.

In early 2018, the Berlin Senate earmarked 500,000 euros for art in public spaces during the 2019 Berlin Art Week. KW and the ZK/U, who had been collaborating within the framework of REALTY, were eventually granted the funds as an institutional duo, and together we made the HdS the topic, context, and cause of an intervention we dubbed STATISTA.

Precious little would have been possible without the long-haul expertise of ZK/U, who were part of the AbBA alliance, as well as that of the other Berlin collectives whose help we enlisted, such as Labor k3000, Raumlabor, openBerlin, image-shift, and others. The clout and status of KW certainly made a difference, and I take pride in the curatorial input

58 AbBA stands for the Berlin Alliance of Artists' Studios Under Threat.

on all sides. But at the end of the day, it was the city-political *nous* and ties to activists, planners, bureaucrats, and policymakers that brought everything to fruition.

STATISTA was art-as-propaganda, art-as-outreach, and art-as-an-international-summit-of-the-likeminded: an occasion to brainstorm around speculative proposals for the HdS and more. We were successful, despite occasional mishaps, on three distinct playing fields: the mainstream press was happy to see art unfold in a setting as weird and wonderful as this (we offered an easy target—hipsters! —and a number of colorful storylines); the senate liked the creative spotlight on a state-sponsored development project; and, finally, the CA field was pleased with the conceptual framing and the visual markers—from the visualizations of the art-in-progress to the spotlights dramatizing the HdS construction site at the vernissage. Finally, the HdS may stand to gain from STATISTA offshoots, such as lighting, repairs, security, political attention, media buzz, and speculative proposals in the realms of architecture, outreach, and fintech.

One master trope of the STATISTA endeavor was "statecraft." The German word *Staatskunst* offers a pun that the English translation is lacking, meaning both "art of governance" (Plato, Machiavelli, Locke, Rousseau, Hegel, Marx) as well as "government-commissioned art." In Berlin and elsewhere, *Zweckfreiheit der Kunst*—art's freedom from purpose—remains an important rallying cry. To propose statecraft as a leitmotif is to break with this tradition.

A highlight of the STATISTA program is Beecoin, a beekeeping effort in collaboration with the collectives Nascent, Moabees, Hiveeyes, ECSA, and others. The aim was to develop a cryptocurrency for the HdS and a network of kindred locations. A homegrown currency would prove HdS to be a site that produces value and offer a way to redistribute that value equitably. How to remunerate efforts of devoted supporters that are usually taken for granted, even in a standard grassroots setting? The HdS, we argued, could become a flagship store for a joint stock company that redistributes beecoins according to in-house criteria and values.

Initially, we thought to use the bees' productivity as the basis for an alternative value chain—with honey as an alternative "gold standard"—but in the hope of a less extractive modus operandi, the wellbeing of our bees (as measured by weight, kinetics, and temperature) was foregrounded instead. To partake in our joint stock company, you could produce Beecoins by either investing money or acquiring our beekeeping kit and monitoring the wellbeing of your own bees.

We were surprised to learn that the downtown HdS was a perfect

venue for this effort. Not only were our beehives built out of leftover HdS window frames—available by the thousands—but it turns out cities are presently a more amenable habitat for bees, since in terms of flora they are more heterogenous than the many countryside regions beset by rampant monoculture.

When it comes to redistribution qua art, fintech experiments such as beecoin offer the deadpan symbolics of automation and a unusual degree of transparency, being bereft of both Robin Hood heroics and the shady touch of benign embezzlement. By way of other examples, see also the Alliance of the Southern Triangle Miami, MACAO Milan, or Furtherfield London, run by Ruth Catlow, whose *Artists Re:Thinking the Blockchain* (University of Liverpool Press, 2017) is freely available online. See also Luiza Crosman and Pedro Moraes' *Come Greet the Dawn*, commissioned for the Sao Paolo Biennial 2018. The aim of the latter, an off-grid solar system connected to a cryptocurrency miner on a blockchain, was to create the permanent means to renewable energy, as well as redistributing resources to venues beyond the biennial.

Artist Christopher Kulendran Thomas's more blustery *New Eelam* (2015 – ongoing) is inspired by a utopian housing plan dating from pre-civil war Sri Lanka,[59] and aims to create a "distributed housing network" for the globally mobile. One day the stakeholders' tokenized property will be "as accessible as streaming movies on Netflix," with company revenues redistributed among constituencies beyond the members themselves via a decentralized community land trust. If it fulfils this promise, *New Eelam* will take CA's redistributive potentials to unprecedented levels: if not, it will become one more artwork, or investment firm, that caters to the cosmopolitan classes while at the same time universalizing its interests.

I hereby end this text with a propagandistic moment, cunningly disguised as an open-ended invitation. If we were to blend all the working premises in this section, if we summoned the expertise and protocols necessary for a broad vision of redistributing CA's resources anew, would that imply another genre of art altogether? A friend of mine sometimes speaks of "post-contemporary art" with a wistful look in his eyes. In its closing pages, my own *TRACTION* polemic suggests "Reallyism" as a moniker. "Speculative realism" and "posthumanist art" are others.

59 Easton West, "New Eelam," *Vimeo*, vimeo.com/202821309 (accessed October 6, 2021).
60 Fredric Jameson, *An American Utopia: Dual Power and the Universal Army* (London: Verso, 2016).

For one reason or another, the most impressive CA offshoots tend to dismiss the art-ontological question altogether, shrugging at such theoretical implications. Such is their right. But this will always limit us as a field to site-specific exceptionalism, *klein und fein*. For a promising taste of strength in numbers, the reader can look to the many hopeful references in this book. The Bauhaus, for one, is a historic precedent whose overarching project remains an iconic example of experimentation, commodification, and institutionalization in one fell swoop.[60] Maybe those clunky modern behemoths scaled across the world—museums, freeways, lunar colonies—no longer capture our imagination, but other scenarios might. The benefits of a better art, with a catchy name to rally around and replicate, are hard to deny. We should at least be curious enough to imagine it mushrooming on a mass scale, cantilevered and projected all over the place. Weirder things have happened.

Following page: cellphone snapshot by Dirk Herzog, 2017.

Biographies

Marwa Arsanios is an artist, filmmaker and researcher who reconsiders politics of the mid-twentieth century from a contemporary perspective, with a particular focus on gender relations, urbanism, and industrialization. She approaches research collaboratively and seeks to work across disciplines.

Khaldun Bshara is an architect and restorer. He holds a PhD in sociocultural anthropology and is currently Advisor of Riwaq Centre, Ramallah (PS), where since 1994 he has worked on documenting, protecting and restoring built Palestinian heritage. He is also Assistant Professor at the Department of Social and Behavioral Sciences, Birzeit University (PS). His design approach uses architectural processes to investigate the possibilities of negotiating tensions between actors within the field.

Marco Clausen cofounded a community garden in Berlin-Kreuzberg, the Prinzessinnengarten, and a neighborhood academy, the Nachbarschaftsakademie. In cooperation with initiatives, activists, educators, and artists, he works on self-organized forms of political education, fostering a local and global perspective on topics such as the right to the city, urban-rural relations, food sovereignty, sustainable urban development, resilience, communal ownership, and socioecological transformation. Since 2021, Clausen has been working with the Spore-Initiative, which collaborates with communities in the Global South with regards to climate justice, and the defense of nonextractivist cultures and knowledge production.

Laura Calbet Elias heads the department for Planning Theory and Practice at University of Stuttgart. Between 2018–2020, she was interim professor for Urban and Regional Planning at TU Dortmund and guest professor for Planning Theory at BTU Cottbus. Calbet Elias has also worked as a research assistant at the Institut für Stadt- und Regionalplanung (Institute for Urban and Regional Planning) at the TU Berlin and at the Leibniz Institute for Research on Society and Space. In her dissertation on "Speculative Urban Production: The Financialization of New Residential Construction in Inner-City Berlin," she examined the influence of financialization trends on developers' activities in new construction projects. She is a member of the editorial board of *sub\ urban. zeitschrift für kritische stadtforschung*.

Simone Hain is an art historian specializing in urban history, planning, and development. As head of the Department of Theory and History at the Bauakademie (Academy of Architecture) of the GDR, she played a major role in reestablishing the Leibniz Institute for Research on Society and Space in Erkner (DE), in particular the "Scientific Collections" pertaining to the history of GDR building and planning. Together with Hartmut Frank, she curated the first pan-German architectural-historical retrospective *Two German Architectures 1949–1989*, a traveling exhibition of the Institut für Auslandsbeziehungen (ifa), which has remained on tour since 2003. Hain has taught at the Berlin-Weißensee Art Academy and the HfBK University of the Arts, Hamburg, held the Gropius Professorship for the History of Modern Architecture at the Bauhaus University Weimar, from 2006–2016 she headed the Institute for Urban and Building History at the TU Graz. She lives and works in Berlin as a freelance writer.

Maria Hetzer is a performance researcher and cultural anthropologist. She gained a PhD from the University of Warwick (GB) with a thesis on everyday life in the context of 1989 and the possibilities of transcultural translation of the experience of crisis. Her primary research interests are rural anthropology, everyday life in times of social upheaval, and the (post-) socialist "East," even if it happens to be located in specific parts of the African continent. She lives wherever her research takes her.

Sabine Horlitz is an architect and urban researcher with a focus on the political economy of the city, housing construction, and nonprofit property models. For several years, she has been researching Community Land Trusts and other forms of collective land ownership. She is a co-initiator of the neighborhood initiative ps wedding (pswedding. de) and comanaging director of the Stadtbodenstiftung (www.stadtbodenstiftung.de).

Suhail Malik is codirector of the MFA Fine Art, Goldsmiths, London, where he holds a Readership in Critical Studies. Recent and forthcoming publications include, as author, *ContraContemporary: Modernity's Unknown Future* (Urbanomic) and "The Ontology of Finance" in *Collapse 8: Casino Real* (2014). Malik is coeditor of *The Flood of Rights* (2017), a special issue of the journal *Finance and Society* on "Art and Finance" (2016), *Genealogies of Speculation* (2016), *The Time-Complex. Postcontemporary* (2016), and *Realism Materialism Art* (2015).

Bahar Noorizadeh is a filmmaker, writer, and platform designer. She works on the reformulation of hegemonic time narratives as they collapse in the face of speculation: philosophical, financial, legal, futural, etc. Noorizadeh is the founder of Weird Economies, an online art platform that traces economic imaginaries extraordinary to financial arrangements of our time. Her work has appeared at the German Pavilion, Venice Architecture Biennial 2021, Tate Modern Artists' Cinema Program, Transmediale Festival, DIS Art platform, Berlinale Forum Expanded, and Geneva Biennale of Moving Images, among others. She is pursuing her work as a PhD candidate in Art at Goldsmiths, University of London, where she holds a SSHRC Doctoral Fellowship.

Penny Rafferty is a writer and visual theorist based in Berlin. Her theoretical essays and creative texts have been commissioned for *Cura*, *Kaleidoscope Magazine*, *Keen On*, *NRW Dusseldorf*, *Rote Fabrik* and *Flash Art*, among others. She frequently draws on antagonistic lines of critique, popular culture, and ideas surrounding cosmic depression, aka paradise without utopia.

Kristel Raesaar is an artist based in Tallinn working with photography, text, and varying performative and collaborative approaches. She is a cofounder of the artist-led platform Neanderthal Cave School and a member and employee of Tuleva*, a cooperative fintech and civil initiative aiming to shift the power dynamics of Estonia's financial landscape from within. From 2012 to 2016, she was the artistic leader of Tallinn Photomonth and continues as a member of the biennial's advisory board.

Christopher Roth is an artist, film director, and TV producer. In 2020, he shot a fictional film with Jana McKinnon and Clemens Schick for the cinema about a commune in the 1980s. He is one of the initiators of *2038*, a project which was shown in the German Pavillon at the 2021 Venice Biennale. In 2018, Christopher colaunched space-time.tv, a cooperativist TV platform with now four stations. In the same year, *Architecting after Politics* premiered, after *The Property Drama* (Chicago Biennal 2017) and its prequel *Legislating Architecture* (Venice Biennale 2016), the third film with Brandlhuber+. Roth made *Hyperstition* with Armen Avanessian and *The Seasons in Quincy, Four portraits on John Berger* with Colin McCabe and Tilda Swinton (Berlinale, 2016). His film *Baader* won the award for "new perspectives on cinematic art" as part of the Silver Bear series at the Berlinale 2002. Christopher shows at Esther Schipper. christopherroth.org

Katya Sander is a conceptually based artist. Her work is about production and circulation of social imaginaries: structures, models, and images through which we imagine ourselves and what we can do. For Sander, the imaginary is not only a realm of subjective ideas but also shared, collective articulations and projections of what is possible, i.e. modes of operation, formats, or institutions in which we imagine ourselves as collective bodies and the things we do to sustain (or escape) these. Sander has published widely, edited magazines and books, and is Professor at Nordland Art and Film College (NO). She has shown at venues such as Documenta 12, Kassel; Tate Modern, London; Museum of Modern Art, NY; REDCAT, LA. She lives and works in Berlin.

Paul Seidler is an artist and programmer living and working in Berlin. He is one of the three cofounders of terra0 and is currently working on bootstrapping Nascent, an EXIT tech production studio, consulting cultural institutions. His projects and papers have been presented at Schinkel Pavillon, Berlin; MAK – Museum of Applied Arts, Vienna; Ars Electronica, Linz (AT); CTM Festival and Transmediale, Berlin; Dutch Design Week (NL), Furtherfield Gallery; London; and ecocore. His work has been discussed by *Wired*, *Forbes*, and *Moneylab*.

Marion von Osten was an exhibition maker, researcher, and artist. She was founding member of the following three collectives: Center for Postcolonial Knowledge and Culture (CPKC), kleines postfordistisches Drama (kpD) in Berlin, and the design collective Labor k3000 Zürich (CH). She curated exhibition and research projects such as *bauhaus imaginista* (2016–2020) with Grant Watson; *Viet Nam Discourse* (2016–2018) with Peter Spillmann; *Aesthetics of Decolonization* with CPKC (2014–2016); and others more. Von Osten received her PHD in Fine Arts at the Malmö Art Academy (SE) with Prof. Sarat Maharaj.

Tirdad Zolghadr is a curator and writer. Since 2017, he has been artistic director of the Sommerakademie Paul Klee. Curatorial work includes biennial settings as well as long-term, research-driven efforts, recently as associate curator at KW Institute for Contemporary Art Berlin, 2016–20. Writing includes *TRACTION: An Applied and Polemical Attempt to Locate Contemporary Art*. Work on Zolghadr's third novel, *Headbanger*, has long been ongoing. realtynow.online

Colophon

Managing editor
Lena Kiessler

Project management
Tabea Häusler

Copyediting
Michael Baers
Aaron Bogart

Graphic design
Neil Holt

Typeface
Arnhem

Production
Vinzenz Geppert

Reproductions
Repromayer, Reutlingen

Paper
Munken Print White
Vol 1.5, 90 g/m²

Printing and binding
GRASPO CZ, A.S.

© 2022 Hatje Cantz Verlag, Berlin

Published by
Hatje Cantz Verlag GmbH
Mommsenstraße 27
10629 Berlin
www.hatjecantz.de
A Ganske Publishing Group Company

ISBN 978-3-7757-5171-1 (Print)

ISBN 978-3-7757-5345-6 (eBook)

Printed in the Czech Republic

Co-produced with
KW Institute for
Contemporary Art

KW